FASHION TRIBES

Editor: Sarah Massey
Production Manager: Katie Gaffney
Library of Congress Control Number: 2014959559
ISBN: 978-1-4197-1390-3

Printed and bound in Singapore
10 9 8 7 6 5 4 3 2 1

Abrams books are available at special discounts when
purchased in quantity for premiums and promotions as
well as fundraising or educational use. Special editions
can also be created to specification. For details, contact
specialsales@abramsbooks.com or the address below.

ABRAMS
THE ART OF BOOKS SINCE 1949
115 West 18th Street
New York, NY 10011
www.abramsbooks.com

This book was conceived, designed, and produced by
Dominique Carré Éditeur-La Découverte.
Photography, interviews: © Daniele Tamagni, Milan, 2015
Editorial concept: Daniele Tamagni and Dominique Carré
Design concept: Stefano Bianchi

Desktop publishing: Fotimprim, Paris
Printing: Tien Wah Press, Singapore
© Dominique Carré Éditeur-La Découverte, Paris, 2015
ISBN : 978-2-3736-8009-6

Dominique Carré Éditeur-La Découverte
105, rue du Faubourg-du-Temple
75010 Paris
www.editionscarre.com

This book is a mix of spontaneous situations.

Its key word, *identity*, is illustrated in very different geographical contexts in which a popular, deeply rooted metaculture has been created, one that at once snubs its nose at colonial and Western culture while drawing from a great well of creativity. The guiding lights are the numerous interviews I conducted during my various travels, interviews that reveal the personal ways of life, styles, and dreams of another identity cherished by the subjects I photographed. In choosing countries and cities far outside the usual context of fashion, I not only wanted to offer an overview of the phenomenon of globalized style, but also to record the resistance to and preservation of traditions.

—Daniele Tamagni

FASHION TRIBES

Global Street Style

Photographs by Daniele Tamagni

Abrams, New York

CONTENTS

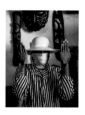
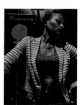
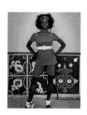

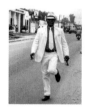
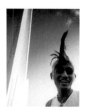

DISRUPTING THE FASHION ORDER
CREATING SOCIAL CHANGE THROUGH FASHION

Rosario Dawson
Actress, activist, and cofounder and co-creative director of Studio One Eighty Nine

Abrima Erwiah
Former global associate marketing director at Bottega Veneta, consultant at the United Nations International Trade Center Ethical Fashion Initiative in Ghana, and cofounder and co-creative director of Studio One Eighty Nine

The fashion tribes that are documented in Daniele Tamagni's photographs are latecomers to the fashion scene. Fashion trends like heavy metal attire, punk rock, and fine tailoring had their moment a few decades ago. In traditional core fashion markets, designer brands have become ubiquitous. Competition is so fierce that brands are constantly in search of creating the next "it" bag that will become a pop culture sensation. As a result, developing markets are often overlooked. Yet, in the periphery, there is a consumer market for designer offerings that arrive in countries like Senegal, South Africa, the Democratic Republic of Congo, Bolivia, and Burma. Arriving by way of both the countries' elite whom travel abroad to buy them and secondhand markets, fashion tribes want these items.

Set against this backdrop of fashion consumerism are the realities of everyday life. In Africa, we have rolling power outages, water and gas shortages, poor infrastructure, exposure to illnesses like typhoid, cholera, and malaria, persistent violence, and lack of access to adequate capital. Despite these challenges, in both high- and low-income areas, the demand for and knowledge of high fashion are growing—and this is evident in the creative styling captured in Tamagni's images. *Fashion Tribes* reveals local consumers well versed in mixing traditional garments with modern fashions and internationally recognized designer labels.

In our designs at Studio One Eighty Nine, we focus on preserving local traditions but mixing them in a modern way, showcasing the culture, heritage, and meaning behind the garments. Our designs often reference the traditional West African symbol of interdependence and cooperation, *boa me na me mmoa wo*, which means "help and let me help you." This philosophy is adhered to by the subjects in this book, like Bolivia's flying cholitas.

Tamagni captures the care that women take in their appearances—combining colorful scarves, hats, and dresses—to engage in a traditionally nonfeminine sport, while maintaining their femininity and sense of self in order to help their husbands earn money for their families.

Studio One Eighty Nine was borne out of a trip to the Democratic Republic of Congo for the opening of V-Day's City of Joy, a leadership community for women survivors of violence. We met women who had similarly overcome harsh circumstances, but still maintained their femininity and stood as leaders for their families. Victims of rape and sexual violence, these women now focus on using their creativity, craft, and fashion sensibility to build small businesses and create a sustainable living and future for their children.

Witnessing the role that fashion plays in the social impact of the women of the Congo, we were deeply impacted by the work of Tamagni, who then introduced us to his book, *Gentlemen of Bacongo*. He helped (and continues to help) shine a light on the style subcultures that have cropped up in forgotten places.

Fashion in developing economies is undergoing a renaissance. There is a new generation of fashion designers and international designers who see the value in producing in countries like Senegal or South Africa. Labels such as Paul Smith and Burberry have found inspiration in this part of the world, exemplified by the bold colors and prints they feature on the runway. New homegrown African brands, including Christie Brown, Bantu, Heel The World, Maki Oh, and Osei Duro, and blogs like *I See a Different You* and *Fresh Wall Street*, have spawned as well.

Developing economies are growing, and at Studio One Eighty Nine, where we place particular focus on Africa, we believe that Tamagni's work has helped lead to an explosion of creativity in fashion and the development of the industry. We believe that by developing a fashion industry comparable to the ones in the United Kingdom and the United States, this will lead to economic development and will in turn lead to social development—access to education, connection to markets, and job creation. Tamagni's photographs disrupt the fashion order by showing a different point of view of subcultures, spotlighting their fashion styles and the untamed creativity that is borne out of adversity.

This year marks the twentieth anniversary of the movie *Kids*, where Rosario Dawson was discovered in front of the squat where she was raised on New York's Lower East Side. This pivotal moment not only changed her life, but put her in a position to affect change in the lives of those around her through her creativity.

Just like Dawson did, the cholitas of Bolivia, the dirriankhes of Senegal, the sapeurs of the Congo, the punks of Burma, the metalheads of Botswana, the Sartists of Joburg, and the youth of Cuba have beat the odds to be creative. They are fashion tribes that transcend with creativity, and Tamagni has helped the world acknowledge them.

Fashion Tribes introduces you to talents that are just beginning to show their potential. They are destined to receive the same accolades given to brands and creatives so often revered in the fashion community. This is what style is all about. Let's welcome the era of the Fashion Tribes.

STREETWEAR WORLDWIDE

Els van der Plas
*Former director of the Prince Claus Fund for Culture and Development (1997–2011)
and general director of the Dutch National Opera and Ballet in Amsterdam (2012–)*

*Tell me the truth, boy, am I losing you for
good / We used to kiss all night, but now
there's just no use*

so sings American pop star Solange
Knowles, surrounded by well-dressed
African men in the music video for her
hit song "Losing You" (2012). These are
Congolese dandies, *sapeurs*, winding up
in a popular music video that won awards
for song, video, and styling. Inspired by
photographer Daniele Tamagni's book
Gentlemen of Bacongo,[1] a photographic
classic that portrays the men's long tradi-
tion of public fashion, Solange, with the
contribution of Tamagni and Dixy Ndalla,

picked up the sapeurs and their style in
London and Cape Town. And soon after,
African street culture and its protagonists
ended up in a video watched by more than
12 million people.

Often, fashion is not created and de-
fined in ateliers, but on the street. Think
of postcolonial Kinshasa, London in the
sixties, and Tokyo in the eighties. At those
times, in those places, being cool was the
thing to do. And many of the people who
lived there made it their goal to be trend-
setters. Some wanted attention, social
status, and respect, while others wanted
to express their own political views and
artistic drives.

In its postcolonial period, during the 1960s and '70s, Kinshasa, Democratic Republic of Congo, was a hopeful place but desperately poor. Its people had nothing and rebelled against their colonial masters, yet at the same time, they—especially the men—used the colonial look to acquire social status and draw attention. They exaggerated the Western suit, using clothing to confront their past and gain good standing—honor, respect—in an uncertain future. They called themselves the sapeurs. The acronym *SAPE* stands for La Société des Ambianceurs et des Personnes Élégantes (The Society of Ambiance-Makers and Elegant People).

In the sixties, London was relatively rich, and in those postwar years it had a young population that wanted to express its political and social opinions and revolt against the older generation. To that end they created their own look and style, as well as an inspiring music scene to go with it.

In the eighties, Tokyo youth rebelled against the establishment by choosing to spend a few hours a week dressed as rock 'n' rollers with transistor radios on a blocked-off two-lane road, effectively denying access for many other people. They lived in a fantasy world that revolved around music, looking good, and being cool.

By dressing up and showing off in flashy outfits on the street, these people got attention, prestige, and power in what were often very poor neighborhoods. At the same time, they inspired other young people to express themselves creatively and independently. And this was frequently accompanied by social and political messages as well.

Looking good, being cool, or making a statement (or a combination of the three) and the search for respect and identity are elements shared by these people worldwide. They use the street as a theater, a public catwalk—or a *T*, as the Africans call it—a boulevard on which to parade. Artistic motives play a major role in this public form of life; at the end of the day, standing out means attracting the gaze.

Daniele Tamagni, an Italian photographer trained as an art historian, is fascinated by the street and its fashion and looks worldwide. From Havana to Brazzaville, Rangoon to La Paz, Tamagni has found people who want to show off in their Sunday best or express themselves as trendsetting and artistically engaged.

Tamagni's interest in street life and ephemera puts him in the tradition of photographers such as Ed van der Elsken (Amsterdam, Netherlands, 1925–1990), Malick Sidibé (Soloba, Mali, 1936–), and Ricardo Rangel (Maputo, Mozambique, 1924–2009). These are photographers who were able to capture men in all the glory and misery of their daily public lives and convey their intrinsic beauty. Dressing up and looking fine is not an end in itself. Street life is always framed within a social context that in part dictates how people display themselves.

Respect is an important word in each of these subcultures. In many places, the concept of respect is synonymous with honor and is the opposite of shame. Gerd Baumann, who conducted a study in the London suburb of Southall, where 50 percent of the population is of Indian and Pakistani origin, demonstrated that for many young Southallians the term *respect* does indeed stand for "honor": "Hon-

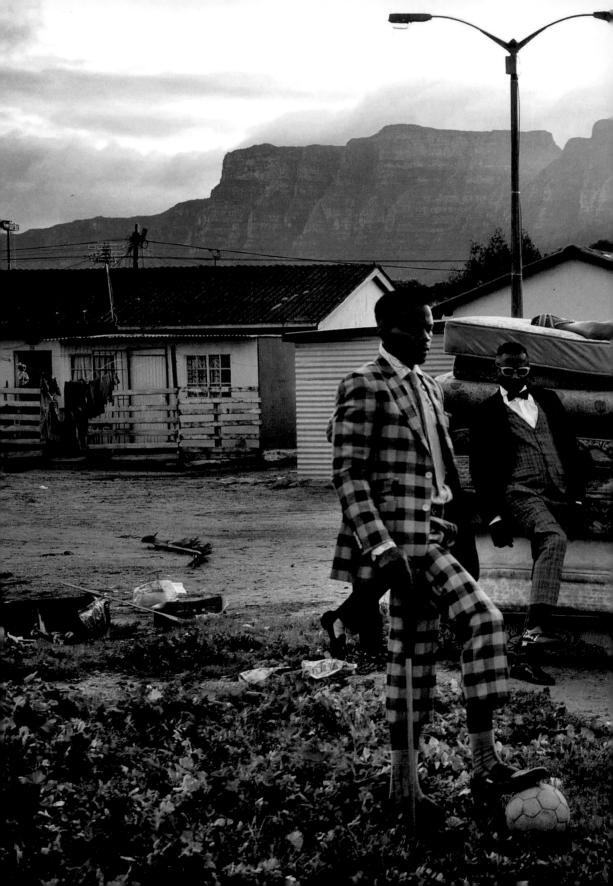

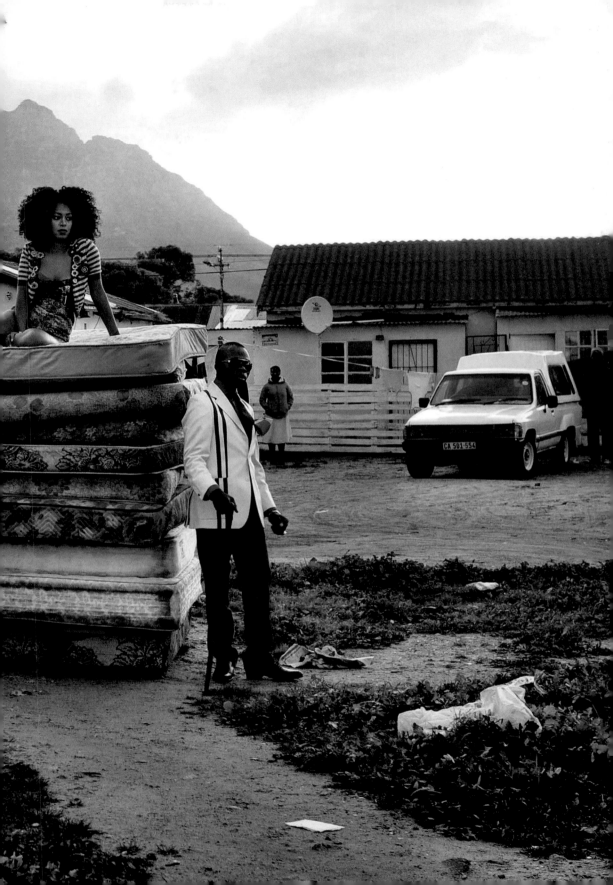

our (*izzat*) appears less as the absence of shame than as the fruit of respect (*izzat*) . . . It represents not the opposite of self-respect, but its fulfillment."[2] Self-respect depends on being treated honorably by others, or on the respect that they receive from others.

The same is true of the Congolese sapeurs, who often have no more than the clothes they wear and sometimes are unemployed and live with their parents. Dressing up, then, becomes an action in which one can acquire honor and recognition, which is greatly beneficial in the desperate situation in which many men and women in the Democratic Republic of Congo often find themselves.

The sapeurs live by codes and rules, and that is what makes the community so tightly knit. A real sapeur has to have traveled to Paris at least once, has to own designer clothes, and must return from France a successful dandy. Justin-Daniel Gandoulou, who was one of the first to undertake a serious study of the sapeurs, described this return as follows: "He must also . . . exhibit his outfits. In other words, he must valorise himself by exhibiting external signs of wealth and social success. It is through such an arsenal of signs that his chosen milieu and the rest of the population will appreciate and classify him among the people who have socially succeeded in life and deserve respect in society."[3] All the values and standards that we have identified in the various street cultures play their part in this: working your way up the social ladder, validating yourself through your clothing, reinforcing and expanding your individuality and identity, and ensuring that you are seen and heard. Fashion is combined with your own culture, rules, codes, and reference points.

Whether they developed in an impoverished environment or an ordinary neighborhood, one thing that these subcultures have in common is that they oppose the establishment. In his photographs, Tamagni not only documents the fashion and the aesthetic, but also tries to capture the essence of where his subjects are from and in what sort of *umwelt* (environment) they live.

Tamagni looked for the underground scenes in Burma because dictatorship and suppression are never far away. It is difficult to step out of line there, but when people do, they go over the top—hardcore rock music, tattoos covering their bodies, really going against the grain. AC/DC and punk are the references for these youngsters who put their lives in jeopardy. Some of them end up in jail. Others cool down, like Einstein MC King Skunk, who doesn't party much anymore but still wears a mohawk and shows it off wherever he goes.

Similarly, the Smarteez in Johannesburg, South Africa, are part of a subculture initiated by young people. Based in the township of Soweto, they combine an infectious rap and dance culture with colorful colonial-style clothing. The backgrounds of these photographs are the suburbs and slums of Johannesburg. Western culture has picked up on the Smarteez' appearance and fancy dress, and articles about them have appeared in various fashion and culture magazines, which shows how easily the "local" can globalize. This is a recurring theme in many non-Western subcultures: the desire to be accepted by the West while at the

same time opposing it. The sapeurs have migrated to Paris, while the Smarteez and the Botswana metal bands that Tamagni documents dream of international careers.

What many of these subcultures have in common is that they imitate the West, but with a twist. They look back, as it were. Just as the colonists gazed at them for centuries, they now gaze back. They use, ridicule, criticize, and honor them. Take, for example, the aggressive-looking metalheads who populate the Botswana rock scene—cowboys wearing leather suits and silver buckles in the African heat. Tamagni wants to record the clothing, the style, and the codes of their context and environment. The metalheads are mostly youths from poor backgrounds who want to show that they are someone. They mix eighties heavy metal and Western cowboy style with African accents, which results in a tough, cool, and intimidating demeanor. As with the sapeurs, it is a matter of appearance, identity, and gaining respect. And at the same time it is a challenging of social and cultural stereotypes and prejudices, especially for the female metalheads, whose appearances tend to violate the established norms.

Some subcultures were picked up by the West, but perhaps in unexpected ways. As previously mentioned, Solange Knowles appropriated the Congolese street style for her music video, which was filmed in various townships in Cape Town with the help of Congolese sapeurs and Tamagni. It is the West looking back to those who look back and then adapt that look to their own taste. Subculture becomes mainstream. Knowles was inspired by the music video for Janet Jackson's "Got 'til It's Gone" (1997), which,

although it was set in Cape Town during the apartheid period, was actually filmed in Los Angeles. Inspired by images from African photographers Seydou Keïta (1921–2001), Samuel Fosso (1962–), and J. D. 'Okhai Ojeikere (1930–2014), we see echoes of those images in the mise-en-scène of her video. Photographs of subcultures inspire fashion, and political messaging becomes a trending topic.

On the other side of the world, the opposite is happening. In Bolivia, women are opting for their own tradition. They wear traditional Bolivian clothing and are choosing the same profession as many of their men—wrestling. The male wrestlers dress like Batman and other Western comic-book heroes; the women go for traditional attire. Their motives are the same—to be seen, to establish a place for themselves, to create identity. In fact, in Bolivia, women used to function on the very margin of the margin; they stood behind their men, who, coming from a deprived background, chose wrestling and made something out of it by dressing as superheroes. Yet it's the women—proudly in action in the ring and with their men—on which Tamagni focuses. For these women, the code is tradition. The way they look attests to courage and an awareness of history.

Another group of women who build on tradition are the Senegalese *dirriankhes*. Dirriankhes are voluptuous women who have raised seduction to an art form. They pay attention to their clothing, perfumes, and coiffures because they want to attract the attention of their men and impress other women. Dirriankhes are universally respected in Senagalese culture, although it is often said that they

devote more attention to their appearance than to their children. Whereas it is Ares that inspires the Bolivian female wrestlers, it is Eros that drives the dirriankhes.

In the art of seduction, a group that more closely mimics the West are the *disquettes*, young Senegalese women with *tailles de guepes* (wasp waists) and the long legs of a gazelle. These women—who are younger than the dirriankhes and more entrenched in the social-media era—take part in the many beauty pageants held throughout the country and dream of international modeling careers. Their message is: Make yourself look even more beautiful. Straightening hair, braiding it, and adding extensions are very popular among the disquettes.

Clearly, for many of these groups, a focus on the West is important. However, Tamagni always shows that each culture is unique and significant in its local context. For example, even the Cubans he photographed on the streets of Havana wear T-shirts and other items from well-known brands such as Dolce & Gabbana, Nike, Louis Vuitton, and Armani, despite the fact that the average income there is around twenty dollars per month. But Cubans have little more than their bodies. As with the sapeurs, their bodies are the only things that they can be certain of, and so they decorate them with Western brands as a show of status and parade them through the streets.

Tamagni photographs these people with respect for who they are, where they live, and what they dream of for the future. He spends days with them to gain their trust, which allows him to take the photographs he wants. And while his subjects' clothes make a statement, the environment often plays a leading part in the complete image. A dilapidated house, a backyard with clothing hanging on a wash line, a barking dog running around—it all shows that ordinary life, their reality, is never far away. But, at the same time, it does not stop them from dreaming and hoping for a bright future. You never know, you might end up in an American pop star's music video.

NOTES

1. Daniele Tamagni, *Gentlemen of Bacongo* (London: Trolley Books, 2009).

2. Gerd Baumann, *Contesting Culture: Discourses of Identity in Multi-Ethnic London* (New York: Cambridge University Press, 1996), 103.

3. Justin-Daniel Gandoulou, *Dandies à Bacongo: le culte de l'élégance dans la société congolaise contemporaine* (Paris: L'Harmattan, 1989).

The two images of **Solange Knowles** wearing **Asanda Sizani** were taken by Daniele Tamagni in Cape Town (South Africa) on the set for the video "Losing You" (2012).

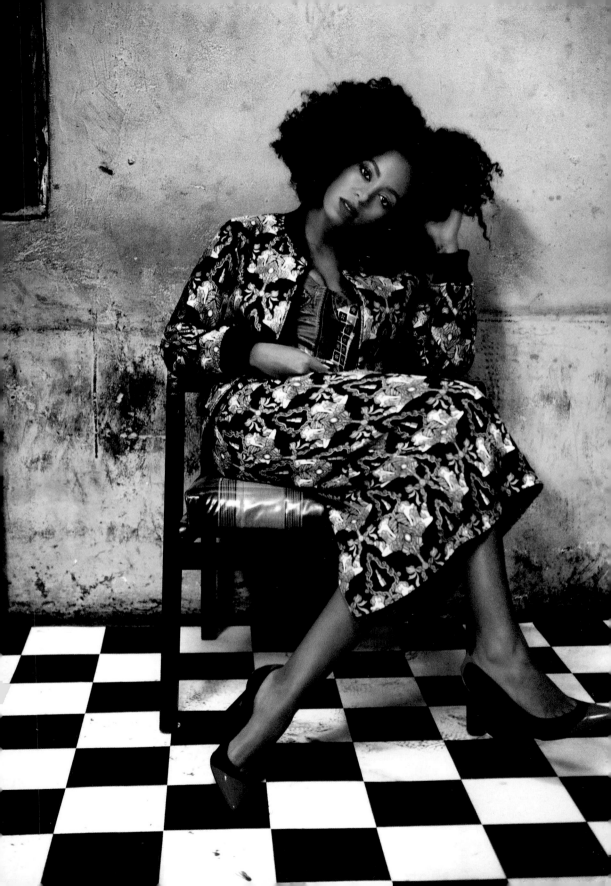

JOBURG STYLE BATTLES

Johannesburg, South Africa

Asanda Sizani
Former fashion editor of ELLE South Africa, *style consultant, and curator*

When the Smarteez exploded onto the South African pop-culture scene, it was a renaissance of a revolution. The collective rapidly gained popularity for reviving the very style that was available to them into extraordinary avant-garde fashion. The Smarteez opened the door to more style tribes who also had something to say through fashion. Cool hunters and fashion writers around the world were talking about them. For a country that had long been spoken for, that had long been muzzled and held back from being everything it wanted to be, this was exactly what was needed.

The Smarteez are daring creatives who wear compelling customized looks—true to the resourceful nature of Africans. They use the streets as their fashion runway, wearing their creations, which are as colorful as the candy-coated chocolates of the same name. What has happened since is the birth of crews with a distinct style emerging from various areas of Johannesburg, South Africa—both the townships and the urban rubble of the cities.

Anyone born postdemocracy in South Africa is referred to as a "born-free." While the struggle pre-1994 was for democracy, change, and equality, the struggle among the contemporary youth is for identity and acceptance. They are

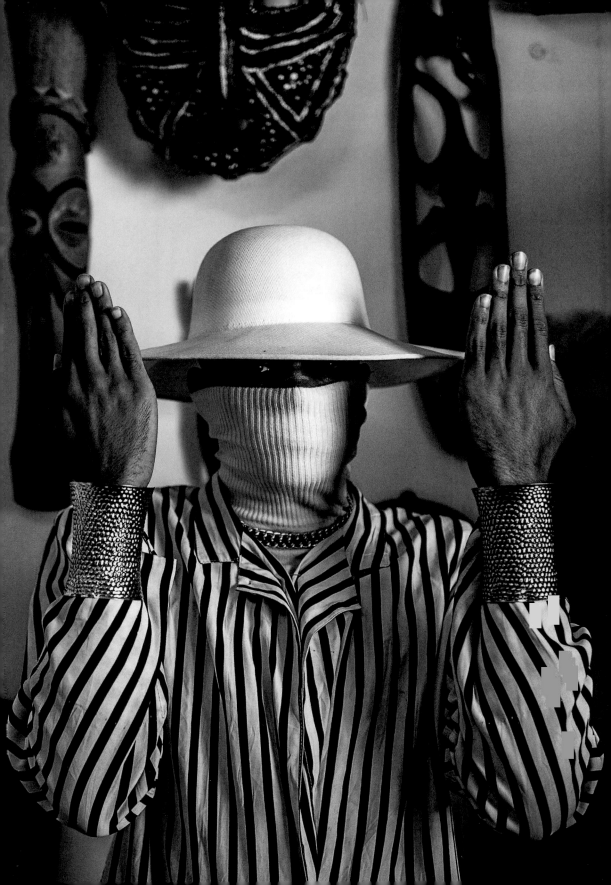

living the dream. Heroes of the resistance fought for everyone in our country, for everyone who lives on the continent to enjoy complete and total freedom. What these style tribes are communicating would have never been realized in any earlier decade. For them it is not just about peacocking through the streets. They are young and free, establishing an identity. Theirs is a message of pride and optimism and a celebration of the freedom that they not only were fortunate to have been born into, but also that they enjoy to its fullest. One of the things that has always been admirable about South African youth is their dedication to innovation beyond their appearance.

Bill Cunningham said, "Fashion is the armor to survive the reality of everyday life." These words could not be more fitting for the members of Vintage Cru. Anti-conformity, individuality, and fearless expression are their mantra. They express themselves through dance and fashion and have performed for Lady Gaga and toured with Die Antwoord. Vintage Cru is a perfect example of people working together as a collective yet utilizing individual specialties and opinions. They wear vintage clothing, pairing it with unexpected pieces they themselves call "absurd." Fashion is capable of expressing the social or political. They educate and raise awareness about the issues closest to them, such as lesbianism and homophobia. In their crew, each member feels respected, valued, and a part of something magical. I admire the qualities they have embraced: optimism, innovation, reinvention. Living in a digital age means they can raise even greater awareness via various social networks. There is something slightly retrospective about their creations and styling. It's a little nostalgic, but inspired, upbeat, and new. They labor all night to work on their costumes as a team. They create, rather than dwelling too much on the past or referencing it. Vintage Cru breaks the rules of conservatism. Its members challenge the norms of society.

Wanda Lephoto and Kabelo Kungwane, more commonly known as The Sartists (or sartorial artists), are the most dapper gents in town, thanks to their innate ability to breathe new life into the old. Rummaging through vintage treasure troves and their elders' wardrobes, these young men see beauty and purpose in the simple and neglected. Through dress, they explore themes of politics, history, and culture, drawing from South African, Italian, British, and American vintage style, especially that of the civil rights movement era. They lead the way in wearing clothes with style and individuality. The suits that were valued and reserved for special occasions decades before them suddenly have modern appeal once worn by them. The Sartists have become a billboard that illustrates and communicates culture—look closely and you'll see the clever coordination of textures and elements borrowed from all over the world. They use fashion as their voice on the streets of urban or downtown Johannesburg. The Sartists are the key players for their elegant dressing, attention to detail, and muted use of color, all set against the environment they live in. These new dandies embody a spirit, an energy, and an attitude rare in other subcultures.

Izikhothane are the wild, controversial born-frees who raised eyebrows for

for burning money in public. The all-male crews hail from various parts of East Rand and Soweto. They all live in the township with their parents, who struggle to make ends meet, never mind sustain a lifestyle of name brands for them. Yet sacrifices are made. Each crew proudly shows off Gucci, Christian Louboutin, and Carvela in flamboyant coordinated looks and is not afraid to destroy these same items openly on the streets. They then battle it out to determine who looks the best and who is wearing the most expensive ensemble. The criteria for membership in one of these Izikhothane groups are straightforward: Buy and flaunt expensive clothes. To the Izikhothane, style goes hand in hand with social status. The whole country has debated whether their lifestyle is a clever statement or wasteful stupidity.

What has been most important about these key style tribes is that, in South Africa, they have started a conversation. All have made us sit up and take notice, look and listen. As a fashion editor, I have always sought to uncover and celebrate the inspiring individuals that make Africa unique. These spirited crews stand out for having created their own culture. I share in Vintage Cru's, the Sartists', and Izikhothane's message: We are young and liberated and have something to say. We acknowledge the painful history of our country, yet we look forward. We enjoy the present liberated South Africa and own our world freely and fearlessly. We use fashion as a tool to communicate how we feel. In postapartheid South Africa, there is still a quest for identity among the youth. A quest to find a place to belong. There are still statements to be made and conversations to be had. South Africa is more than African print and animal skins. We are more than braids, turbans, and beads. There is a vibrant, irreverent, pulsating freedom. And there are storytellers like these style tribes at the forefront of it all. They help to tell of a hopeful new chapter and the colorful present of an unshakable continent.

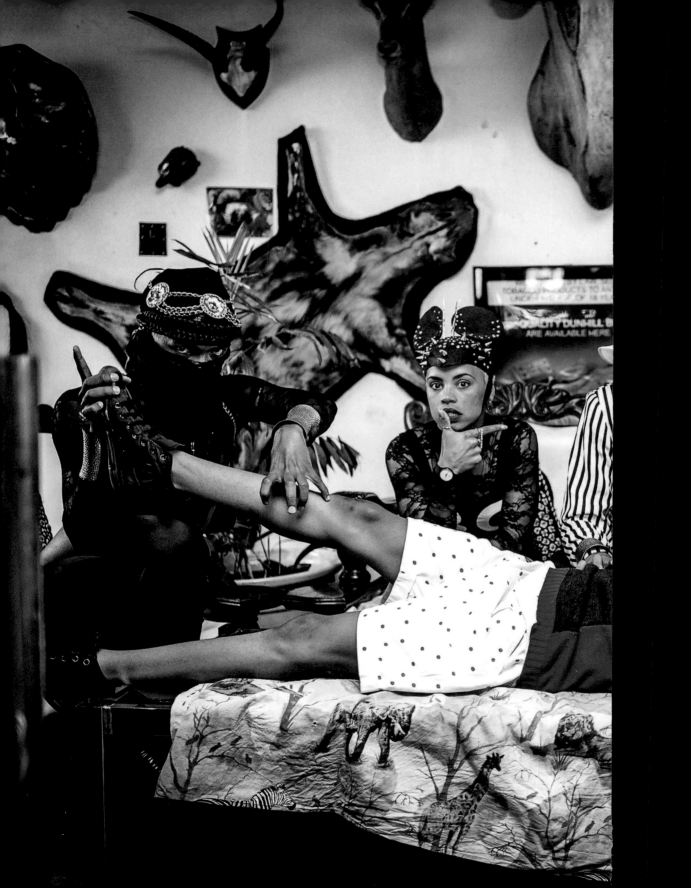

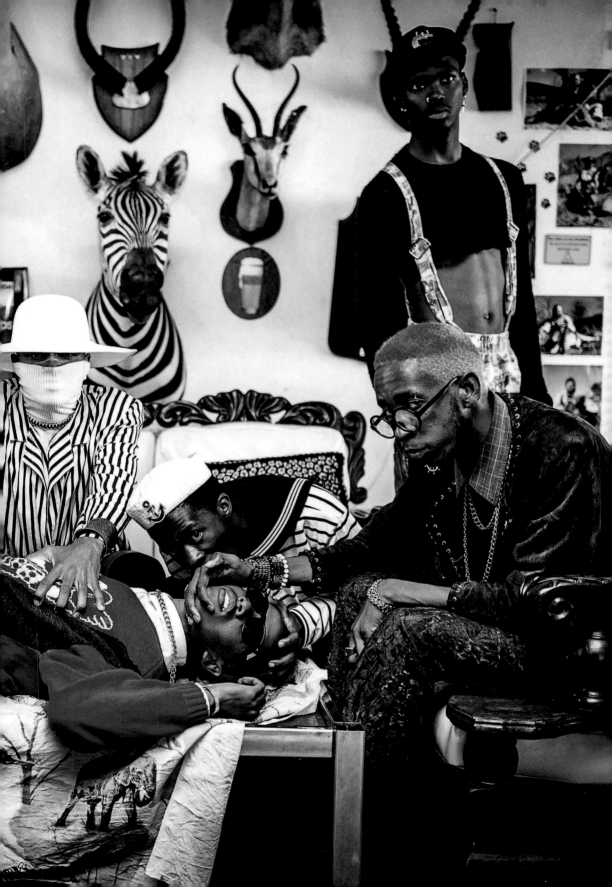

Vintage Cru

"I am the manager of the group. At eighteen I was still living with my mother, in a small village outside the city. During my last year of high school I decided that I had to move, do something new. I have always been very involved with sports, and on Facebook I got to know Lee-che', who was doing dance. We decided to create a group inspired by Vogue, a dance style popularized in the 1980s. We met Manthe, who contributed the legendary and timeless fashion element we developed.

This led to the ambitious idea of doing something unique and new, but also tied to the past. It may seem like a contradiction, but our idea is really to free ourselves from groups that do only hip-hop or only street dance, and to do things that are different."

Ashwin Bosman

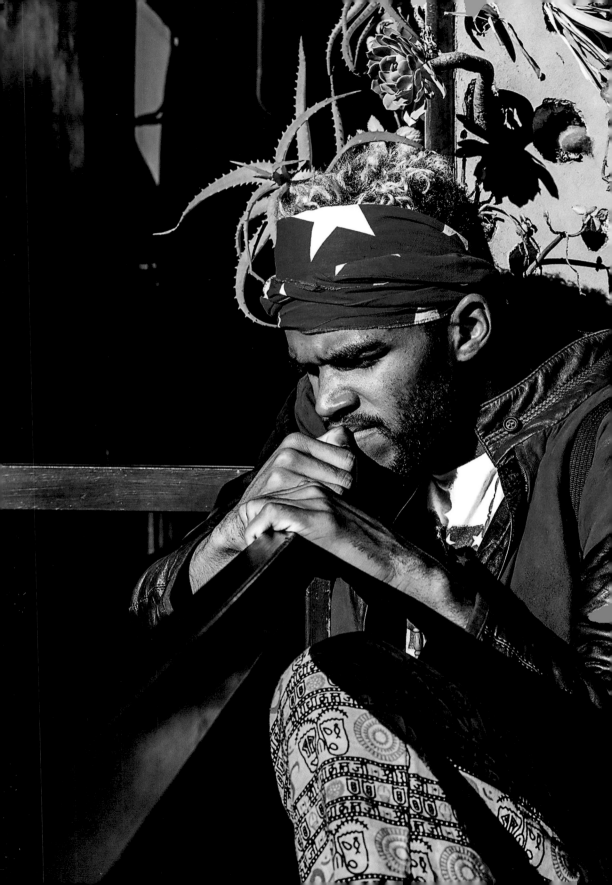

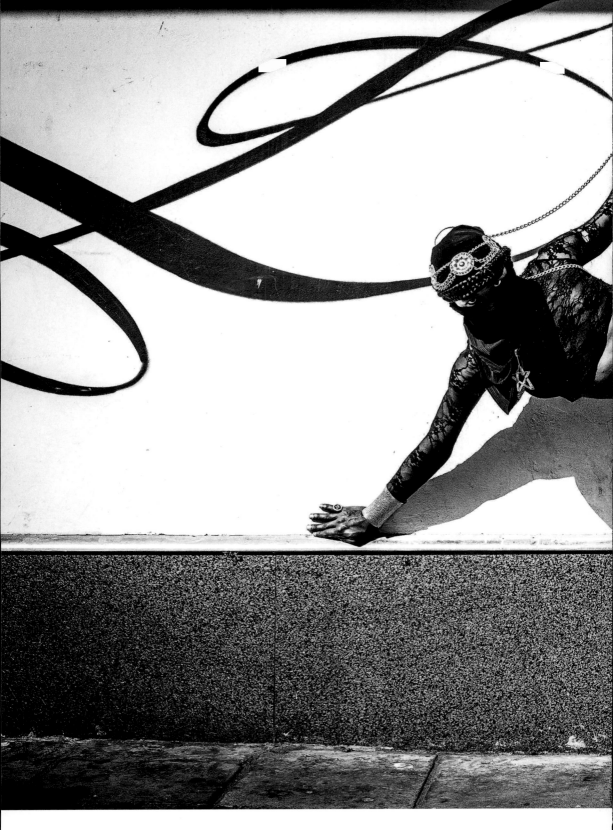

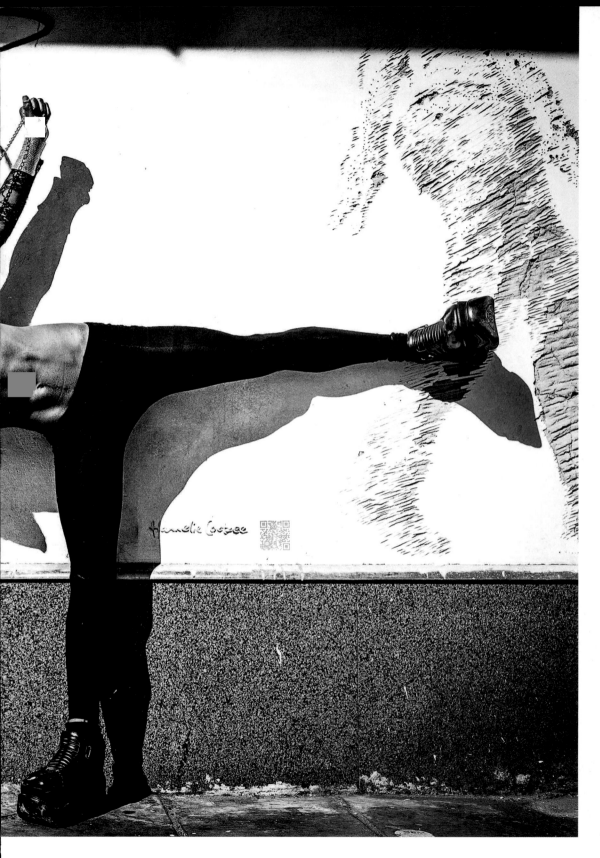

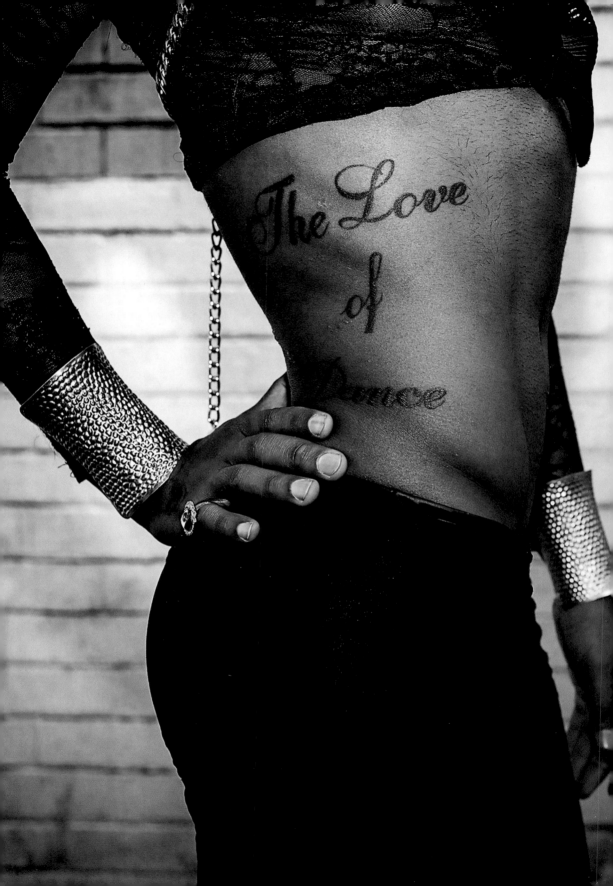

"Our performances, where we pay attention to everything, not only the look and the dance, became something like an art gallery, and then we pushed ourselves further and created the Haus of Vintage collective, which brings together designers, academics, and freethinkers. We have performance and choreography practices three times a week, on the roof of the Art Hotel. It's a symbolic choice not only because we are artists, but also because the roof gives us a sense of freedom that our group inhales. We have no limits."

Lee-che' RudeBoy Janecke

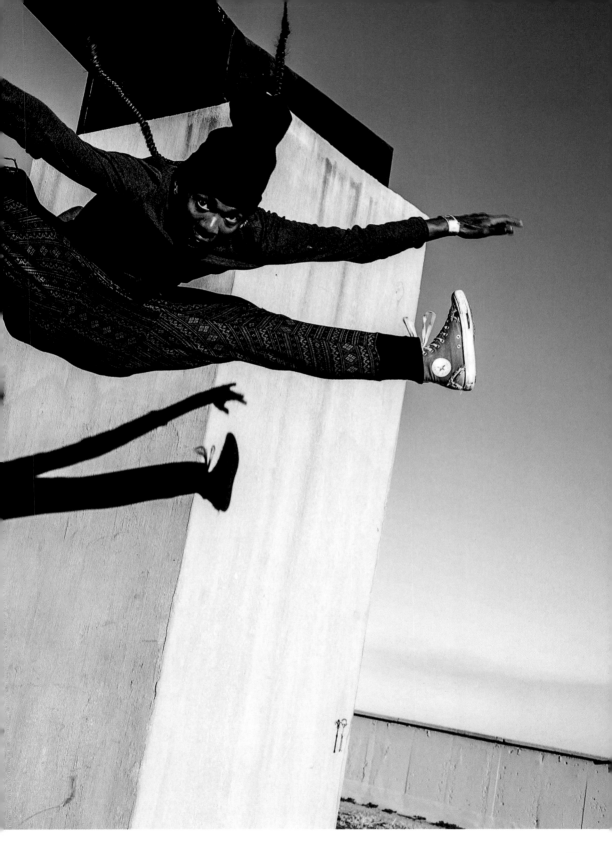

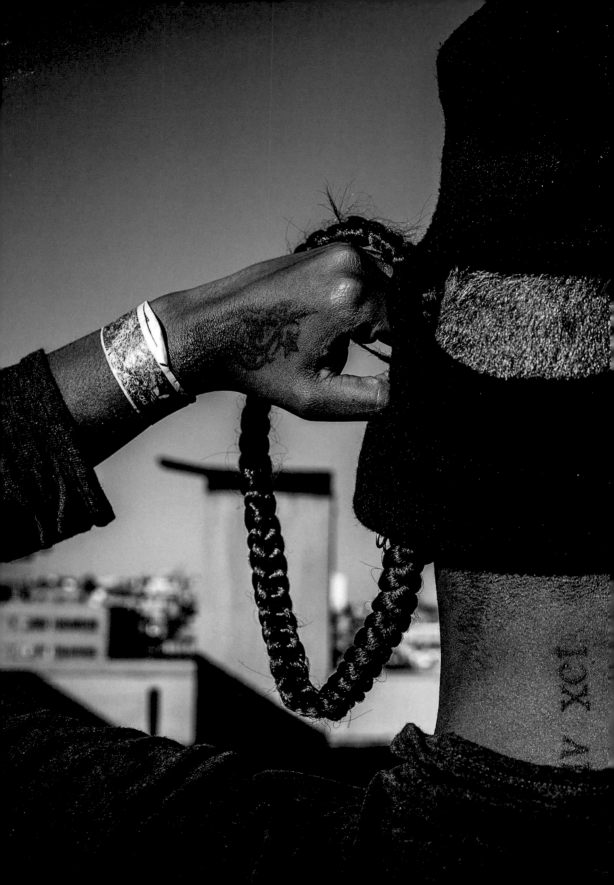

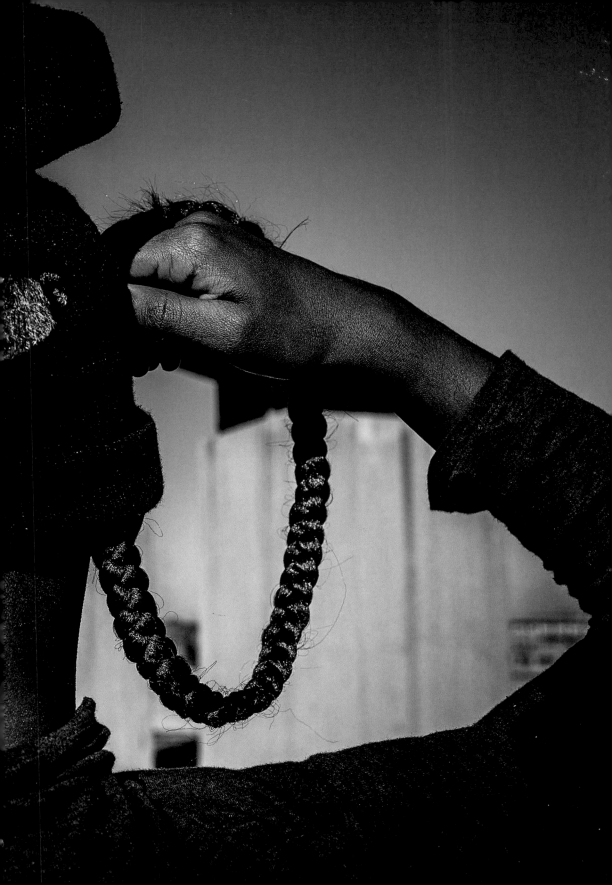

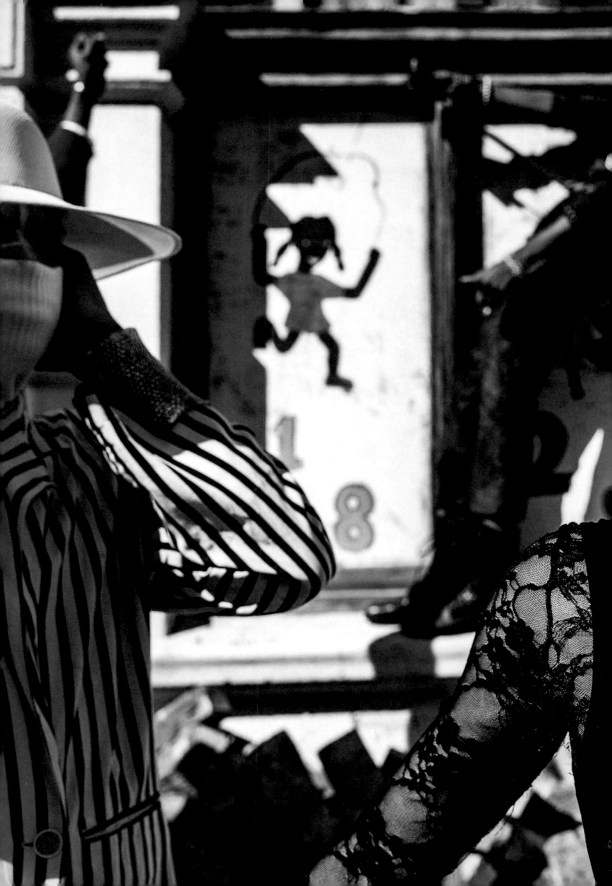

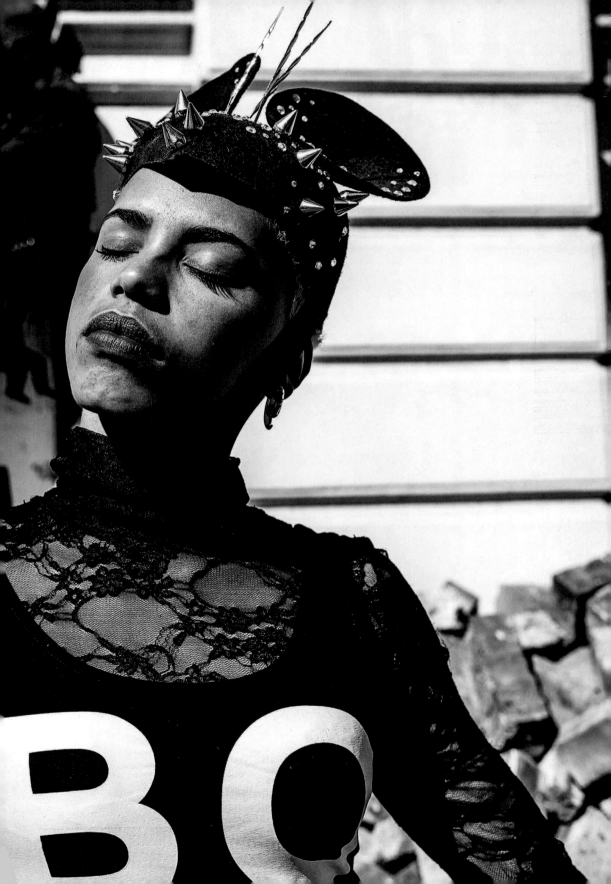

"I'm lucky I didn't grow up under apartheid. I'm fortunate to live in a democratic country where I'm free to attend any school and learn any language of my choice. Most importantly I'm glad to be an artist, free to entertain, educate, and inform my peers through dance, whereas during the apartheid, that was impossible. R.I.P. to Mandela, a legend and our father, who believed in the equality of all people and that each of us deserves an equal opportunity to make his or her dreams a reality, and that's made all the difference."

Tarryn Alberts

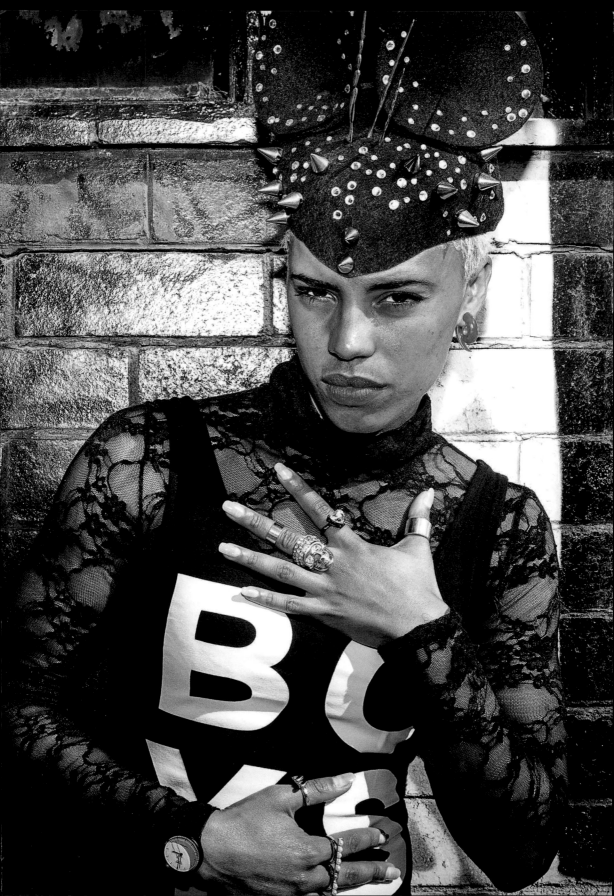

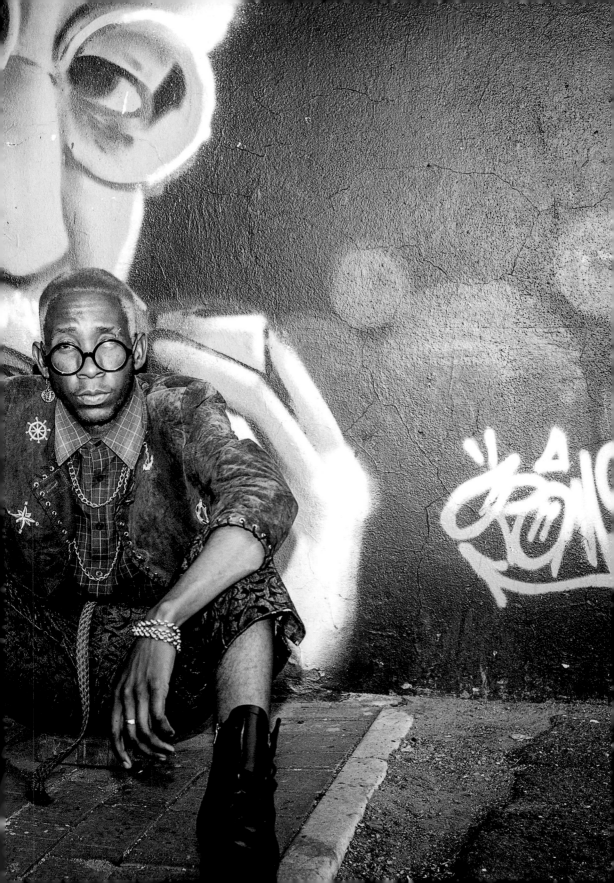

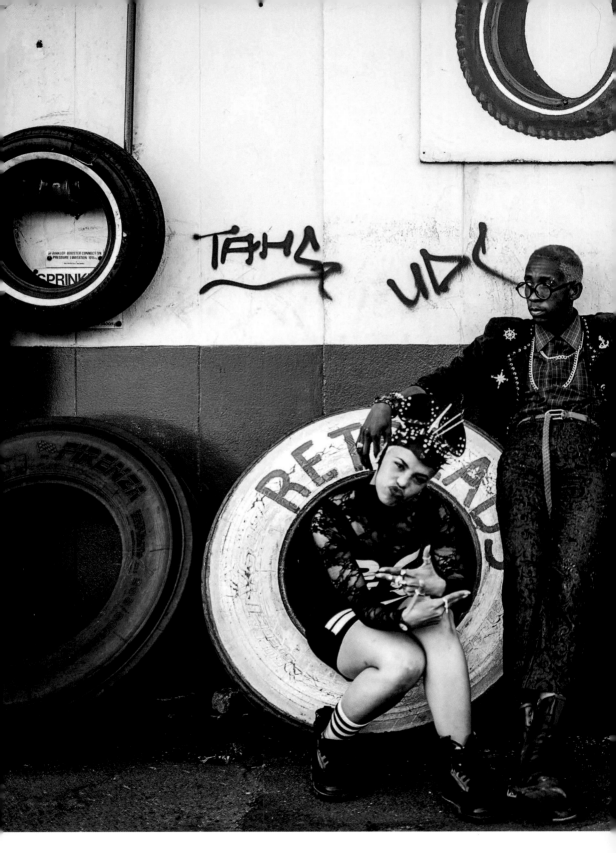

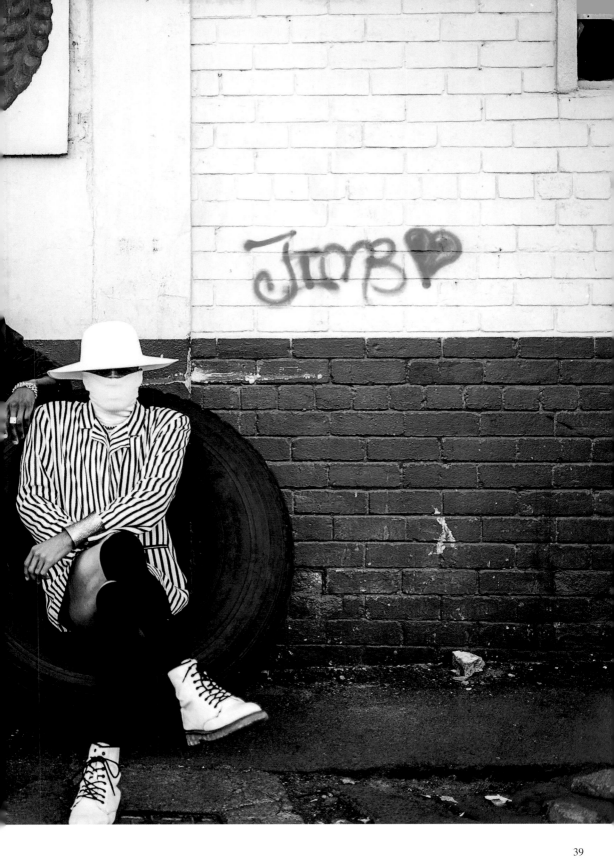

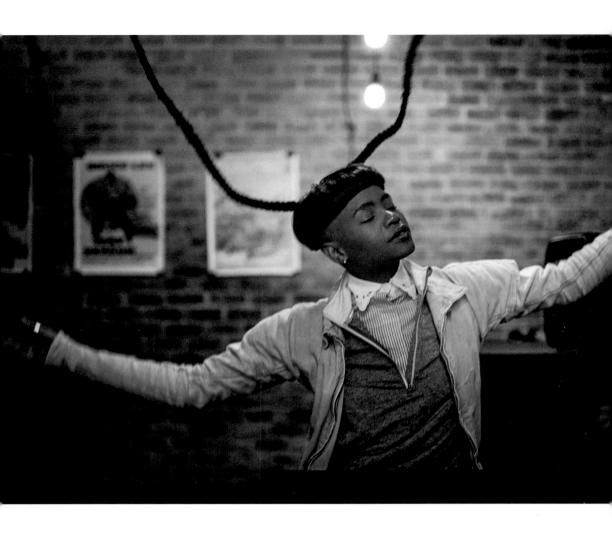

"You can come from the dingiest place, but it's about how you are going to see yourself, as trash or gold? Nobody knows your struggle or what you have left behind at home. It's how you are going to present yourself to the world that matters most."

Manthe Ribane

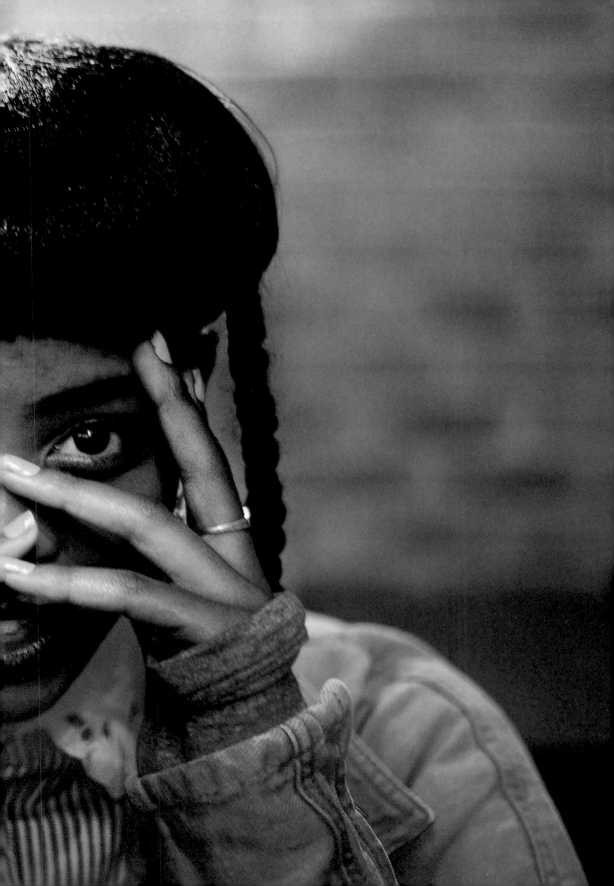

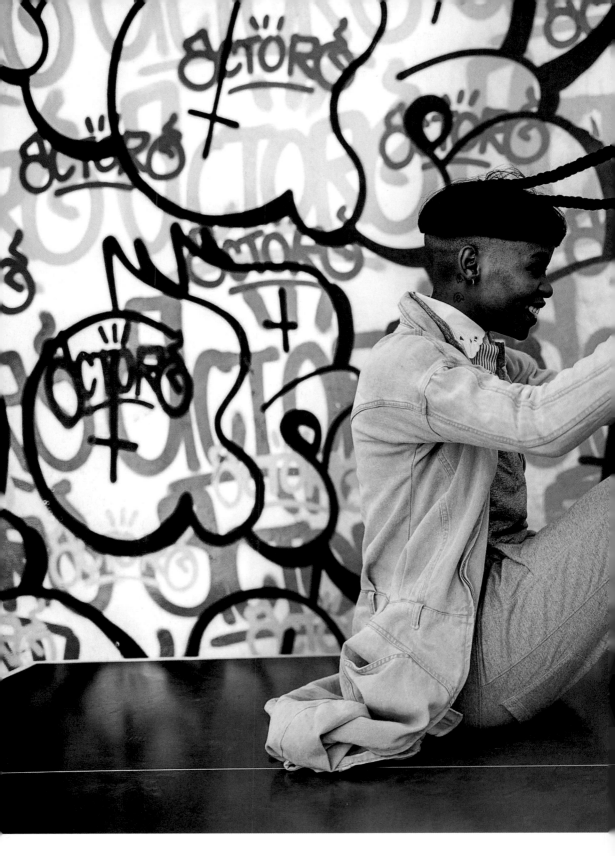

Smangori Dance Crew

"We were established in July 2007 by dedicated dancers who live in the Mogale City district. The word smangori *derives from the words* smanga, *meaning amazing, and* gori, *meaning busy or hectic. I define myself as a fashionista, creative, passionate, expressive, artistic, chic, bohemian . . . I'm a person of many dimensions. I've got a crazy passion for photography, theater, and music, and my style is inspired by modern fashion and retro colors."*

Jerry Moeng

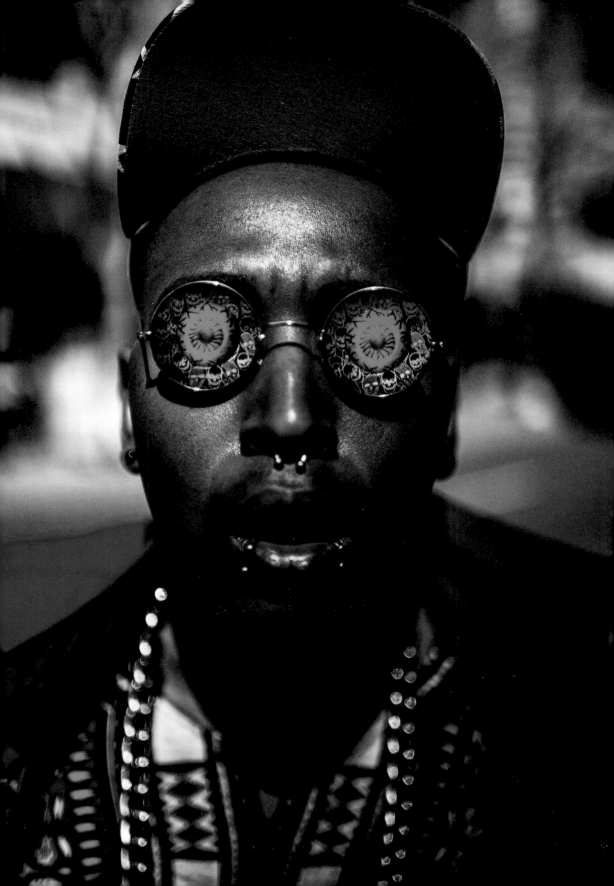

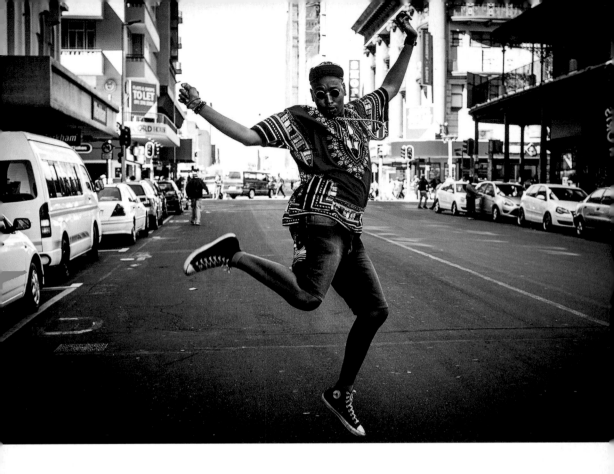

"We are specialized in various forms of South African dances: smangori dances (bhujwa), kwasa-kwasa, *contemporary dance*, pantsula, *hip-hop, Afro fusion. Our mission is to raise the standard of the township dance to a higher level through our dance, our workshops, special events, and festivals, giving emerging talents new perspectives.*"

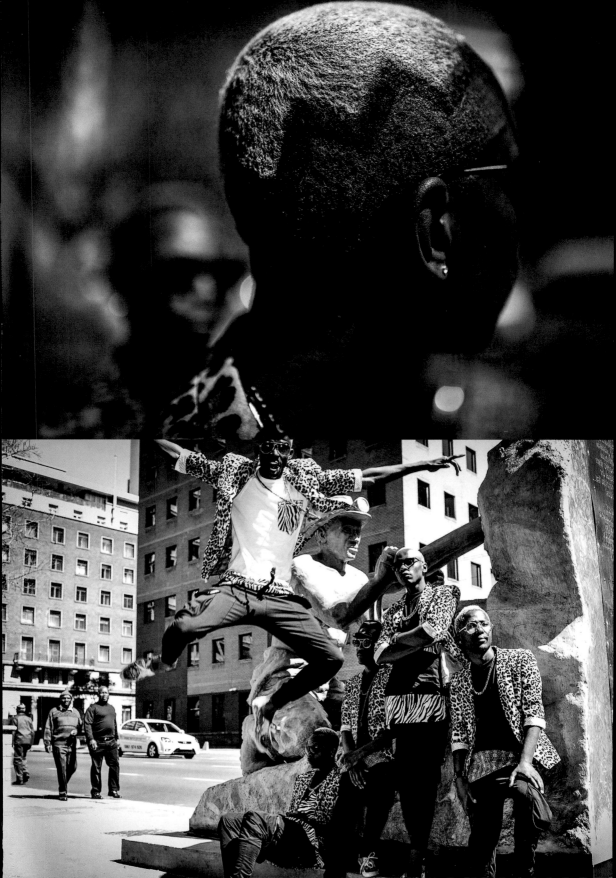

Tembisa Revolution

"We began in 2003 when we were in school, and from that point until 2008 we did performances. We became popular on the TV show SA's Got Talent *and participated in entertainment events for tourists. During the 2010 FIFA World Cup ceremonies, we collaborated with hip-hop artists HHP, Kelly Rowland, and Kanye West, and in 2012, we were named the best group at the SA Best Dance competition. We also were finalists, with Vintage Cru, in the* Step Up or Step Out *dance competition. We are passionate about everything we do, and this passion leads us to be disciplined in our work. We listen to practically all types of music in order to improve and be creative in our choreography. We love fashion in a way that results in our dressing differently from other dancers."*

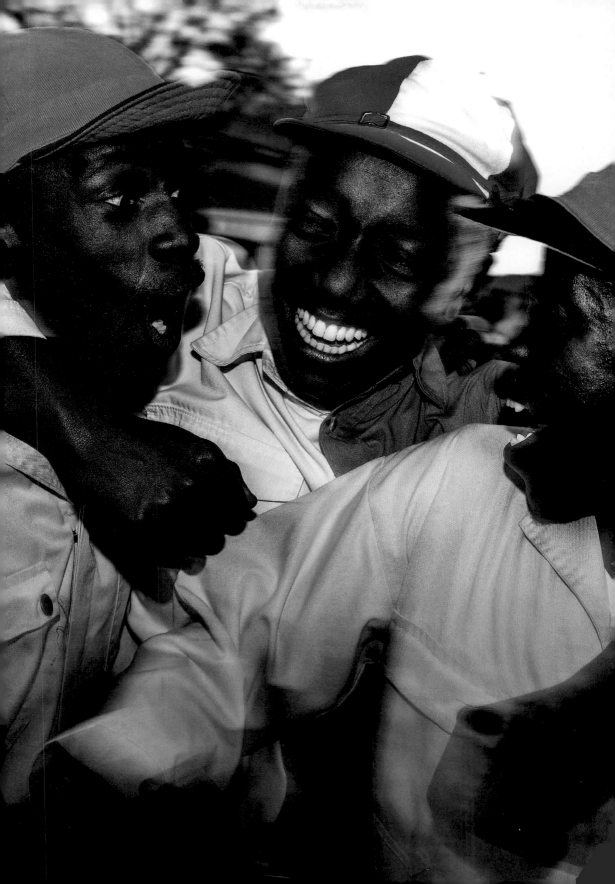

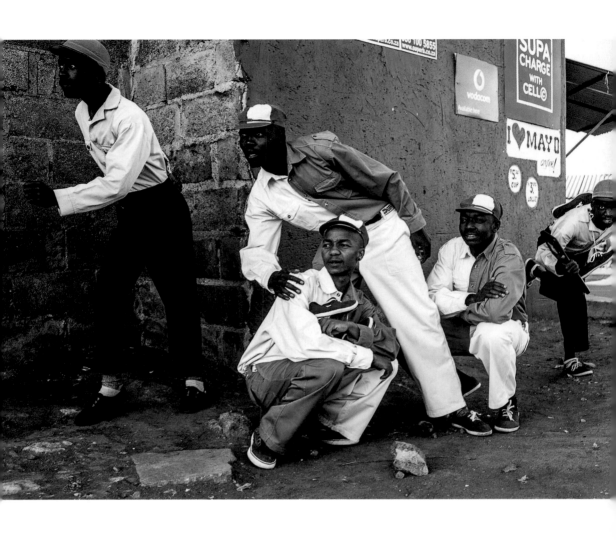

Bongani (Jozi), Moses (Moss), Abel (General),
Bonganksai (Phanzela), Arthur (TA)

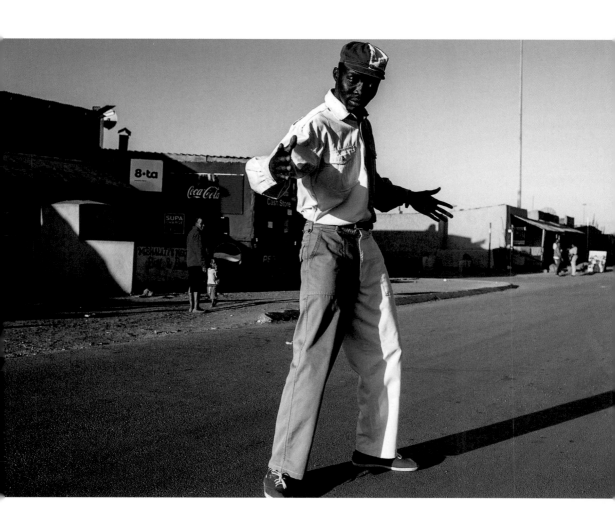

"We wear tap shoes when we dance. Since they are very expensive, we created these shoes from cans. We recycle the cans when they are worn out and then replace them. We work with Collect-a-Can, a company that recycles cans, and we have participated in the Collect-a-Can competition."

Tembisa Revolution

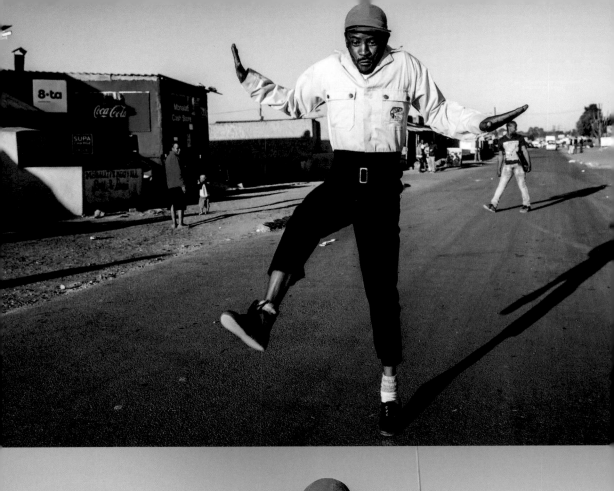
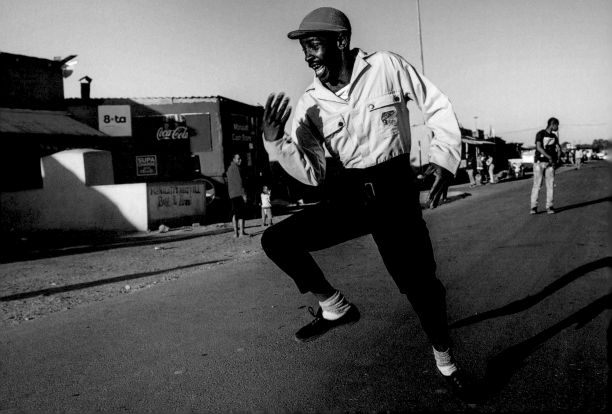

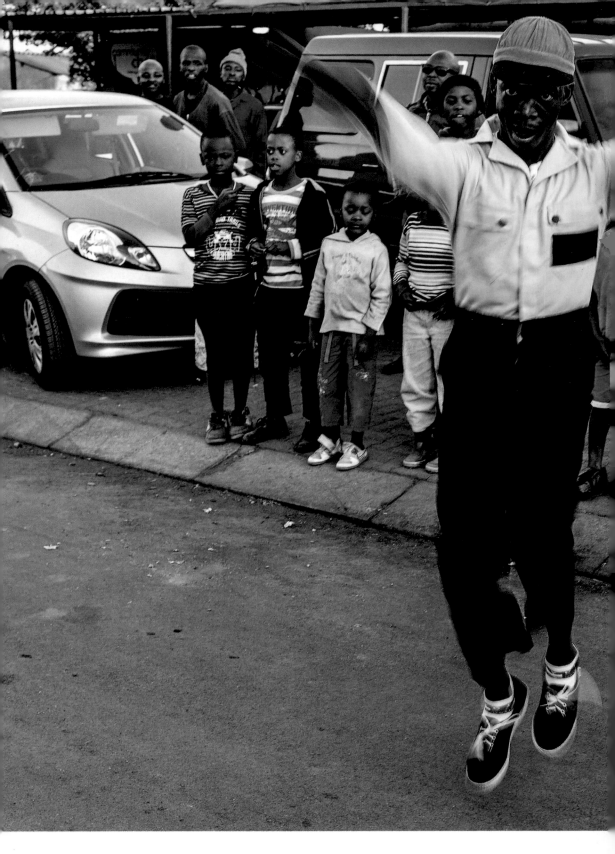

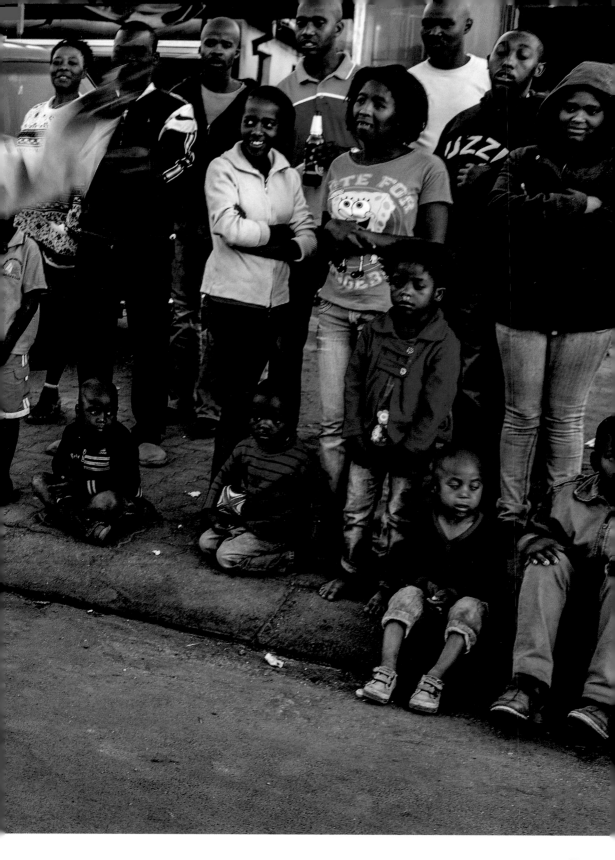

Smarteez

Morapedi Manotoana (aka Floyd Avenue), Kepi Mngomezulu, Sibi Sephito, Teekway Makwale, Lebo Makaale, Lebogang Flair stars, and Lebogang Makgale are all creative young South Africans in Soweto who are part of the Smarteez, a "collective," or rather a movement, founded in 2005. The word comes from the Smarties chocolate candies, black inside and colored outside. Their clothes are unique with a refined style; blending vintage and re-rendered fabrics, combined with items from flea markets. They share the same passion and desire to explore the possibilities offered by South African diversity in a globalized society. They find their inspiration in the past, in their heritage and their roots, but also on the street and in the urban realities they live in, constantly seeking new expressions and new languages.

Floyd Funky LowLife Avenue

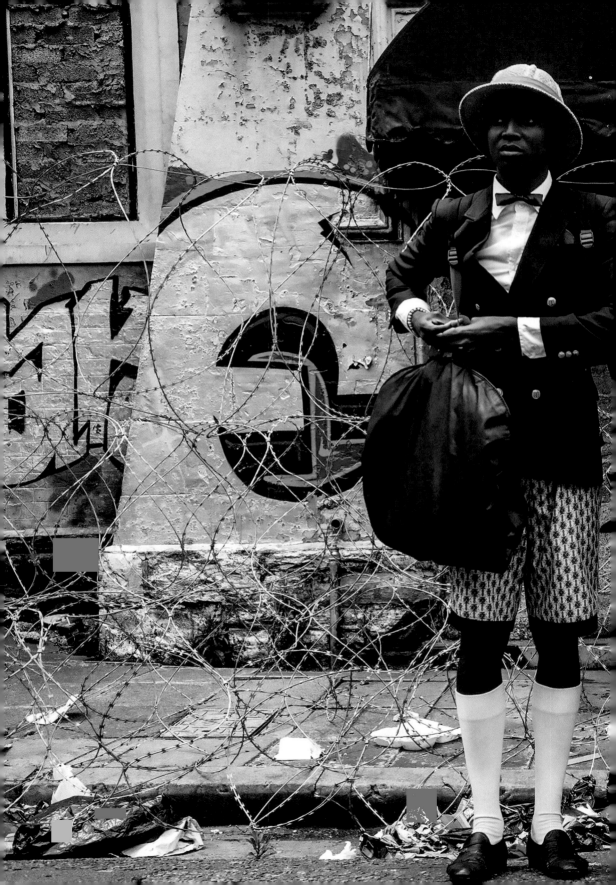

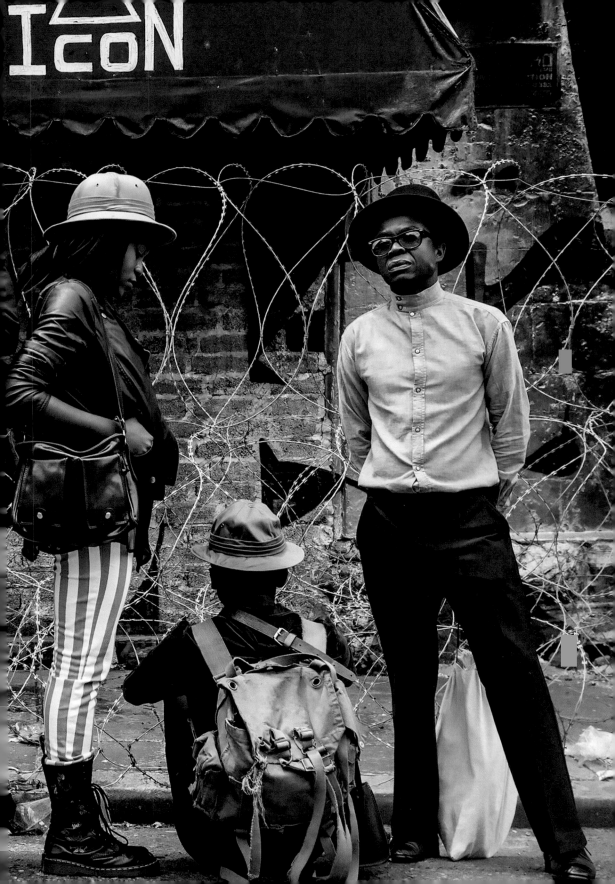

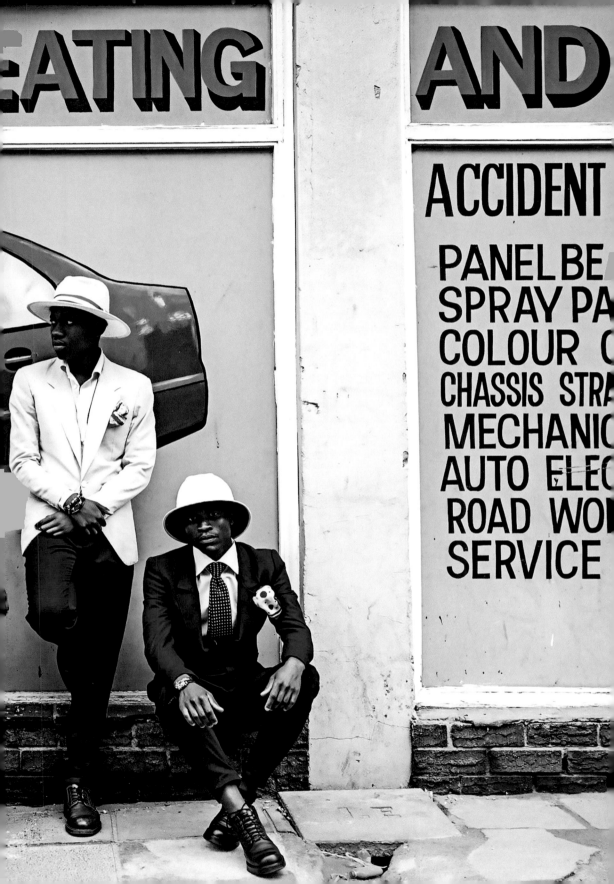

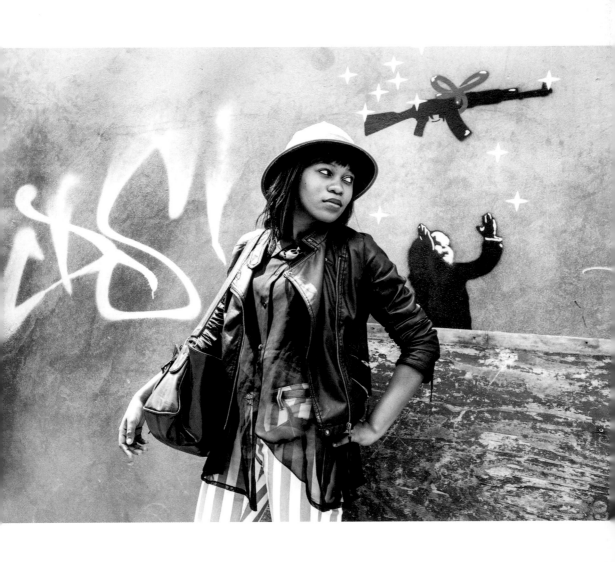

Lebogang Flair stars

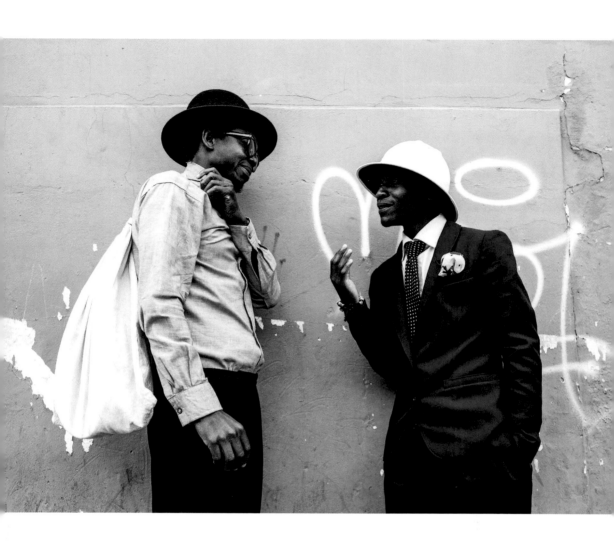

"*My style is classic; fashion often changes, but I stay faithful to my taste. I am inspired by the 1960s and '70s adult style, by authoritarian father figures, like Mobuto Sese Seko, whom I consider the greatest fashion designer of all time.*"

Teekay, fashion designer from Soweto

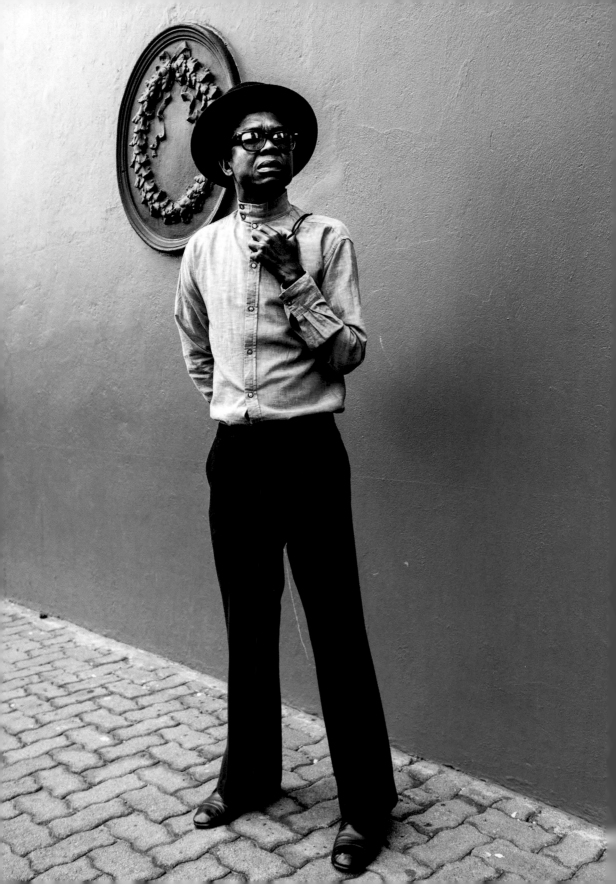

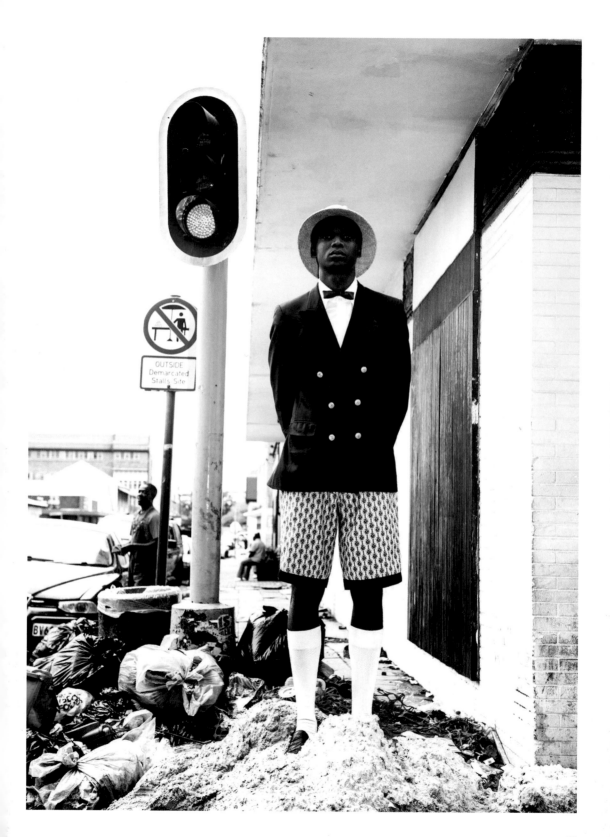

The Sartists

Kabelo Kungwane and Wanda Lephoto are two friends who have always been passionate about fashion. Lephoto studied at the LISOF fashion design school in Johannesburg, while Kungwane studied journalism. Both twenty-year-olds are already well-known in the South African fashion world for their vintage look. The Sartists are elegant and have a pronounced individual sense of fashion.

"While studying in high school, when I was sixteen, I liked the style of political figures from the 1950s and '60s—Martin Luther King Jr. and Patrice Lumumba, for example."

Kabelo Kungwane

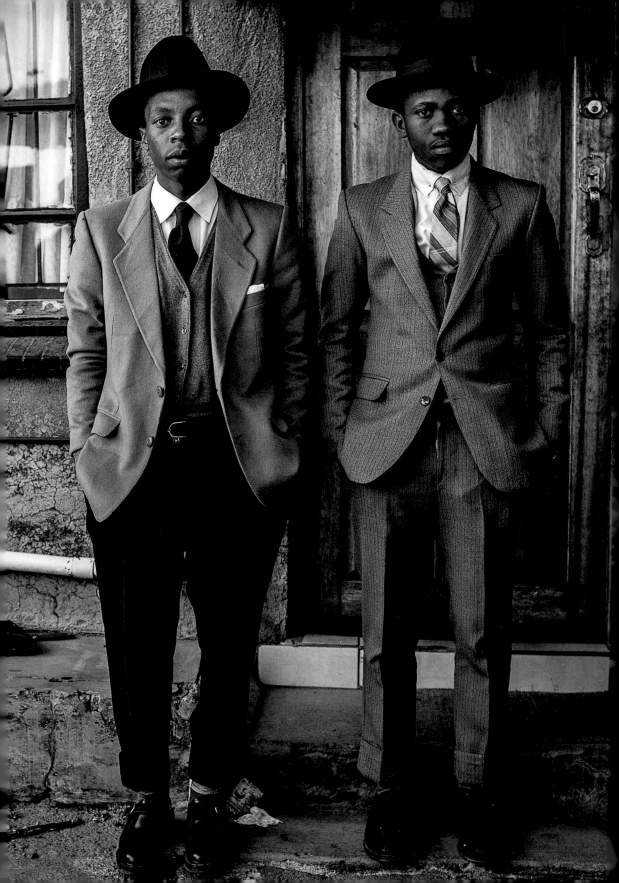

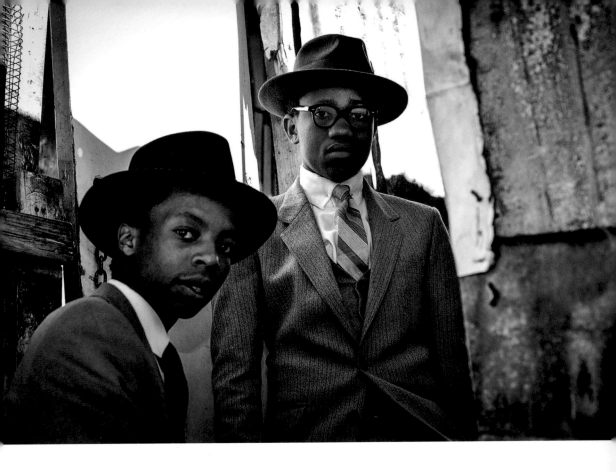

"*The Smarteez are very colorful, [with a palette] unlike classic fashion styles. In South Africa, classic means Coco Chanel, but we also like to dress women in Thom Browne and his reds, whites, and blues.*"

Kabelo Kungwane

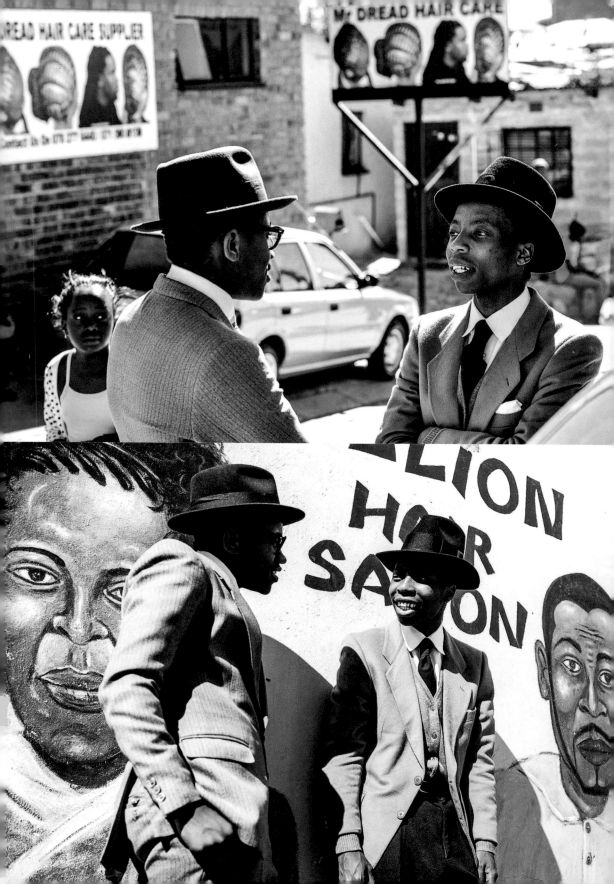

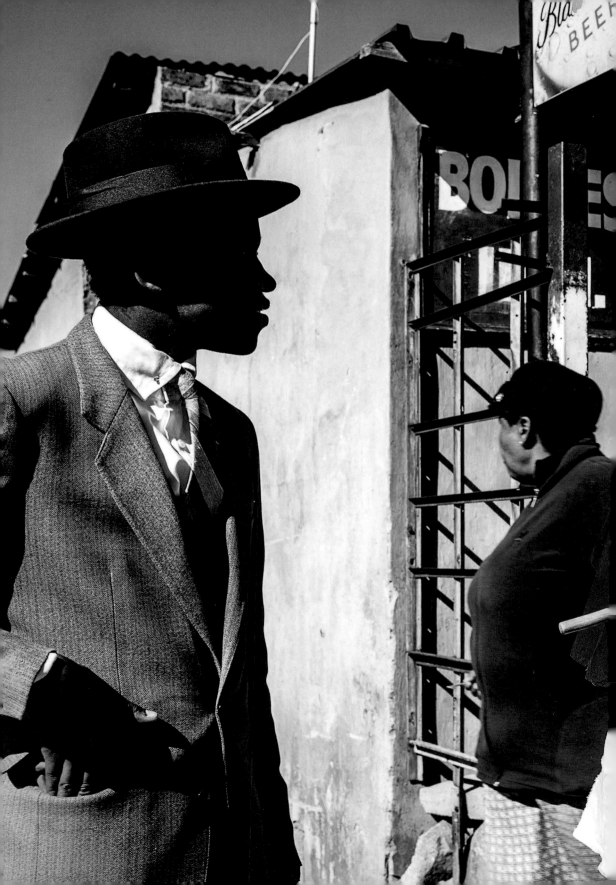

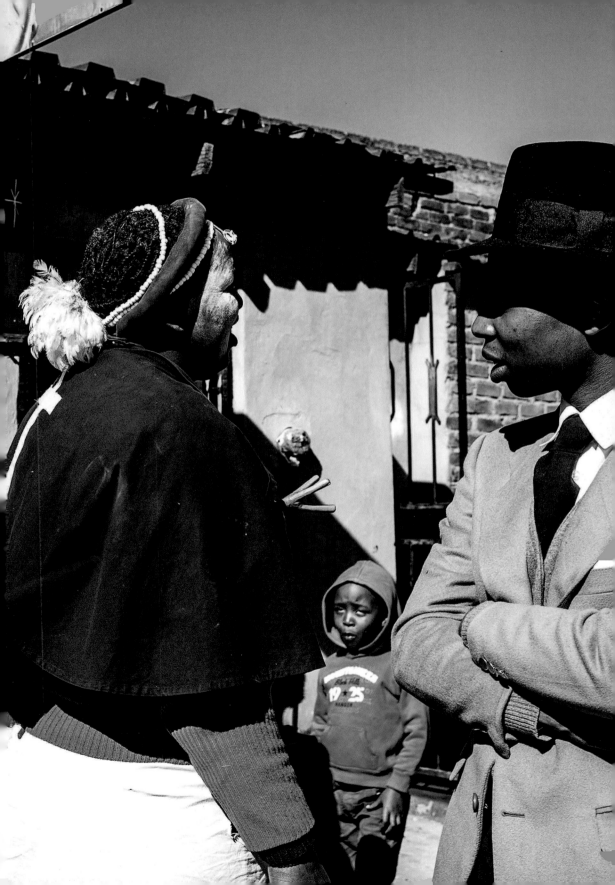

Izikhothane

The movement is made up of young and impoverished South Africans who drape themselves from head to toe in designer brands, which they then frequently destroy. These bling-covered youths compete in dance battles throughout the sprawling townships by publicly trampling on, and even setting fire to, their own expensive possessions. They have been known to tear up money and destroy their own cellphones.

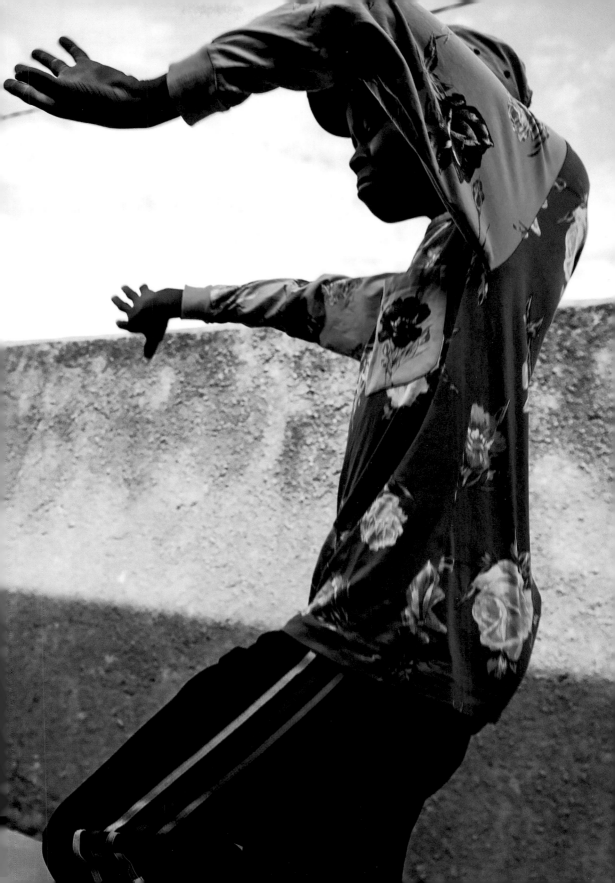

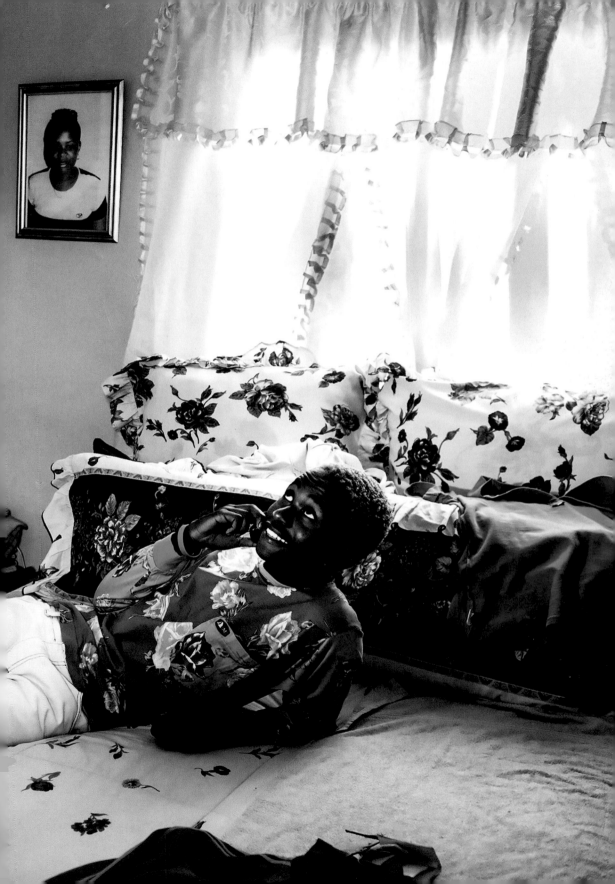

Sfarzo jeans, Arbiter shoes, pink flower shirts made by MD, the so-called Italian style brands are increasingly popular in Johannesburg, and teenagers are passionate about them. These kids bring a lot of creativity to their style; they perform their dance and choreography while showing off their clothes.

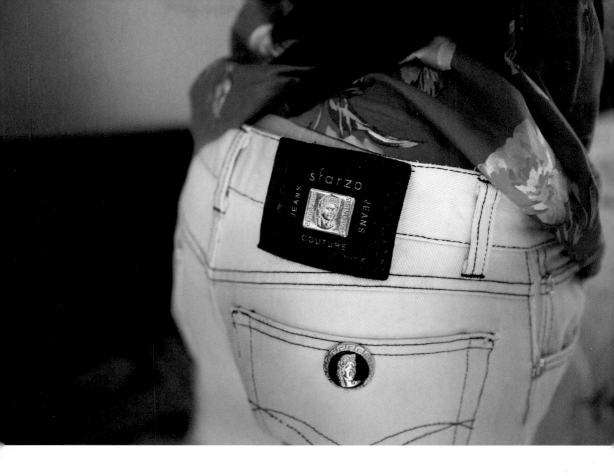

Izikhothane *is a Zulu word meaning "to lick," but it has now become street slang for "bragging." It has its roots in the early days of the movement, which first emerged around 2010, when "Izis" would deliberately spill packets of custard, considered a treat by many poor black South Africans, and then ostentatiously lick it off their hands and clothes.*

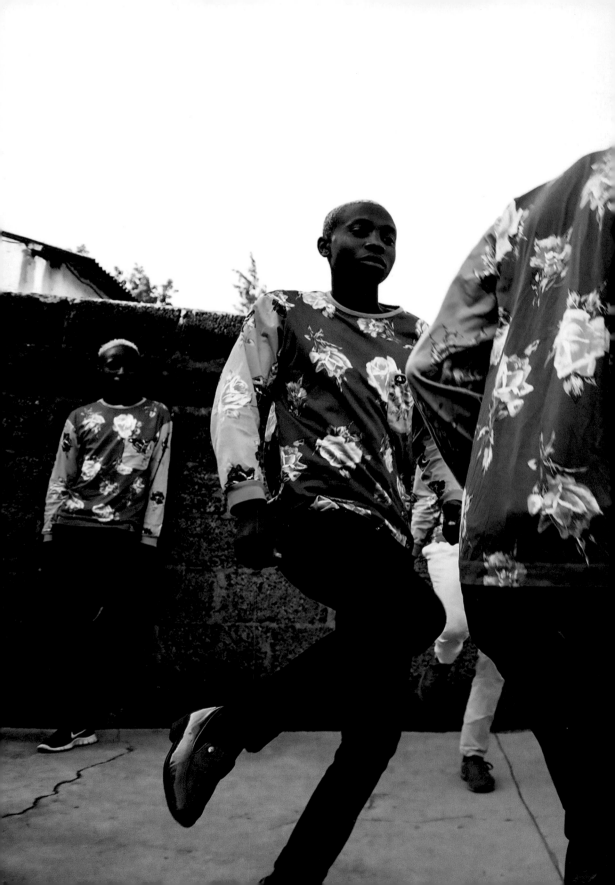

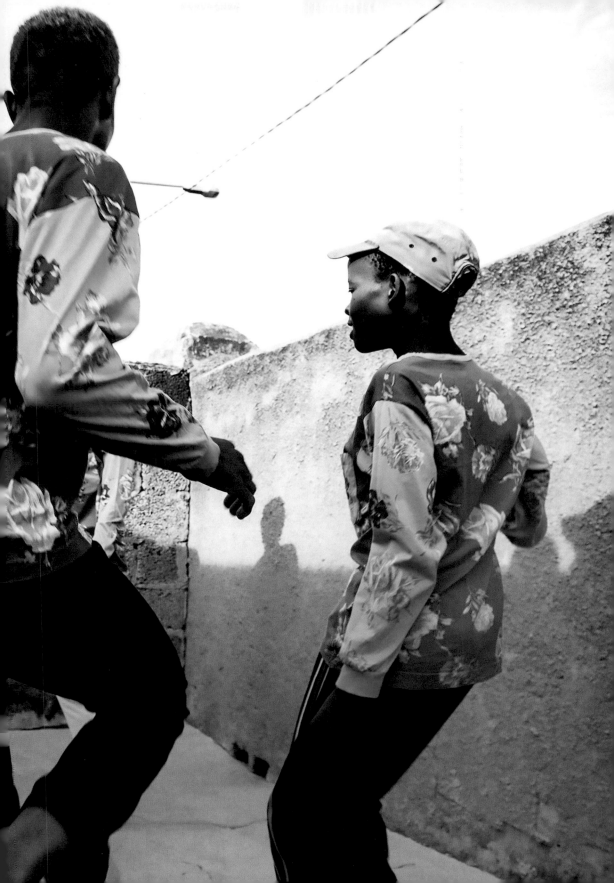

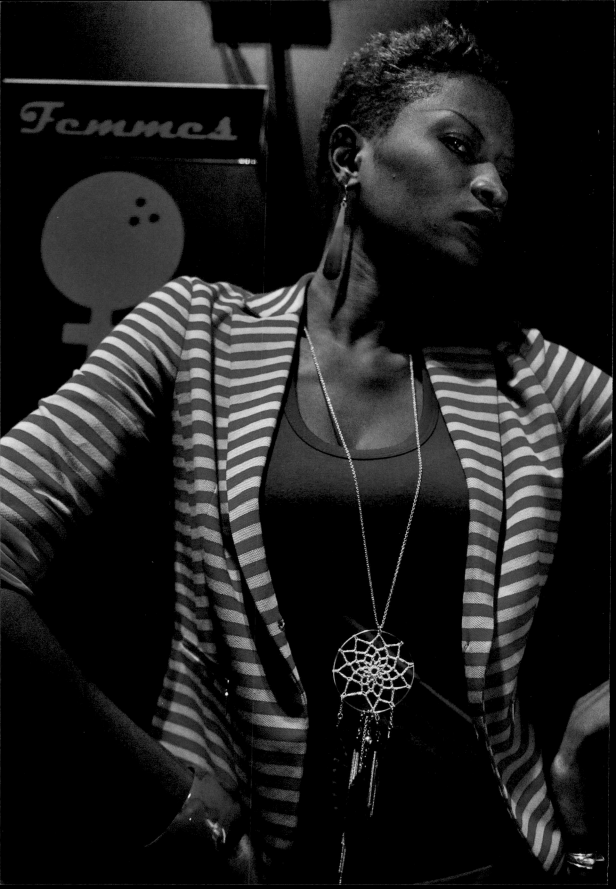

XALEY-FASHION AND THE *DIRRIANKHE*

Dakar, Senegal

Emmanuelle Courrèges
Independent journalist, Paris

Perched atop six-inch heels, legs sculpted in leather leggings or strapped into XXS dresses, metallic color-block eyelids and glossy lips—this is what the creatures of Dakar's nights look like during Fashion Week, founded in 2002 in Senegal's capital. Like everywhere, you have to be there. And they're all there, in front of Barramundi, a fashionable lounge-bar in the Almadies neighborhood: the *xaley*-fashion, the xaley-buzz,[1] the *minettes* (kittens)—as they say in Dakar—who are all the rage. Inside, popular bloggers and TV fashion hosts try to snag spots next to top models arriving after the shows. The model Fleur Mbaye, her head topped with an orange crest, and the very popular Sachakara Dieng, queen of the Senegalese catwalk, turn heads. Dieng, her head partially shaved and topped by a thick ponytail made from long braids interwoven with blue and gold mesh, defies the laws of traditional Senegalese femininity. With her Grace Jones air, her futuristic haircuts, her androgynous look, Dieng leaves no one indifferent. She also has emulators: "Today, half the girls have cut their hair," says the twenty-two-year-old. "And when I do something new on my head, I'll see it within a few days on beginner models. I love it. Because, thanks to me, they're daring to."

There's no wind of revolt blowing through Dakar. Neither the models nor the girls that emulate them follow any particular ideology. But a new generation, born in the 1980s and 1990s—these are girls of the Internet age and globalization—is bringing new life to Senegalese identity. It's about much more than clothes. These girls want to reinvent themselves, to express their individuality. Many of them are fashion designers, but they're also bloggers and photographers. Some work together. Some have studied in Europe or the United States. They've traveled. And from these geographic and cultural comings and goings, fruitful mash-ups are born. While staking claim to their African roots more than ever, they draw their inspiration from everywhere—the alternative scene in Senegal to Beyoncé's music videos, from English-language fashion blogs to TV series.

Whether self-taught or not, they have that quality of daring. The movement's leader, the young designer Selly Raby Kane, creates an urban world influenced by cartoons, pop art, and film. "For many, the point of fashion is to enhance the body," she says. "The people who wear my clothes prefer to enhance themselves through the discourse of what they're wearing. And this discourse is most of all about freedom." A new aesthetic is set in motion. The Afro has made its comeback; color is sculpting funky silhouettes; jeans are blended with wax; *bazin* flirts with plastic. Of course, not everyone can afford the clothes of a young designer yet. And although imitations of these designs are on the market, they're still discreet.

Working women, the ones who have gone to college—they hold positions in the government and the cultural industry, or in liberal professions—are also looking to set themselves apart. But they do it with subtle flourishes. The youngest have raffia added to waxed boleros; they get blouses and dresses made from the cloth *tchoup*; they dare to wear their motorcycle jackets over their pagnes or pair their color-block head scarves with their skinny jeans. Their elders prefer a contemporary traditional fashion. While they wear Senegalese basics like the *taillebasse* (a tight-fitting blouse matched with a skirt or pagne) or the boubou, they bring in sophisticated and very subtle details in terms of cut or fabric choice. They buy the finest bazins on the market and often bring home textiles from their travels throughout the world. And although, like many women, they have their own tailors (to whom they leave little of the decision making), the most fortunate among them also like to dress in clothing by the stars of Senegalese couture, such as Oumou Sy and Colle Sow Ardo.

When it comes to purely traditional fashion, it's all about the *dirriankhe*, those often very round women who represent the ideal traditional Senegalese woman. And they're not ready to let go of their wardrobe. Even if some have updated their taillebasse by adding metal epaulettes (like in Selly Raby Kane's last collection) or by opening the back, the *ndokette* dresses,[2] boubous, tunics, pagnes, and scarves remain the same. Just as the xaley-fashion do, these elegant women (from all walks of life), love fashion. And nothing is left to chance. The quality of the fabric, the number of flounces, the shape of the neck, the size of the kerchief (the scarf that may or may not match her

outfit)—everything has a meaning. A thirty-year-old woman and a fifty-year-old woman do not wear the same outfits. The younger ones let their *bine-bine*[3] ring; the *mamans* (mamas) wouldn't dare to anymore. The secrets of dirriankhe charm are something all Senegalese girls learn as part of their heritage. Regardless of whether they follow these precepts or not, every young woman knows how to prepare *thiouraye*,[4] the incense that fills their house and perfumes their clothes. They all know how to tie the scarf, even if some might go to the salon to get it done for ceremonies—it's just like going to the hairdresser for a bun.

Suspended in time, the Miss Diongoma[5] competition, founded in 1992, is once again the especially beloved dirriankhe event, particularly among the working classes. Religious leaders disapproved of the theatrical display of these plus-size women, but this pageant—where women walk the runway in several traditional outfits and reveal their skills—is also a way of resisting the flattening effects of globalization. At the tailor, women can afford prêt-à-porter but often prefer to wear their own fabrics, which they buy at the community market. The dirriankhe often design their own models, drawing inspiration from what local stars like Viviane and Coumba Gawlo are wearing. Their tailors might suggest some embroidery or a beaded bustier, or give advice on the length of a train. For major holidays, like Tabaski or Korité (at the end of Ramadan), wealthier women may spend as much as fifty thousand CFA francs.[6] Like Miss Diongoma, which is broadcast on Senegalese television, these soirees kick off seasonal trends in the neighborhoods.

In Dakar, an inexperienced eye might see the abundance of color, pattern, fabric, and scarves as a long parade without any logic, but Senegalese fashion has a very rich vocabulary. Every Friday, the day of prayer, it is customary to wear traditional dress (a cultural custom shared also by Christians). Young modern women are no exception—and Friday boubous are just as subject to trends as the rest of their outfits. As for Sachakara Dieng, she doesn't follow this movement. "Traditional dress is only something I wear exceptionally for ceremonies, but in those cases, I prefer to put on a big boubou for the men, which I adjust to create a bit of a masculine look for myself." The world has changed. The *imams* (leaders) may grumble sometimes, the mamans sigh at the sight of their daughters, but in the end, they all accept this joyful and hybrid transformation.

NOTES

1. The word *xaley* means "child" in Wolof. Literally, it means the "little ones of fashion," "the little ones being talked about."

2. Also called *Maboï*, these "camisoles" (there are many kinds) are one of the basics of the traditional wardrobe.

3. Also called *dial-diali*, these are bead necklaces that the dirriankhe wear around their waists. The sound they make endows them with great erotic power.

4. A mixture of roots and oils traditionally burned over wood embers.

5. The *diongomas* are very round women, and are often very tall.

6. Almost one thousand US dollars.

"Today, thanks to fashion, lots of girls can blossom—they can go beyond preconceptions and astound the world with their unrivaled elegance."

Oumou Sy, fashion designer

Fleur Mbaye, model

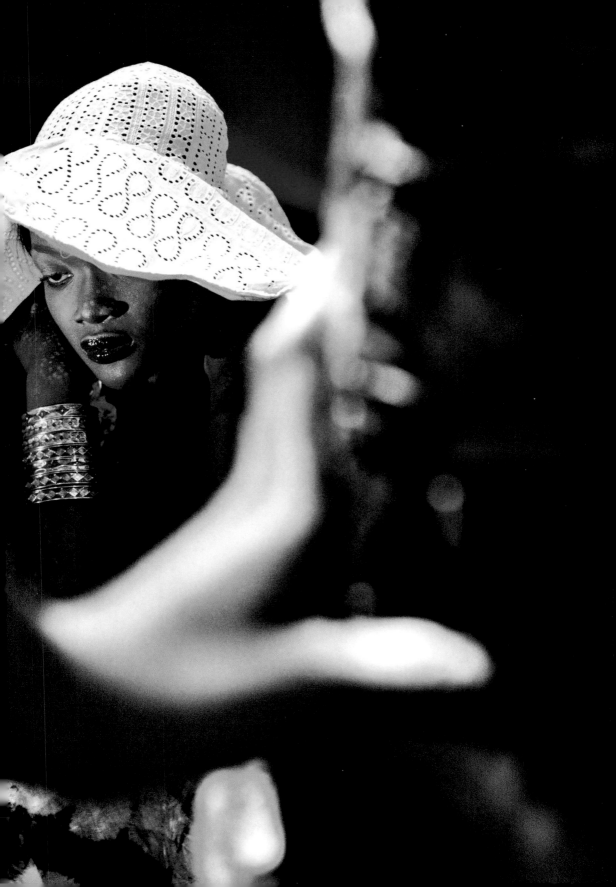

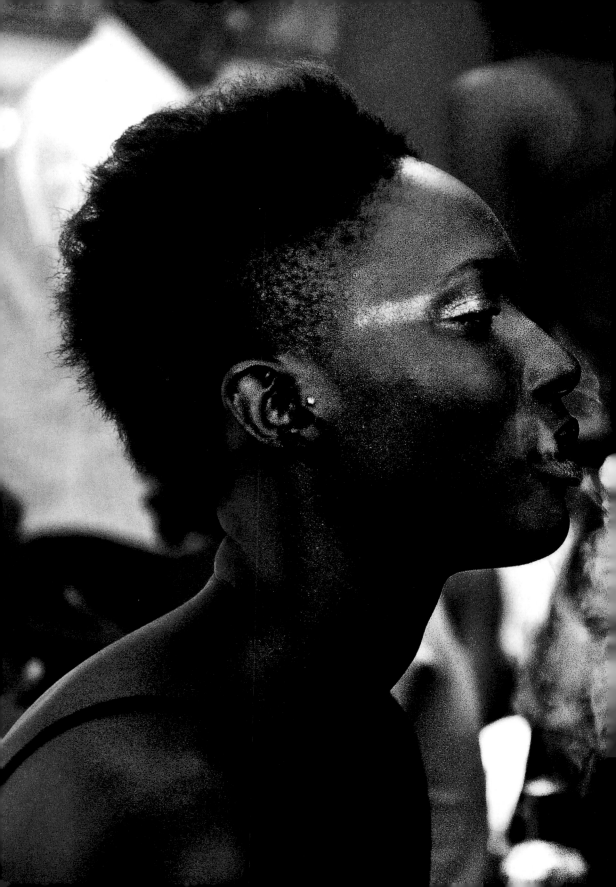

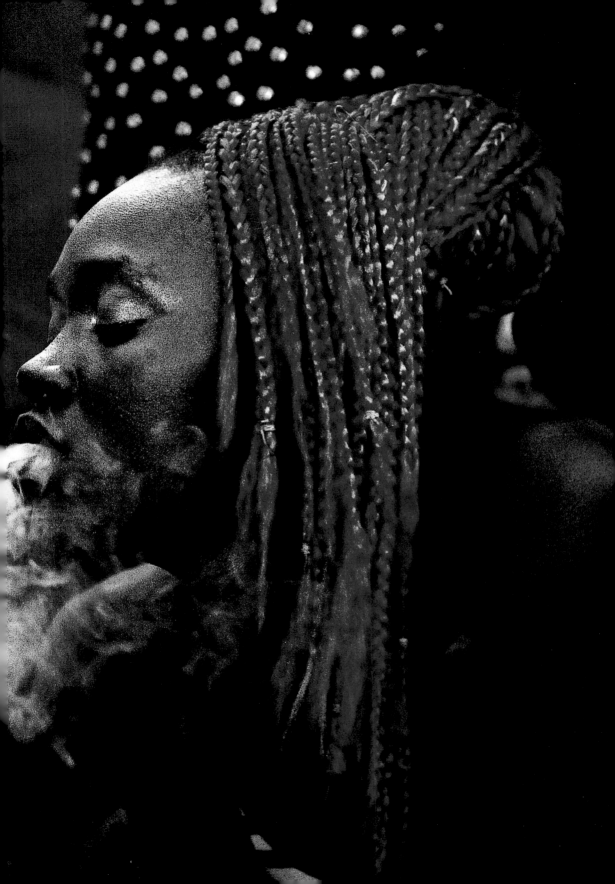

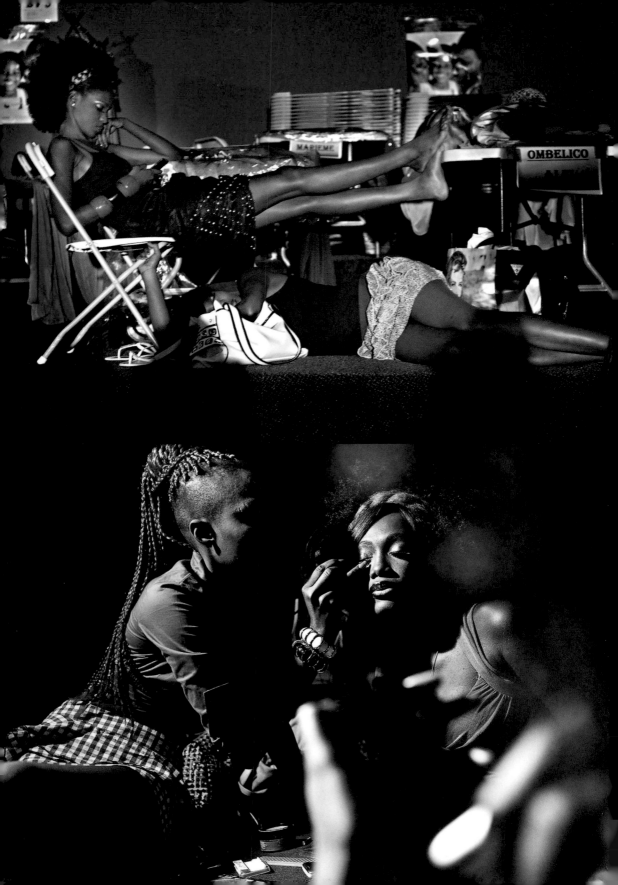

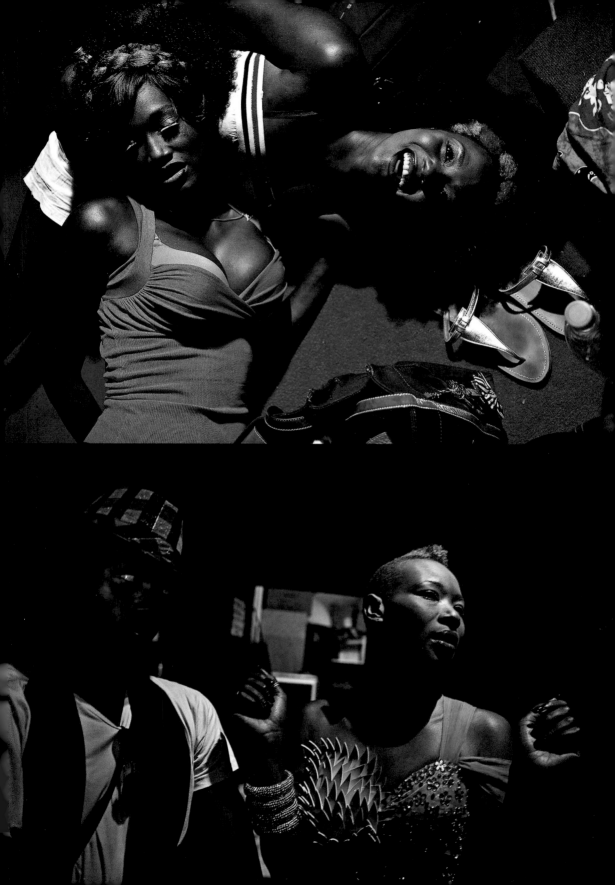

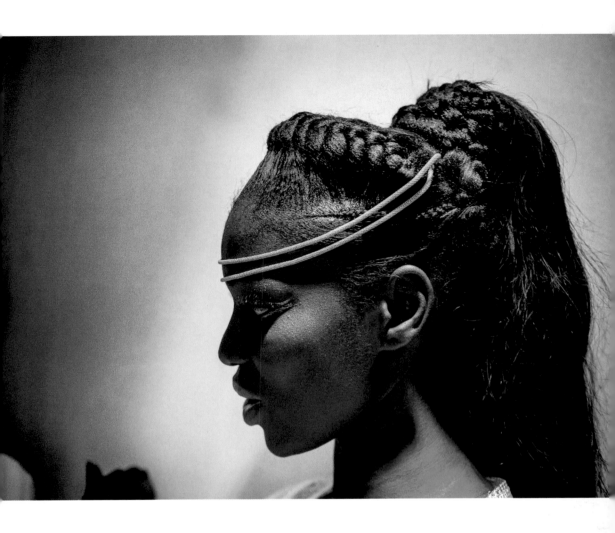

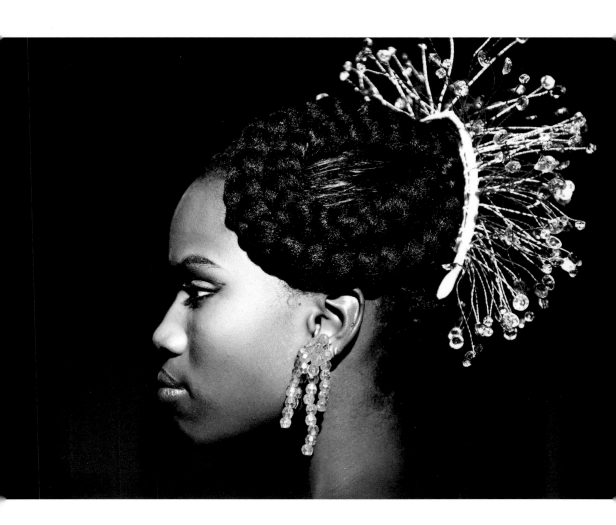

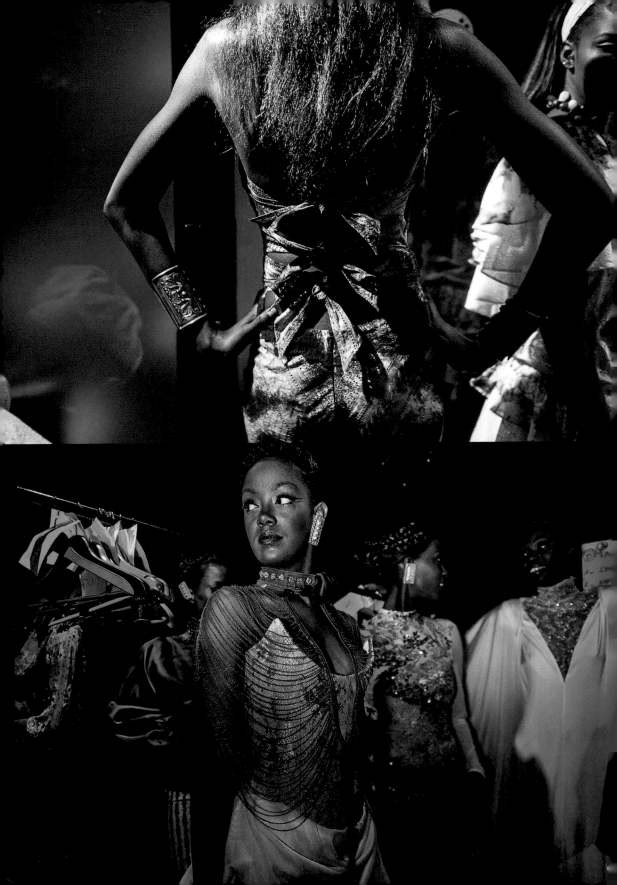

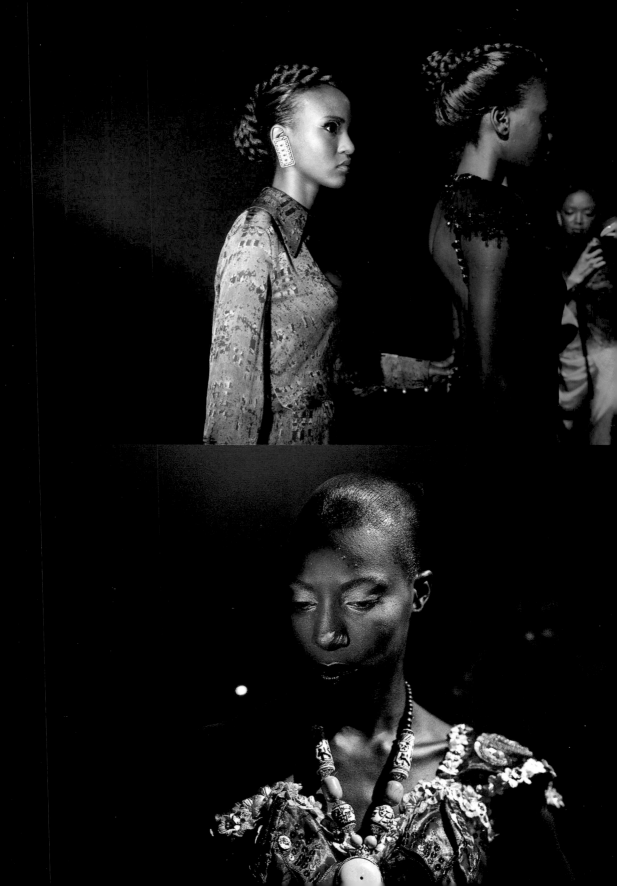

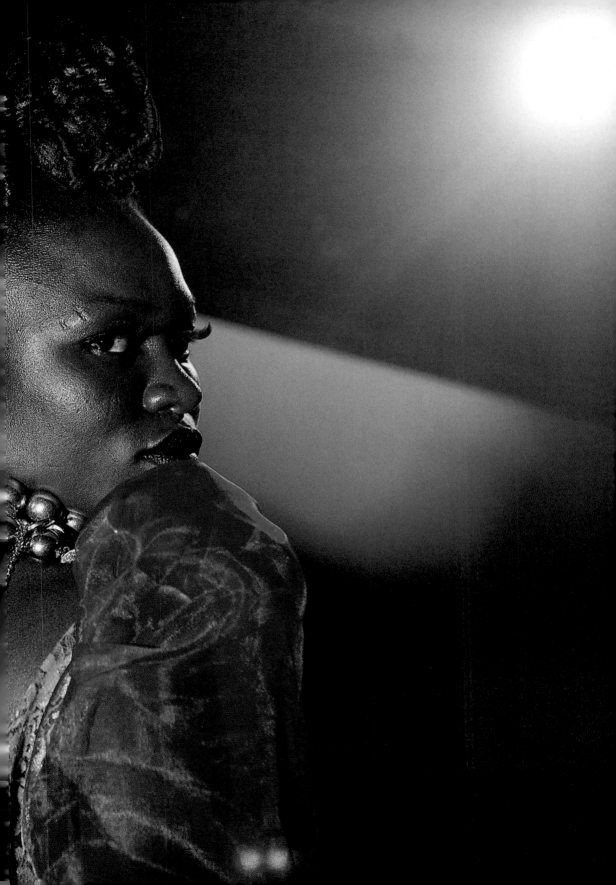

"I'm very inspired by images of London, by that freedom. When I wear blue or green braids, I'm using the African side and that European inspiration. And when I do something new on my head, I'll see it within a few days on beginner models. I love it. Because, thanks to me, they're daring to."

Sachakara Dieng, model

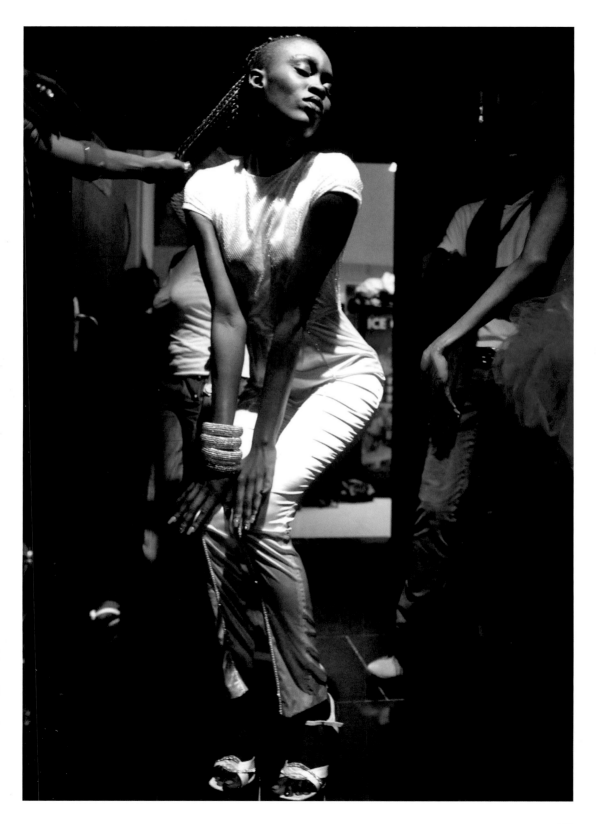

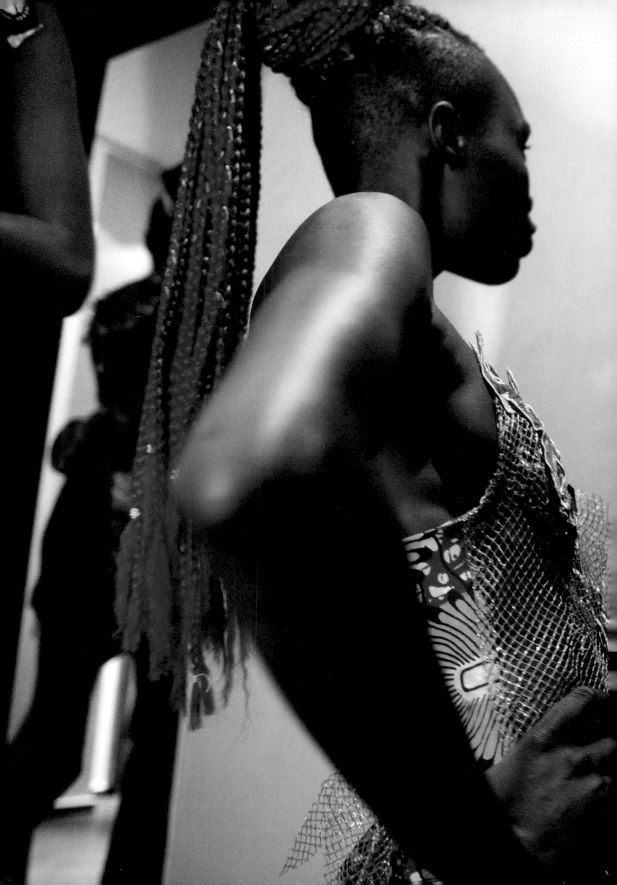

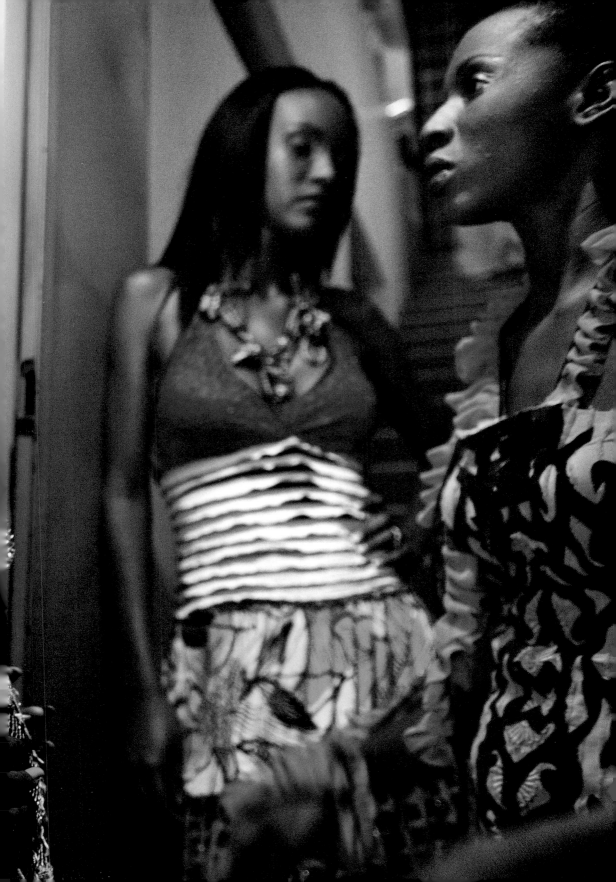

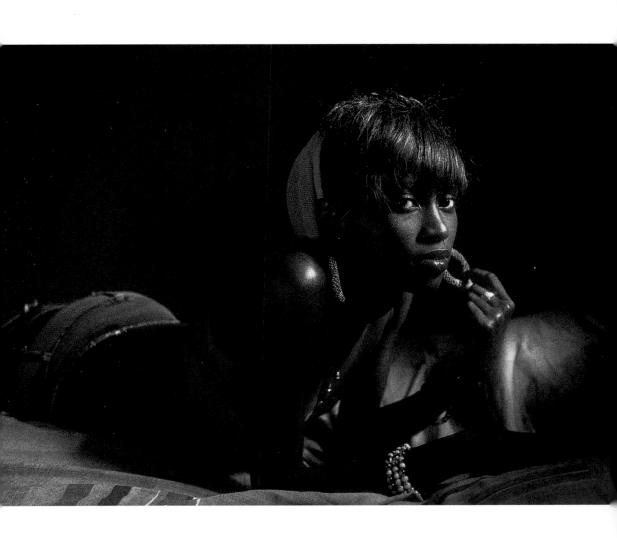

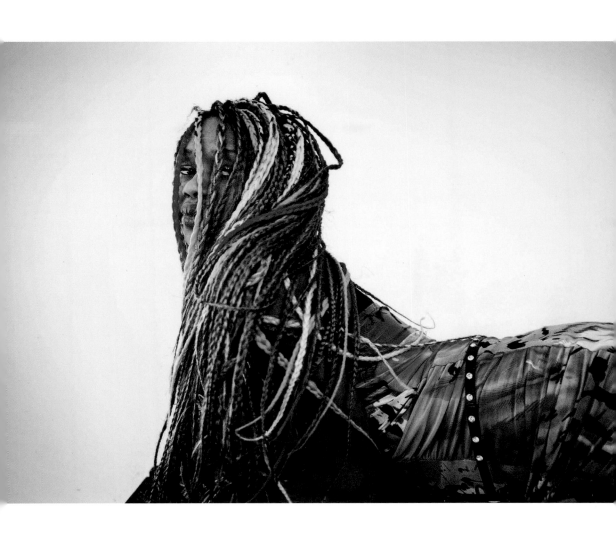

For a long time, only mamans wore waxprints, and in pretty traditional ways. But ever since Beyoncé wore them, it has become a trend among young people, like a kind of pronouncement. Today, you see it everywhere. Even if she has to wear Mango, or a Chinese pagne, to be well-dressed is a question of honor for a Senegalese woman.

Aiche Deme, creator of the cultural page at AgenDakar

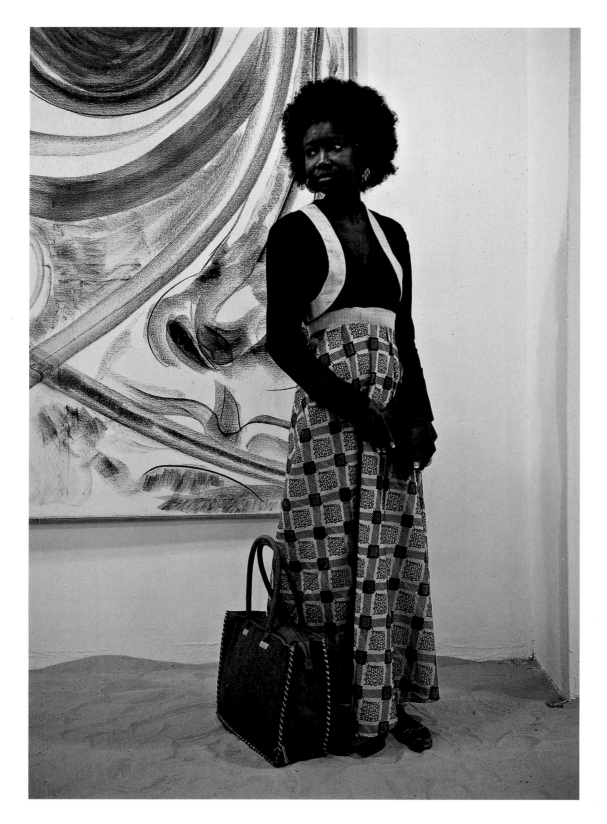

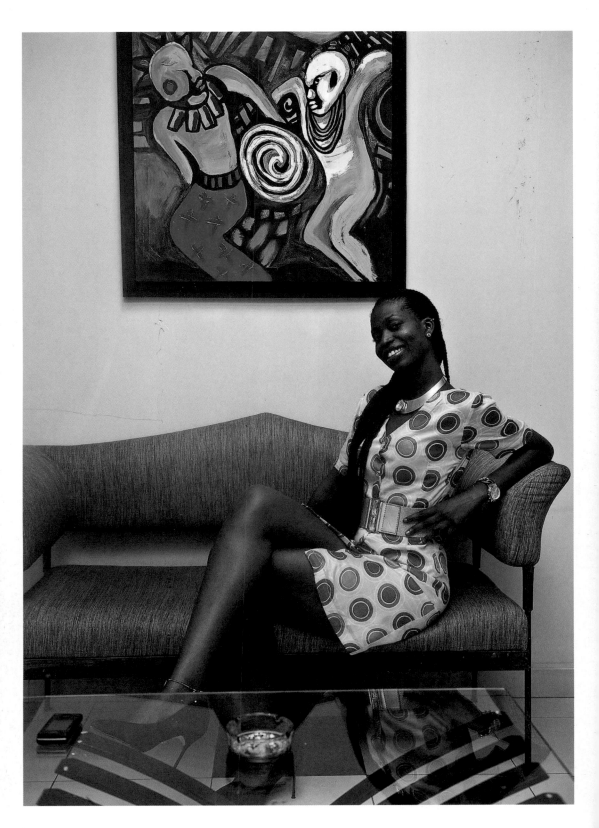

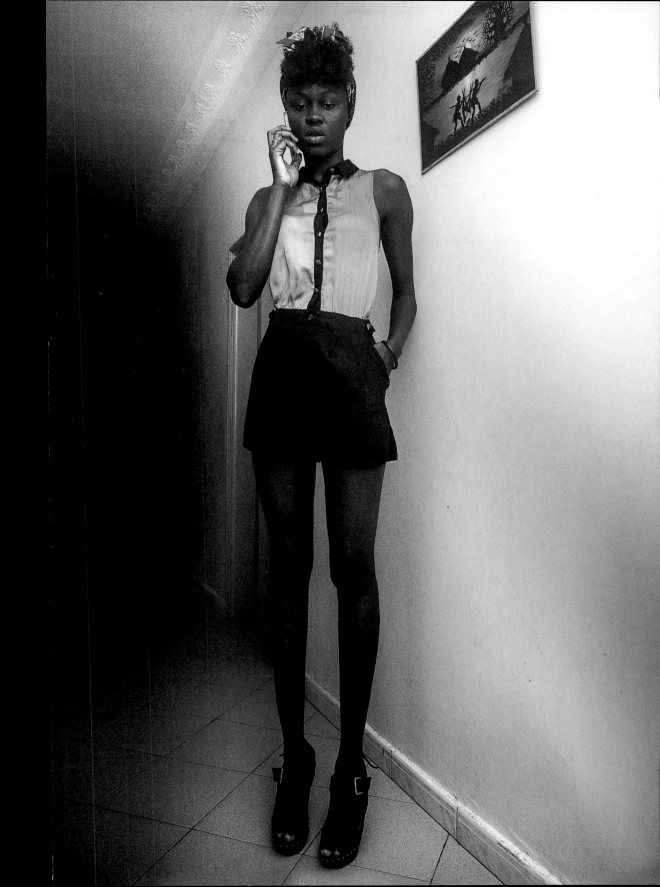

"I like to dress in different looks. I am a professional when it comes to personal care, beauty, the body, and carriage. I teach people to dress well, behave well, and apply makeup. I have a studio near my house where I organize get-togethers and classes in deportment and good manners for models."

Kadja Sall, model, actress, and television host

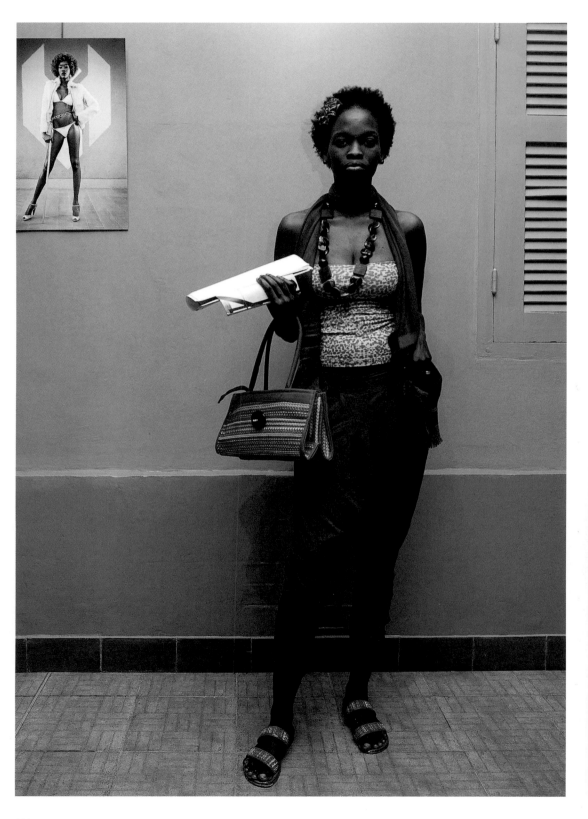

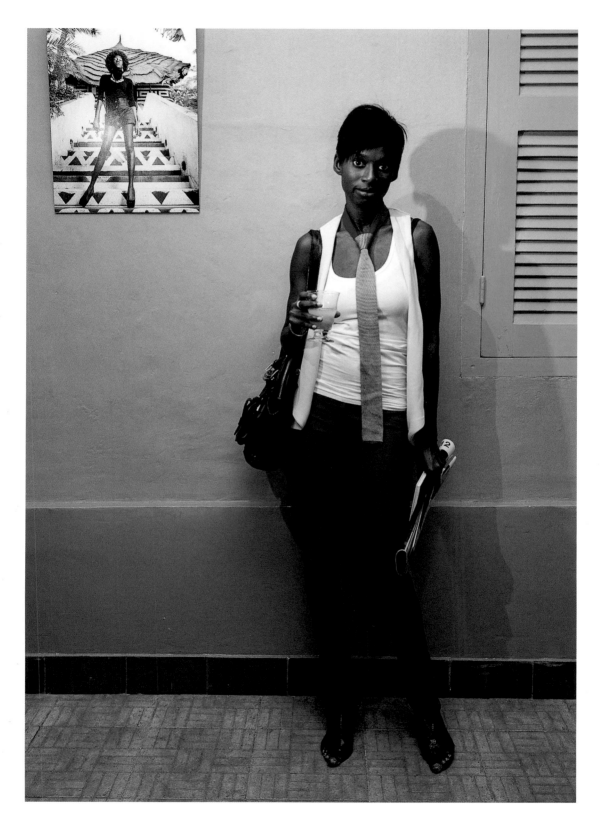

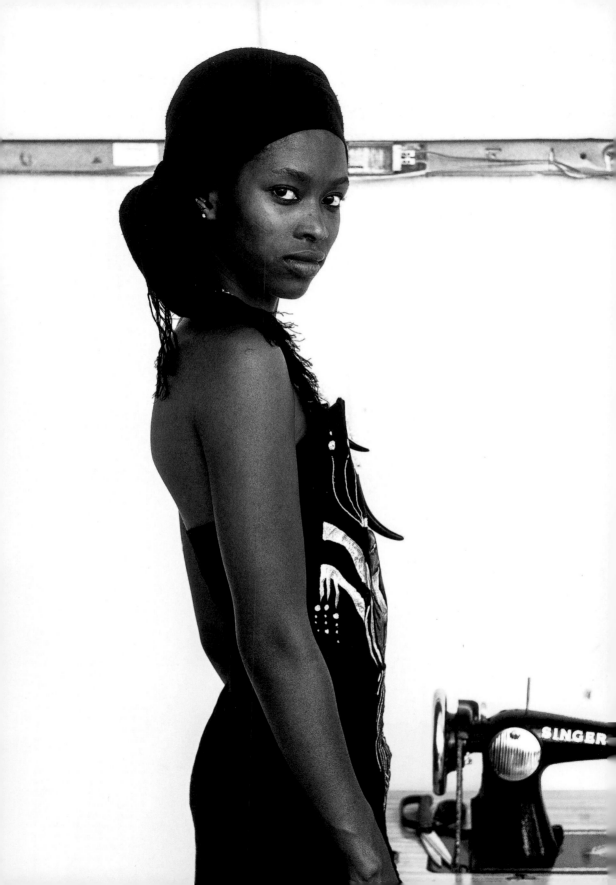

"I finished my studies at Leydi, Oumou Sy's school. My dream is to become a famous designer like her. The dress I'm wearing is a piece from my most recent collection."

Ami Diouf, fashion designer

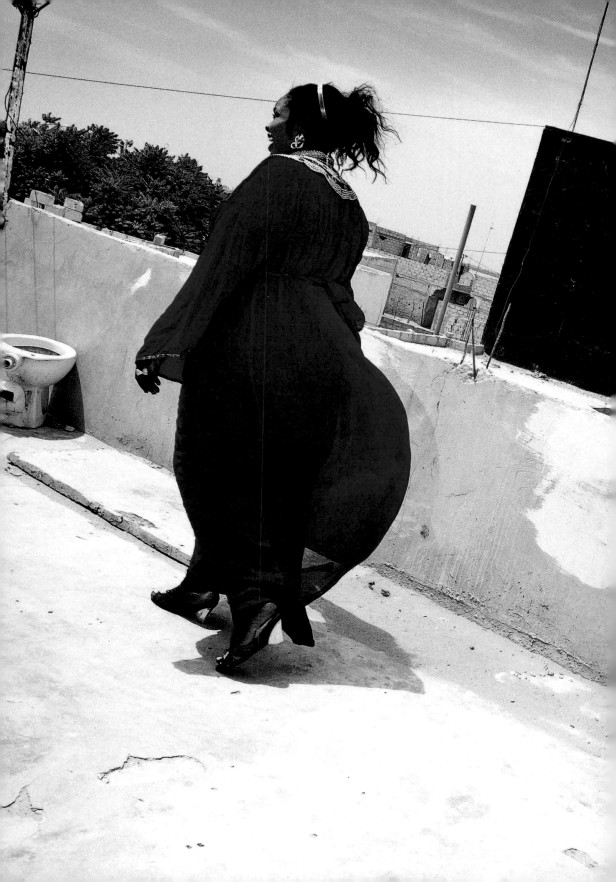

"Men are afraid to approach us, because they know we have very strong personalities. They are drawn to our incomparable elegance, but at the same time they are afraid of our impressive physiques and the self-confidence we exhibit in public."

Doraba

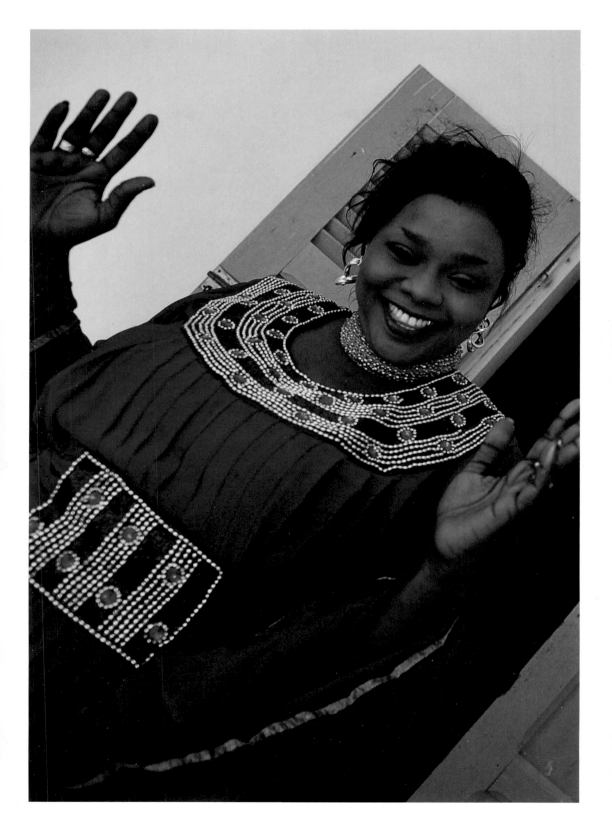

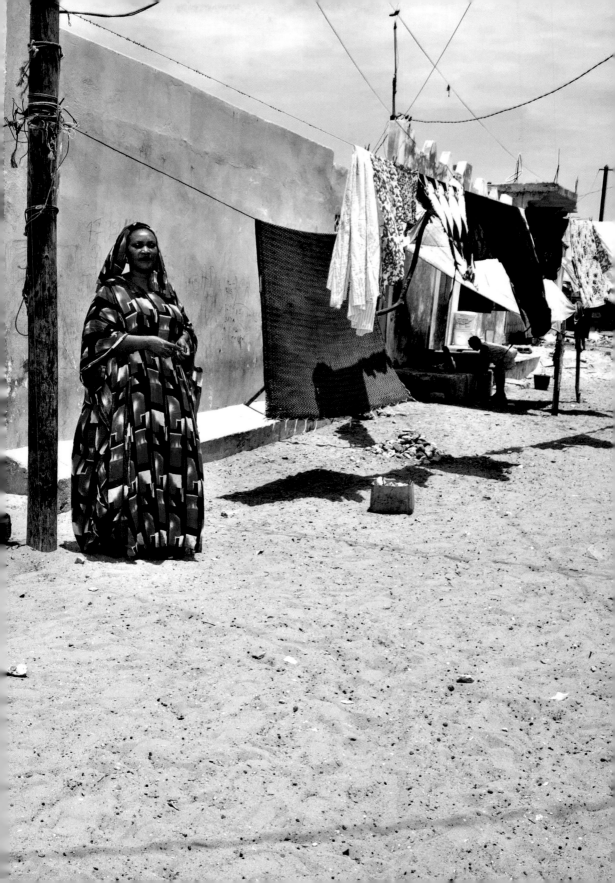

"I am proud of my 'excess weight.' I am a symbol of prosperity and elegance. When I leave the house, I never pass unnoticed."

Famarama Mbaye

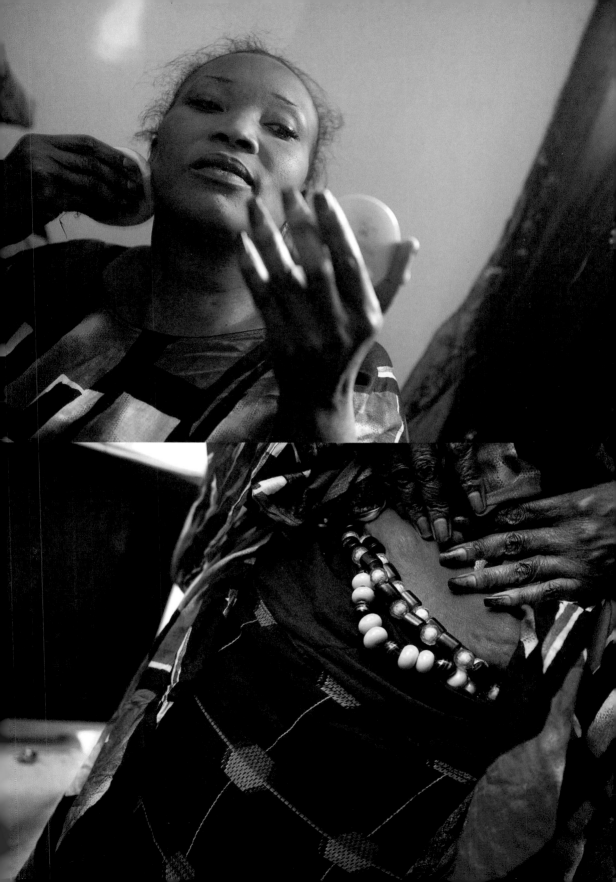

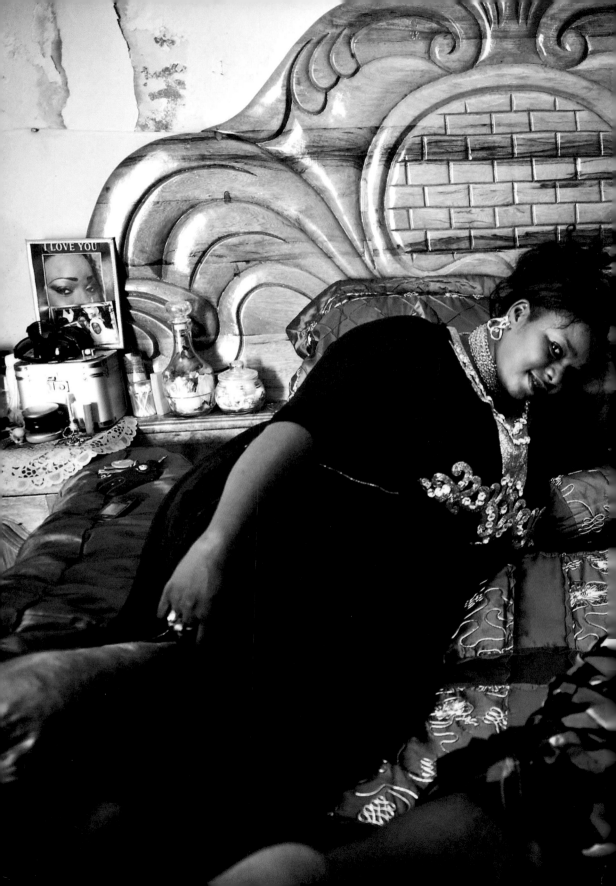

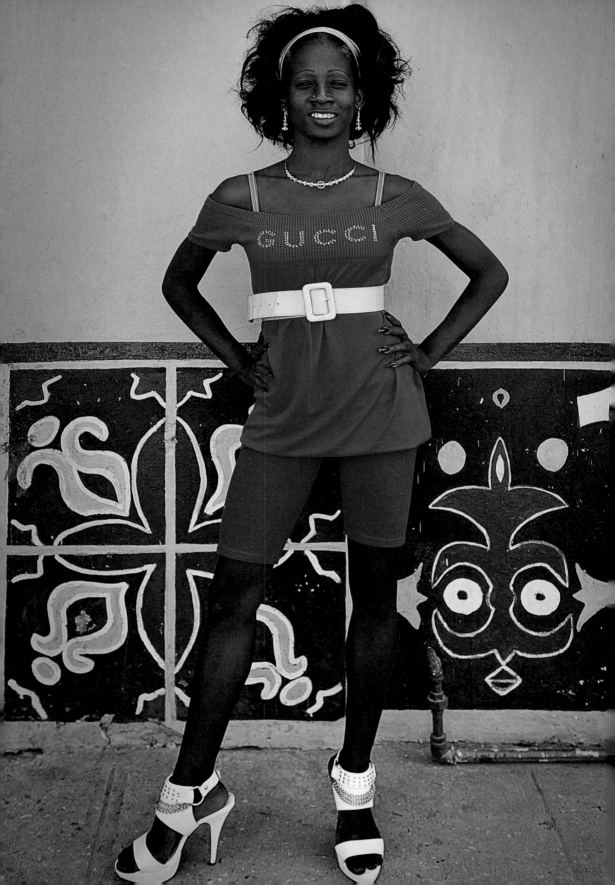

HABANEROS IN BODY AND SOUL

Havana, Cuba

Antonio Eligio (Tonel)
Artist, writer, and curator, lives in Cuba and Canada

During his time in Havana, Daniele Tamagni has assembled a collection of portraits that vividly—and with the crispness of a snapshot—documents the whims of fashion and the love of dressing up, while at the same time allowing a glimpse into a much broader and more intricate social landscape. His impromptu models, the men and women who are inseparable from the eclectic architecture surrounding them, convey the dynamism, the fluidity, and the contradictions of a society that at times appears to be moving forward—through the youth, like many of those photographed by Tamagni, and others who are not so young—toward a fascinating and somewhat perverse future, a future in which Cuba is heading toward a reunion with a globalized, capitalist twenty-first-century version of its own past.

Havana is a theatrical city, with the aura of a stage left behind to the elements, that can at times stand out because of its radiant yet decayed beauty. Those who pose for Tamagni reveal themselves to be actors attuned to the textures, contrasts, and colors of the stage on which they move. With their surprising combinations of different garments and their love for improvising, adapting, and altering, these subjects complement the

varied monumentality of this port city that has been the heart and soul of Cuba for centuries.

During recent years, with the very modest growth of its economy, the country and its most celebrated city show visible levels of disparity and poverty. The economic and social crisis, which began in Cuba more than two decades ago, has become a chronic phenomenon, although it is no less dramatic because of that. Among the small business ventures that the government has allowed in recent years is the retail sale of clothing. The authorization granted for private retail businesses came about reluctantly, and the sector functions in an environment of constant uncertainty and within very strict limitations. Even so, one can speak of a veritable explosion of small shops, often opened up in private homes, stocked with clothing, shoes, and costume jewelry that arrive by the tons on the island every week in suitcases, cardboard boxes, and expandable tote bags sent as baggage on flights out of Miami, Quito, Caracas, Luanda, Panamá, Madrid, and other cities where Cuban emigrants make up large communities, or that serve as a base for the thousands of workers (physicians, sports coaches, and all sorts of technical employees) temporarily hired abroad. The distribution and sale of these textile products in Cuba can now take place through both legal and irregular channels, thanks to the extremely efficient networks that make up the island's ever-prosperous black market. With regard to the clothing seen today in Havana, special mention should be made of the workshops headed up by local designers, who on occasion take advantage of the small space available to the private sector for creating and selling exclusive pieces of haute couture.

Tamagni's Havana photos do not find their inspiration in the exclusivity of runway designs. His lens captures the comings and goings of people out on the street and focuses on ordinary people who are relaxed in the presence of a camera belonging to a foreigner whom they assume is just another tourist. By focusing on these young people who move throughout the most populous and decrepit neighborhoods of the city, Tamagni reveals essential features of a society that is cautiously moving into the new millennium. This is a society in which the government's ideological message insists on making promises while at the same time resorting to a worn-out rhetoric, such that the official discourse is increasingly less attractive to considerable segments of the young population. This young population is generally educated—free education and public health, sectors that were impacted by the crisis, still function as the glue that holds Cuban society together—and they are thirsty for consumption and to feel connected, to a greater or lesser degree, with the outside world. The connections with outside culture are still somewhat rough, but in general they do function, thanks to the growing number of emigrants in other nations, as well as tourism. Emigrants and workers living abroad send an increasing flow of shipments of cash and goods (clothing, cell phones, software, films, television series, and music) to their family members and friends who are, at least for the time being, still in their native country.

Through the individuals photographed, these pictures capture a sense of ostenta-

tion that appears to be very mindful of the value of brands and that is not at all averse to corporate propaganda. They reflect a consumerist ideal, and with that, the importance of symbolic goods in establishing identity, something highlighted by Wilfred Dolfsma, who also posits that "when people conspicuously consume, they express socio-cultural values," which in turn "denote strong underlying convictions."[1] Among those who pose for Tamagni, there is a clear preference for combining an array of logos, together with bright colors and intricate prints, in addition to gold and silver accents. The styles of dress associated with *reguetón* and hip-hop music clearly are aesthetic models to be imitated. These preferences denote identification with cosmopolitan and urban values, and they speak to the eagerness of some young segments of the population to feel integrated into the current cultural world of capitalism, which many identify—with a frivolousness that is accentuated by the relative isolation of Cuban socialism—with the visual prominence of global symbols. These symbols—from the dollar sign to the ubiquitous brands found at any shopping mall throughout the world—are adopted indiscriminately and with unbridled enthusiasm by Cubans of all ages.

The photographs show how a dichotomy is manifested in the streets of Havana, which many scholars attribute to the phenomenon of globalization.[2] On the one hand, it confirms the way that communication and the movement of capital and goods, while expanding, condition the taste of the world's inhabitants, including many of the people walking through the barrios of Havana. By dressing and styling themselves in keeping with transnational styles, these Cubans are participating in the homogeneity that—almost always with negative implications—can be attributed to globalization. At the same time, these portraits make very clear the fact that the espousal of global trends does not take place passively. In the images, the signs of homogenizing capitalism merge together and coexist with powerful and unmistakable signs of the local culture. As such, the devotion to the Orishas, spirits from the Yoruba religion (at a simple glance there can be spied attributes of Elegguá, Orunmila, Obbatalá, Oshun, and Yemayá, among other Afro-Cuban deities from the Regla de Ocha—Santería—practices), appears everywhere, from the very bright colors of the clothing itself—oftentimes chosen due to the religious connotations of the color scheme that predominates in the garments (the yellow and gold of Oshun, the black and red of Elegguá, the blue of Yemayá)—to the traditional necklaces and bracelets that coexist together with an Ed Hardy T-shirt or a Dolce & Gabbana watch. The ultimate symbols of modernity proclaimed by brands have been adopted and combined together with accents that demonstrate the importance of national traditions (two examples are the Cuban flag and the effigy of Che Guevara). And beyond the immediately recognizable local, religious, or patriotic attributes, there can also be seen a particular "Made in Havana" contribution through the joyful and casual way of donning the clothing, in the often carefree way of displaying it on the body, and in the decisions to, for example, blend the features of certain global brands together with the style of school or professional uniforms.

For most of the individuals depicted in these photographs, it is impossible to recall the sixties, seventies, and eighties in Cuba, when individuals and families bought their clothes using a ration card at stores designated by the State. Even less so do they evoke the fifties, when this same country, as one of the nations that was most profoundly influenced by American culture, adopted without any reservations whatsoever the fashion produced in the United States, from the garments worn at the aristocratic parties to the clothing and shoes that were worn in offices, and even the styles of menus in cafés and home decorations and furnishings.[3] These chapters in the history of Cuban fashion, from the mid-twentieth century up until the present time are, of course, inseparable from the country's unique history during that same period. Cuban identity at the beginning of the twenty-first century is a fragmented mosaic in which class differences can be read, as well as affiliations based on subcultures, urban tribes, gender, and race. For now, we must enjoy the diverse and motley society that the photographer Daniele Tamagni has captured through his both sympathetic and complicit lens.

NOTES

1. Wilfred Dolfsma, "Paradoxes of Modern Consumption—Reading Fashions," *Review of Social Economy* 62, no. 3, (2004), 355.

2. For a sound discussion about globalization as a process of homogenization or diversification, see Robert C. Ulin, "Globalization and Alternative Localities," in *Anthropologica* 46, no. 2 (2004), 153–64.

3. Louis A. Pérez Jr., *On Becoming Cuban: Identity, Nationality, and Culture* (Chapel Hill: University of North Carolina Press, 1999), 314–16, 360–63, 387–90.

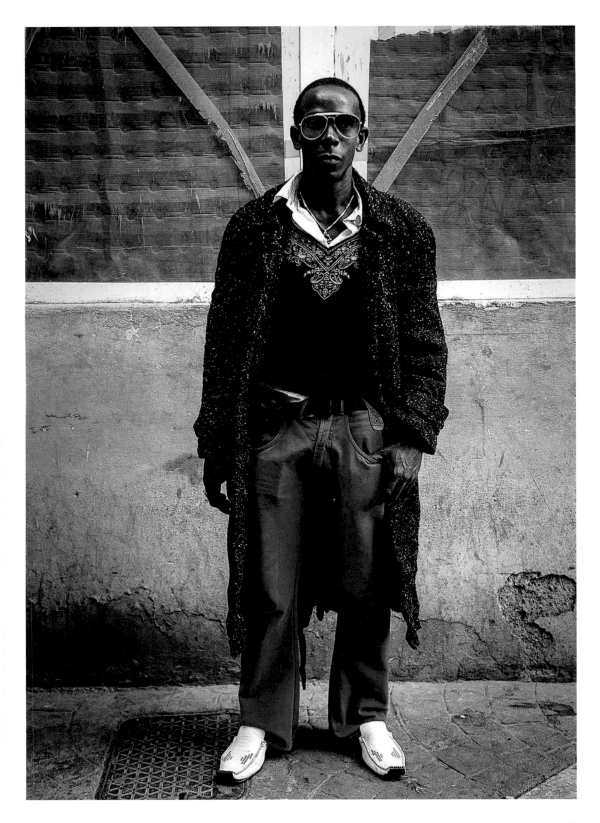

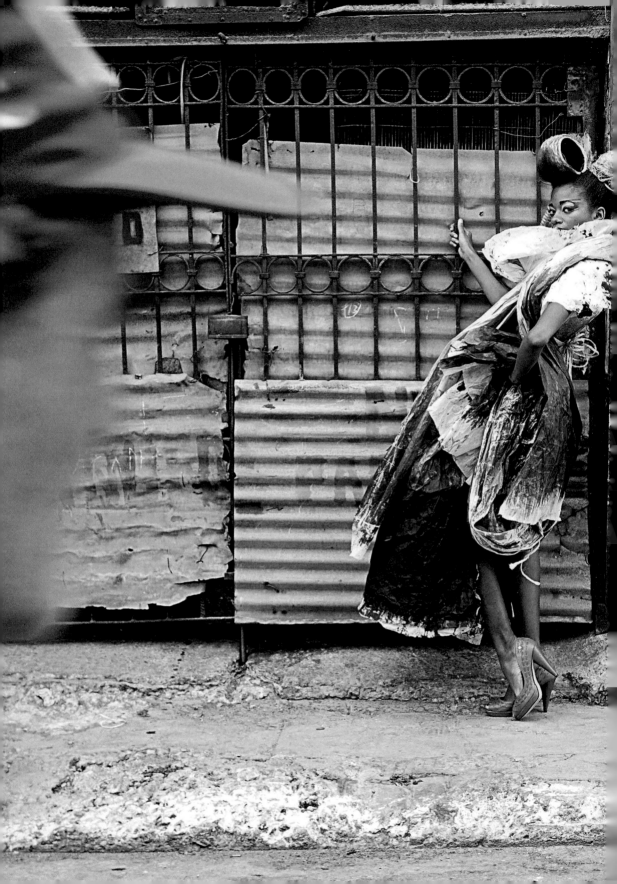

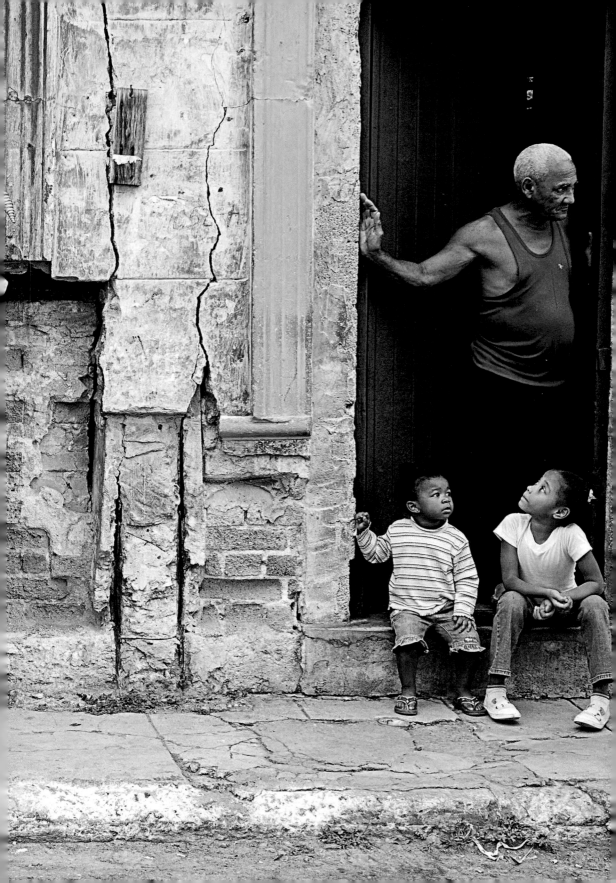

"The Cuban is a cheerful person. Cuba's wealth lies in its diversity. Now there is more interest in fashion in Cuba; young people fully participate in this process and stay up-to-date by following global trends."

Raul Castillo, fashion designer

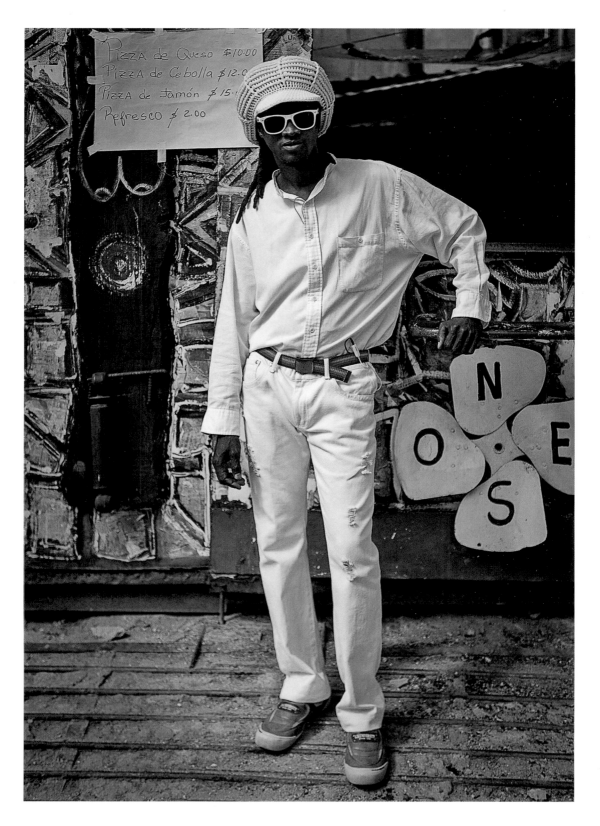

Pizza de Queso $10.00
Pizza de Cebolla $12.0
Pizza de Jamón $15.
Refresco $2.00

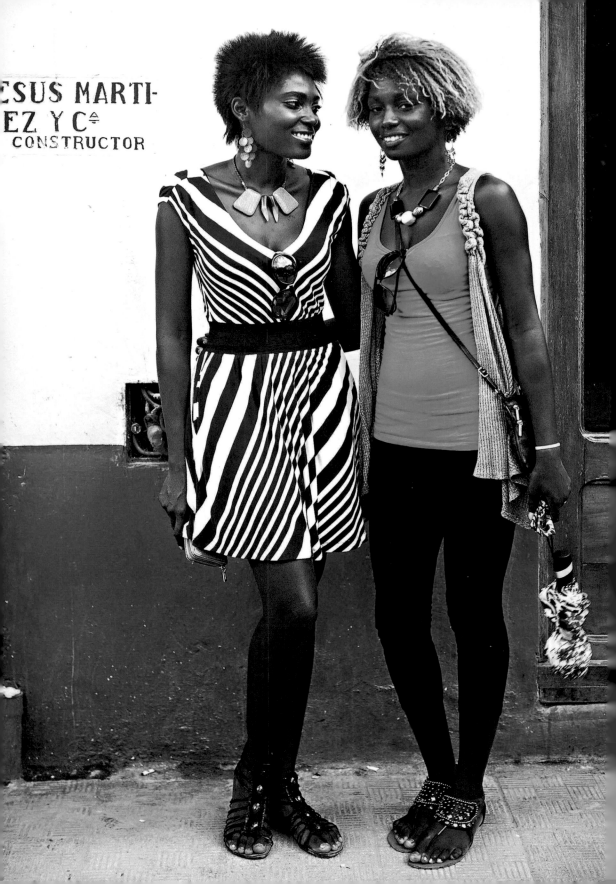

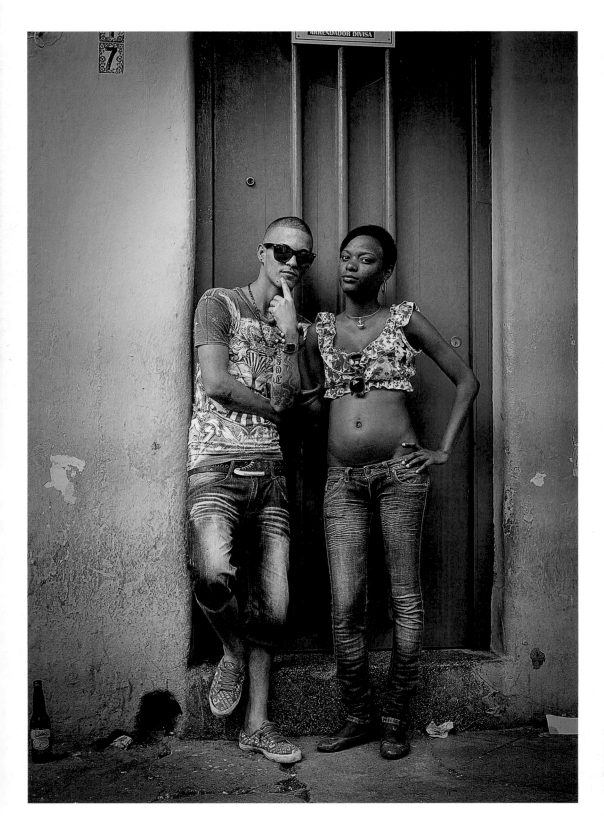

141

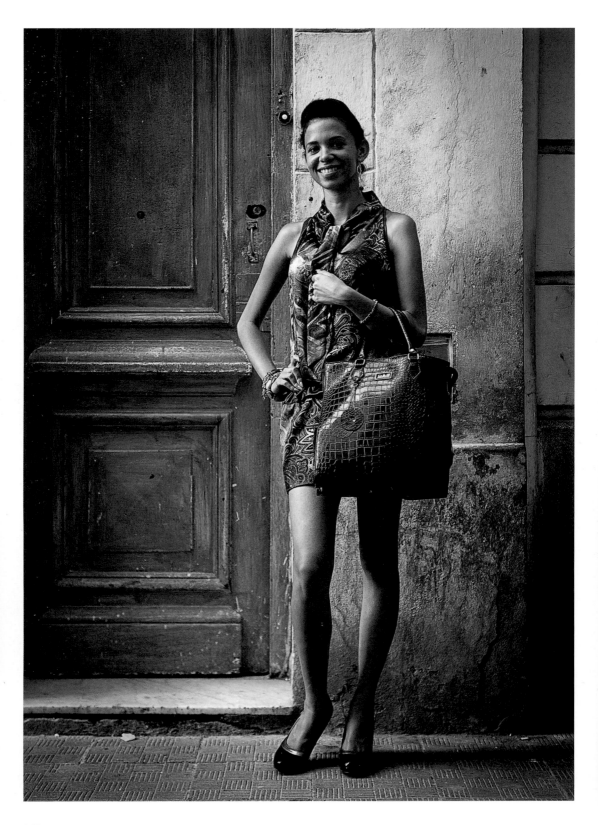

"Young Cubans adore fashion. They are profound, they are revolutionary, they have suffered, they have respect for values and their own history, but they like to dress well. By nature, Cubans have always had a sixth sense for beauty, for elegance. Thirty years ago, all Cubans dressed alike, but now there is much more freedom."

Raul Castillo, fashion designer

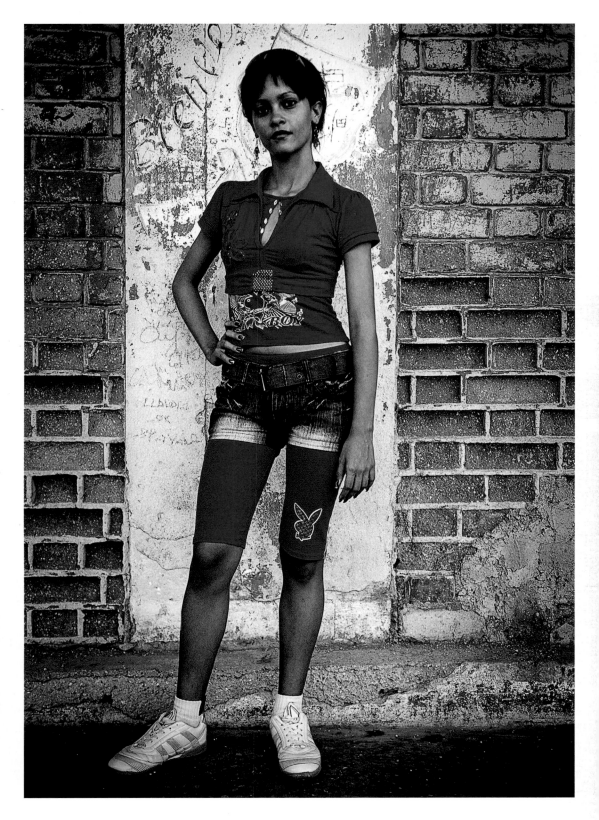

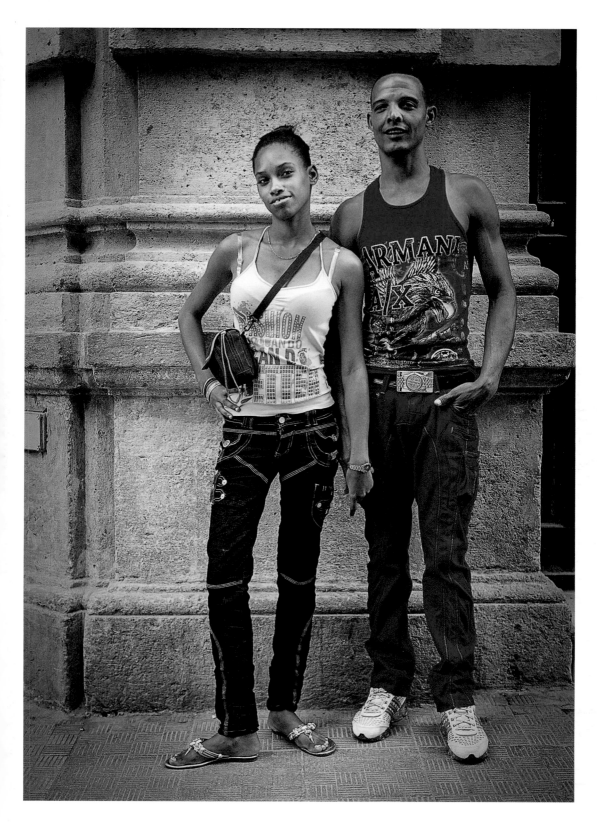

"I try to create an abstraction wedded to a preference for Cubanness, namely a mixing of races. It is very exciting to adapt color, texture, the shapes of materials to the shades of Cubans' color, their skin tones. Cubans like to dress up. Boys and girls in Cuba lend themselves well to my style. I would define my style as avant-garde and eclectic."

Lazaro Dùlce Dobouchet, fashion designer

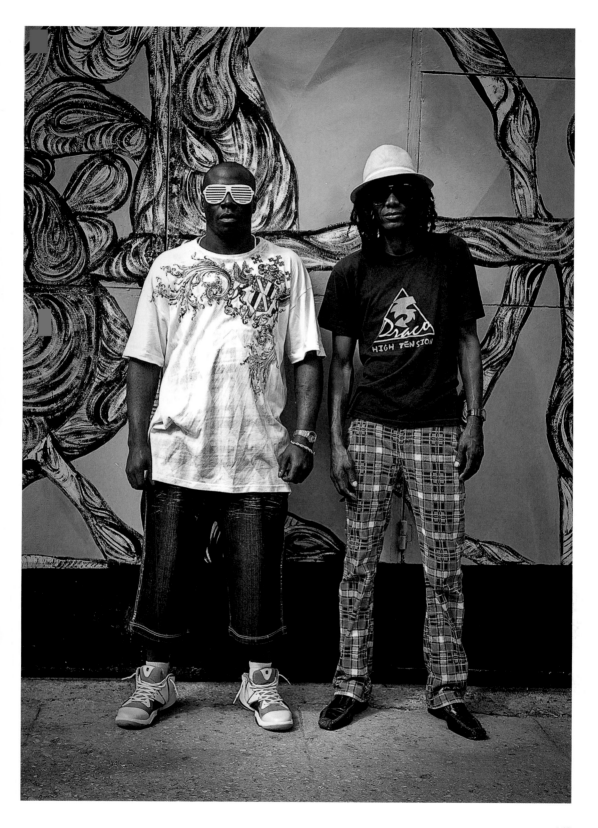

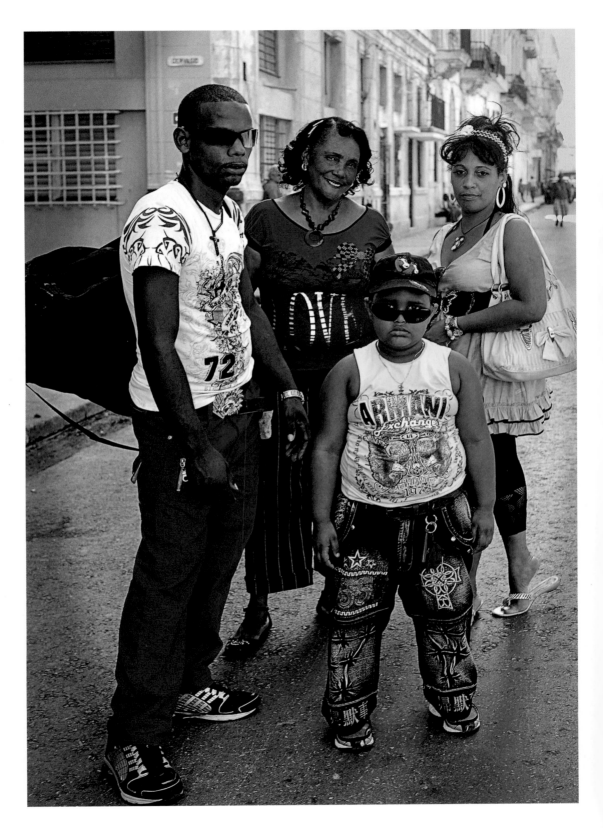

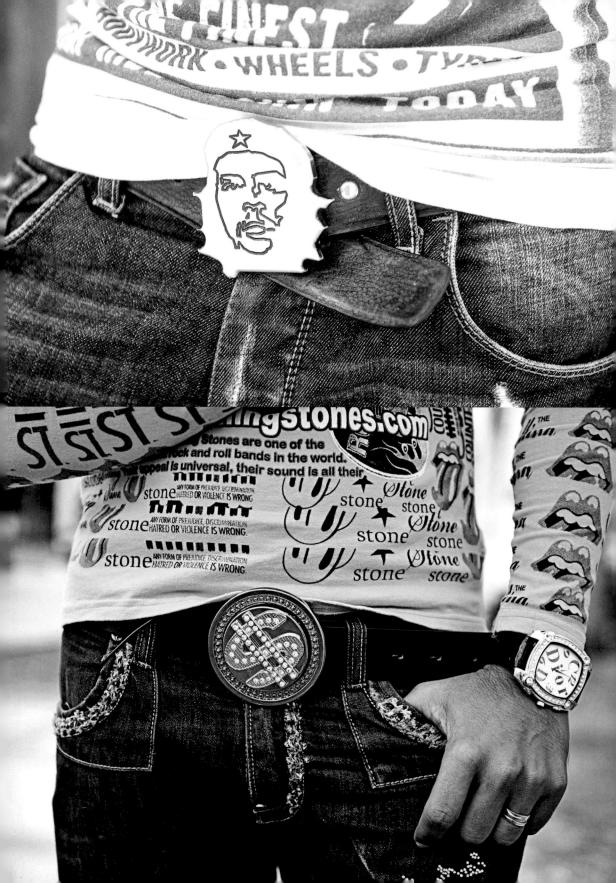

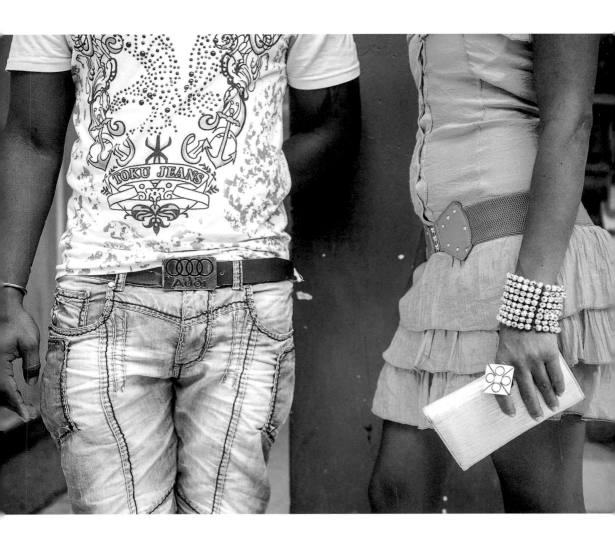

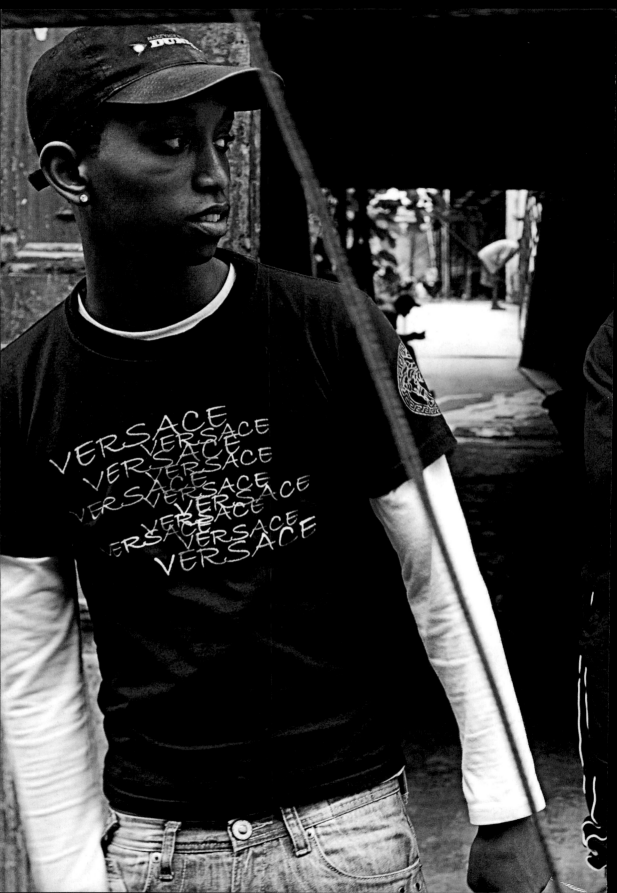

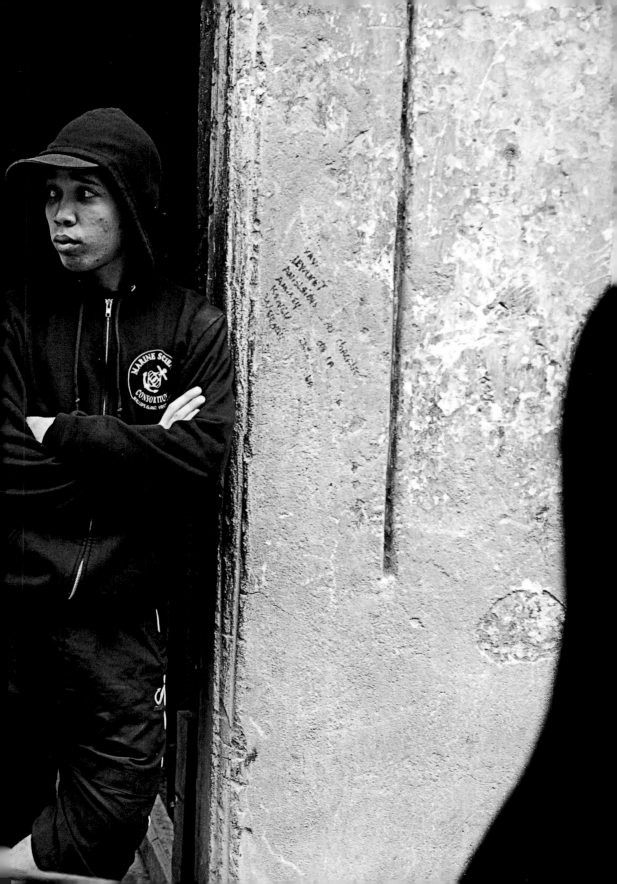

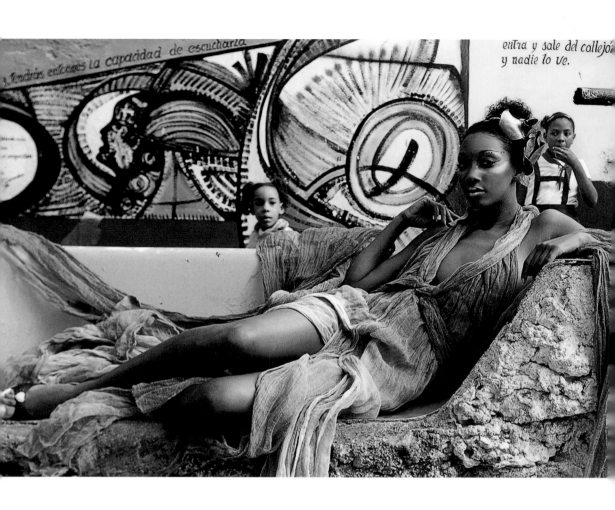

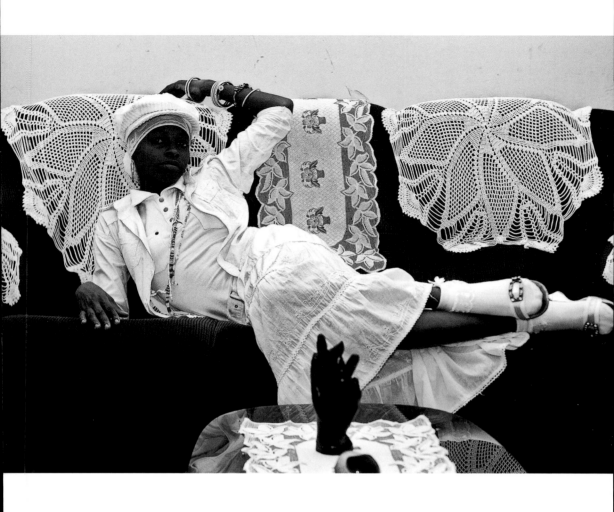

Girls dressed all in white indicate that they have taken a one-year vow to Santería, a religion that originated in the Caribbean. It begins with a weeklong initiation that culminates in a celebration where they offer gifts to the female divinities and then join the religious community.

There is a very strong relationship between fashion and religion in Cuba, characterized by a unique syncretism. Multicolored necklaces, symbols of the Orishas, are omnipresent, often alongside necklaces with crucifixes or Christian saints.

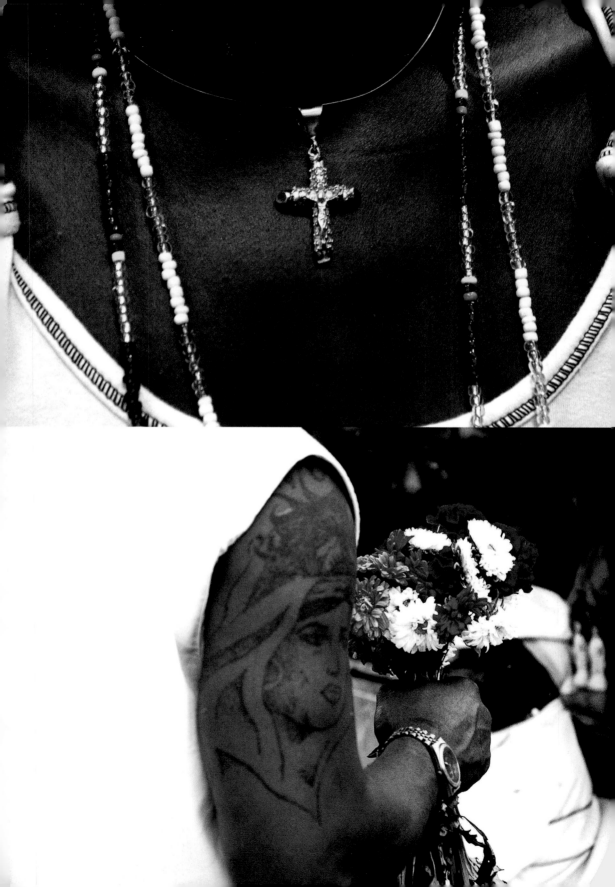

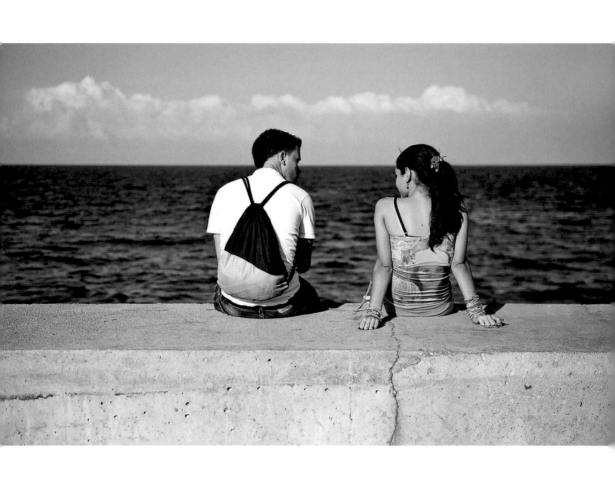

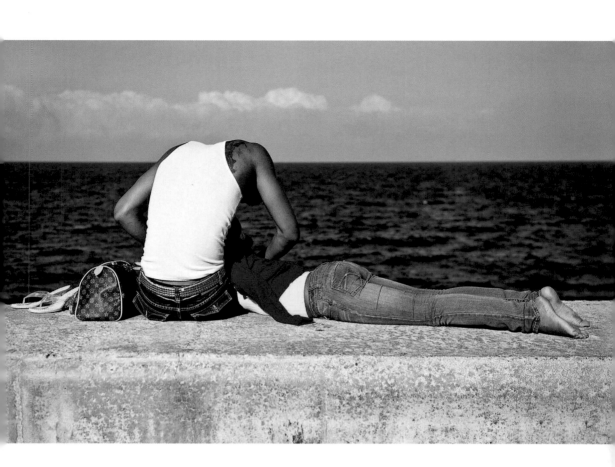

FLYING CHOLITAS

La Paz, Bolivia

Véronique Marchand
Sociologist and lecturer at the Lille University of Science and Technology

Cholitas are easily identified by the particular skirt they wear—a bouffant style gathered at the waist—known as the *pollera*. They prefer to call themselves— and not without pride and coquetry— "*nosotras las mujeres de pollera*," or "we the pollera women." In doing so, they set themselves apart from peasant women, who wear dark, traditional skirts—both in name and appearance. The cholitas' clothes are made from shiny fabric that is more colorful and sometimes embroidered with gold or silver thread. They finish off the look with a slightly tilted bowler hat that sits on top of two long braids adorned with ribbons and pompoms. The cholitas double their efforts for festivities, ceremonies, and big events like the Miss Cholita pageant in La Paz or wrestling matches. At these events, they compete using the quality of their fabrics and the amount of jewelry they wear: hanging earrings and golden or silver rings set with stones, brooches decorating their tasseled shawls, and *mariposas*, which are pinned to their hats.

Their dress is synonymous with social prestige. Their ballerina flats are chosen with care, with particular attention paid to matching colors. The small motifs decorating their stockings enhance their ankles. In these ways, pollera women distin-

guish themselves from señoras, who are in *vestido*—dresses, suits, pants, or jeans in the Western style. The pollera—which by extension metonymically designates cholita dress in general—reveals an art of detail and a sense of feminine beauty that rests on the embellishment of the form of the hips by wearing two—and sometimes three—constantly twirling petticoats. As opposed to the Western look, which favors thin women, fleshy women are seen as a sign of health and social success. This entails accentuating the woman's body while simultaneously covering it: skirts must never be too short, sleeves are long, and shawls envelop the bosom. The aesthetic involves harmonious layers of clothes, each more sumptuous than the next, all as the means of putting one's social status on display through the quality of what one wears. Even the off-balance hat—which requires holding one's head high—helps maintain a dignified attitude, the pride of being pollera.

In fact, being a pollera woman allows her to show her superiority over peasant women—the *indias*—in order to be treated with less contempt than they are by the señoras. The cholitas of La Paz, and by extension of El Alto, occupy an intermediate social position in terms of migration, profession, and language. Originally rural, born in the country or the offspring of peasants, they migrate to the city in search of work, most often alone with their children. Their bilingualism—and sometimes trilingualism—also grants them intermediary status. (They speak Aymara, Quechua, or both, in addition to Spanish.) Pollera women are above all distinguished by their almost exclusively female professions as domestic workers

or shopkeepers. Although pollera women are originally migrants, once they enter an urban environment, they make it clear through dress that they now belong to the city, unlike peasants. Their look is indisputably and above all urban; they are women between two worlds who play with the boundaries and dress codes of each one: that of peasants on one hand, and that of señoras—"ladies of the city"—on the other.

Pollera women have always played a considerably progressive role in the struggle for women's rights in Bolivia. In 1927, polleras founded the Fédération Ouvrière Féminine, the first union in Bolivia. It was constituted by cooks and covered market shopkeepers. Starting in the 1970s, unions for street vendors flourished in La Paz. And in 1984, the first union for domestic workers was created—their top demand was an eight-hour workday. The polleras' actions demonstrate their leadership in the fight for women's rights, but they don't bill themselves as feminists. Nevertheless, anti-male elements are common in their discourse: Men are most often presented as irresponsible alcoholics or as children that need to be taken care of. Their fight is not directly and explicitly aimed at male dominance, but rather for the defense of their families, as working women. These are the battles of mothers who have made a sacrifice—and sometimes they take extreme forms like hunger strikes and symbolic crucifixion. These are brave, fighting women, not victims. Their actions challenge the classic perspective of the division of labor between men and women and associate physical strength with women, as in the case of wrestling. Cho-

litas like to prove that they can get along perfectly well without men—as mistresses of the home—in their work and also in their political and union activism. They participate in the liberation of women in the sense that their professional activity, mainly in commerce, is a demonstration of their independence with regard to men. Furthermore, their actions contribute to the greater visibility of women in the public realm. In 1989, the first pollera woman—Remedios Loza, a member of the CONDEPA party (Conciencia de Patria), former radio host, and flamenco dancer—was elected to the Bolivian parliament. Bolivian president Evo Morales, who nominated the former leader of the union for domestic workers to be minister of justice in 2006, sanctioned such political ascension. Since 1989, cholitas gradually have reached top-ranking posts in the Bolivian government.

It's therefore not surprising that cholitas are excellent wrestlers. The matches embody their daily struggles, in which the stakes are as vital as family survival, and they also represent their mastery of performance in certain forms of theatrical protest. The cholitas are not naive, and are best at juggling with ethnic ambiguity, which is now so effective in the political domain. Their identity is full of apparent paradoxes, of subtleties that allow them to thwart social and gender inequality, like a veritable kick in the face to the established order. As a result, they hold front-row positions in the modern world, the press, the Bolivian world of politics, and the ring.

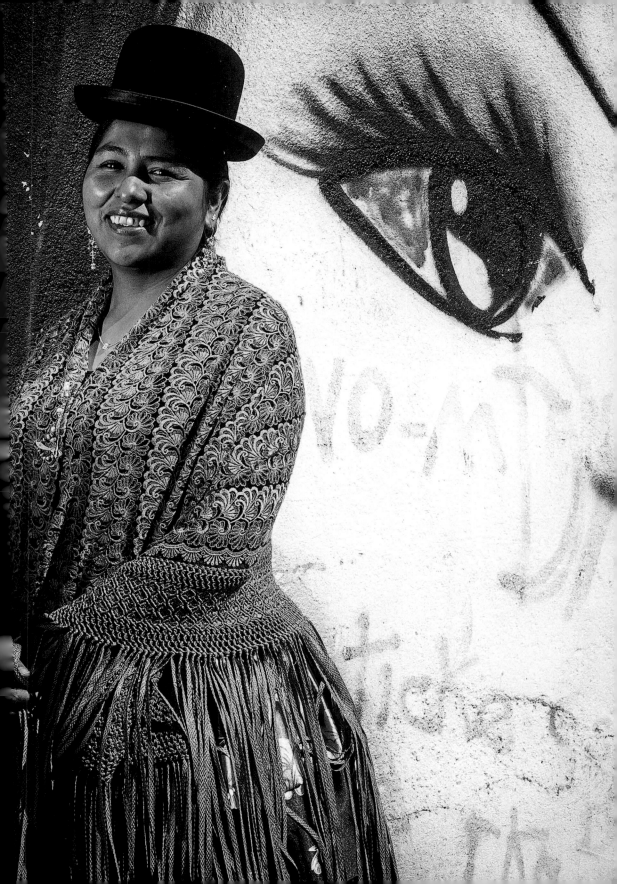

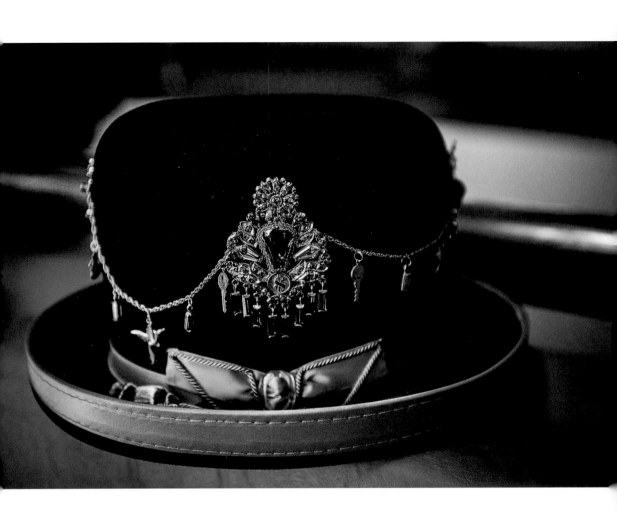

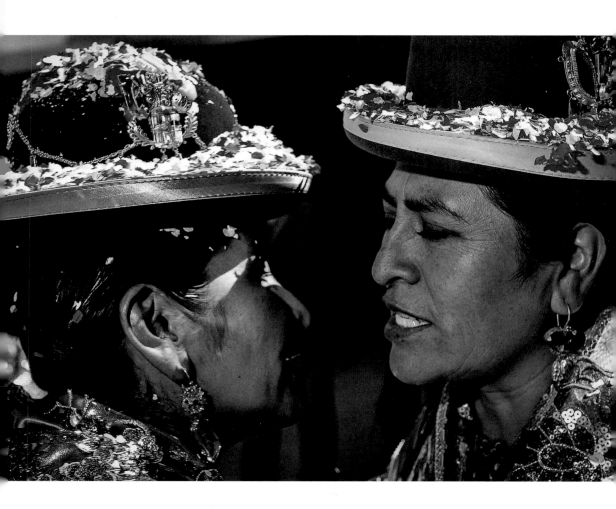

The cholita has an innate elegance in her carriage and attitude, in certain details, in her long, braided hair, in the way she knows how to combine colors and patterns in her clothing. She has a way of walking, of behaving.

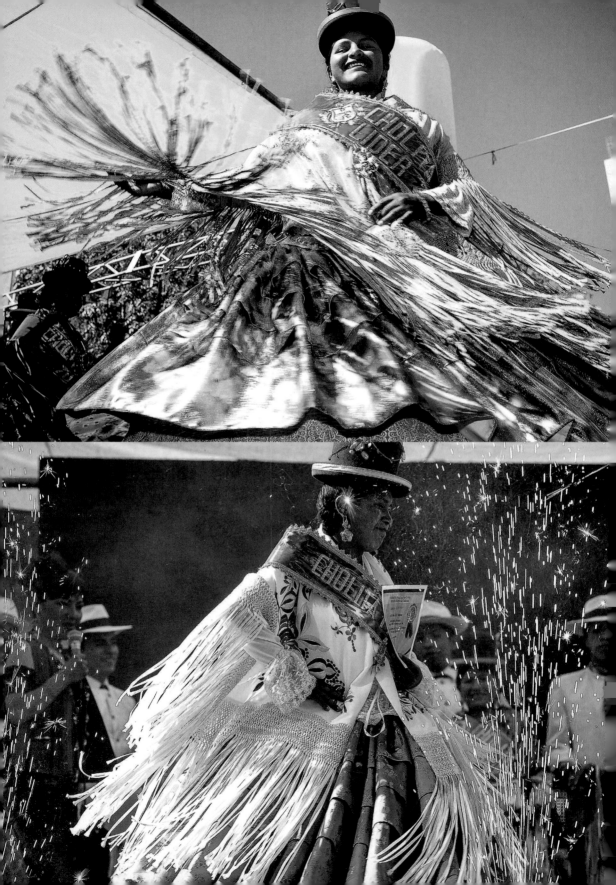

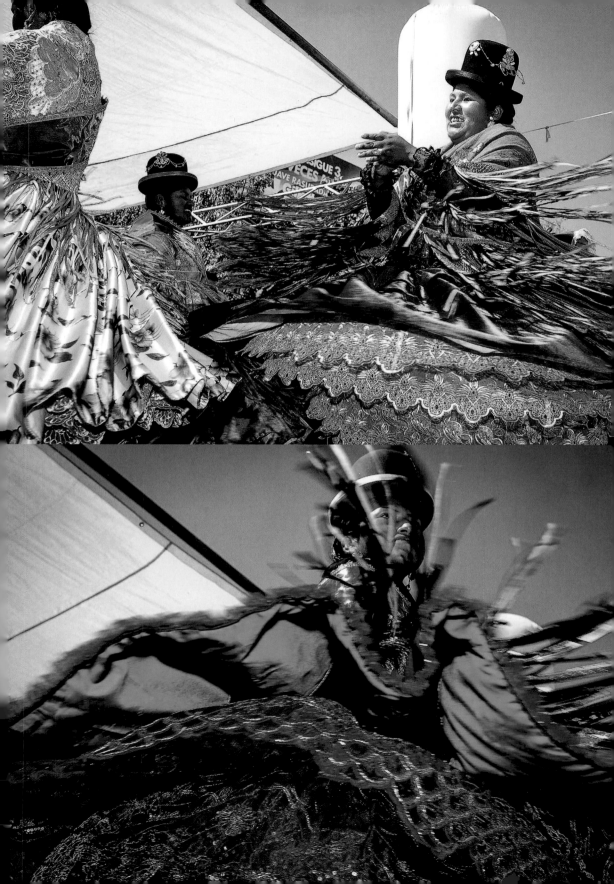

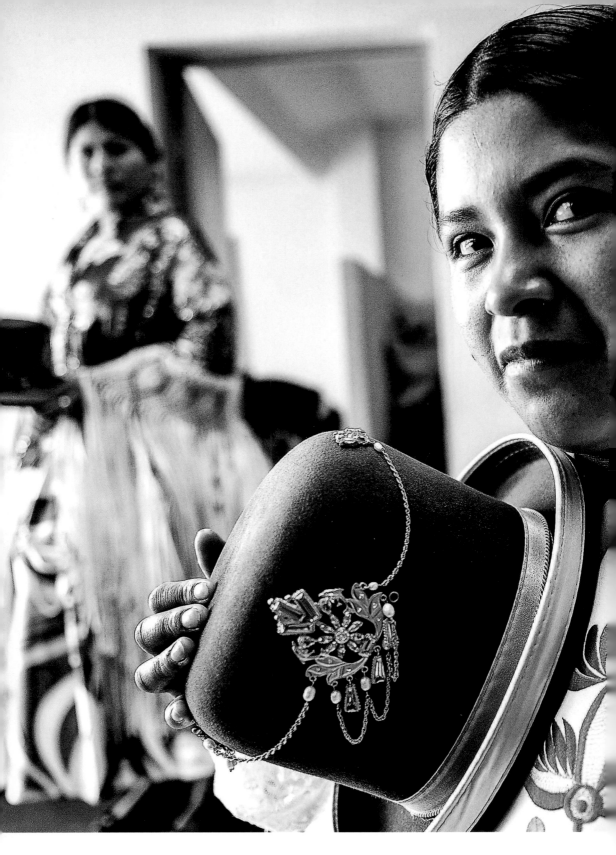

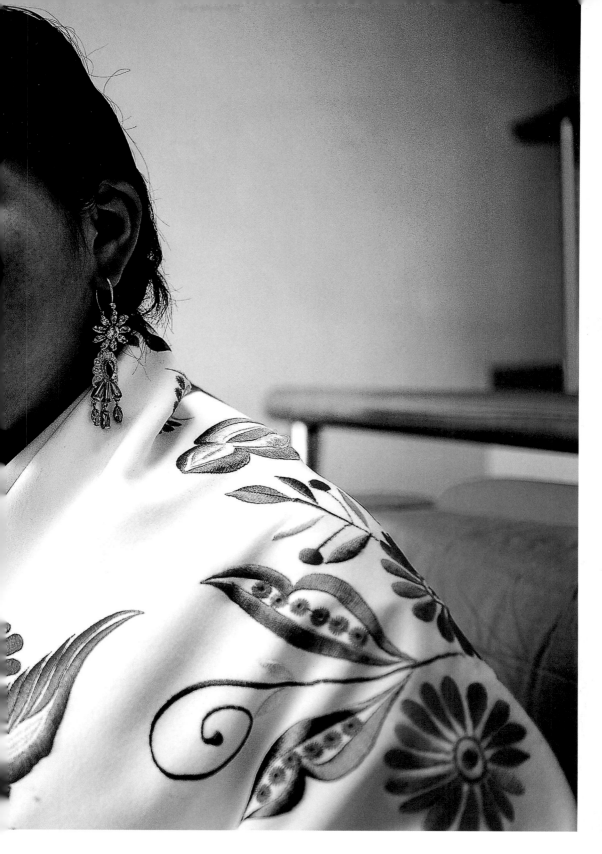

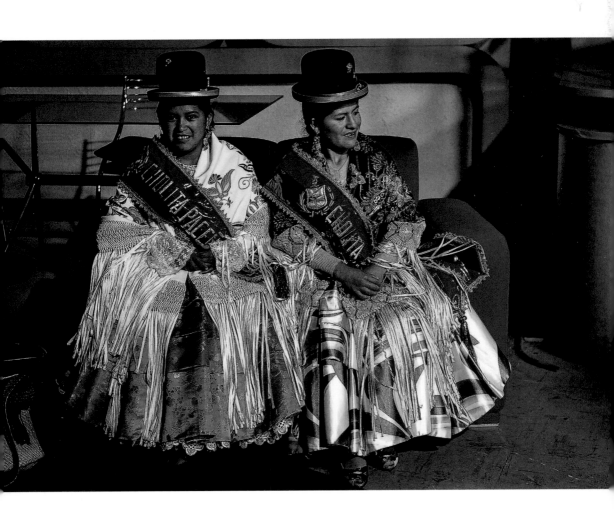

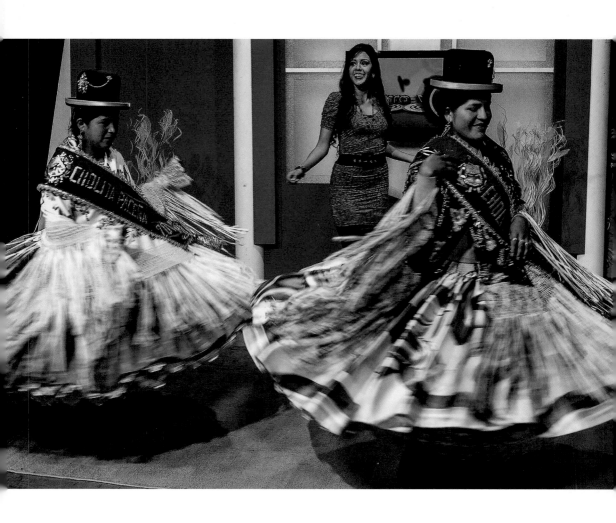

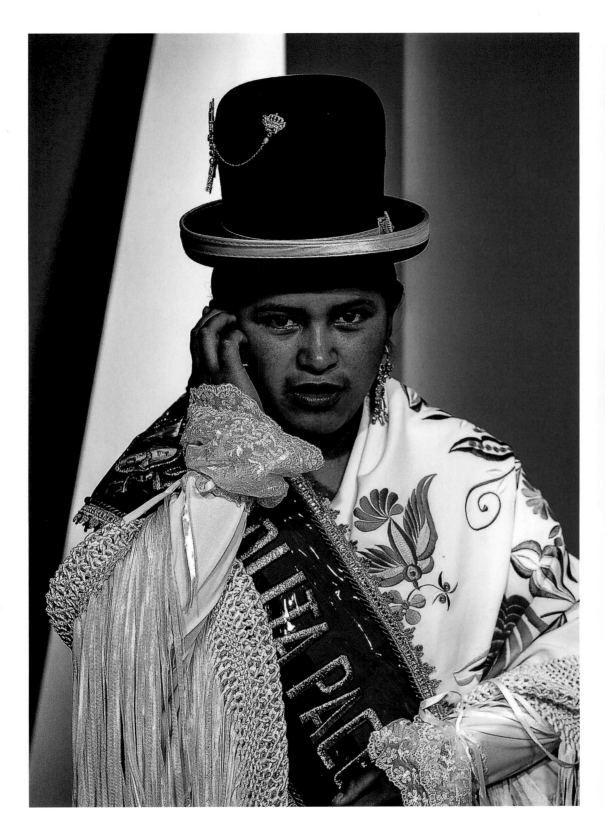

"A cloak costs seven hundred to nine hundred Bolivian dollars, depending on the type of canvas; a pollera (an elaborate skirt) can cost two thousand or more, depending on how large it is, and the embroidered middle portion as much again; shoes cost one hundred to one hundred and fifty; a Borsalino hat, nine hundred to one thousand. A cholita has to know how to combine colors and patterns; for example, the pollera is floral, like the cloak, highlighting the elegant style, and it must match the sombrero. And atop this is the mariposa—a hatpin that must match the jeweled headband and earrings. Good taste and stylish dressing are mandatory. The cholita dresses this way for celebrations during the day, wearing a pollera and a simple cloak. She will have ten different outfits in her closet. Every year, she changes her attire."

Dora Soldado, Miss Cholita Pacena, 2010

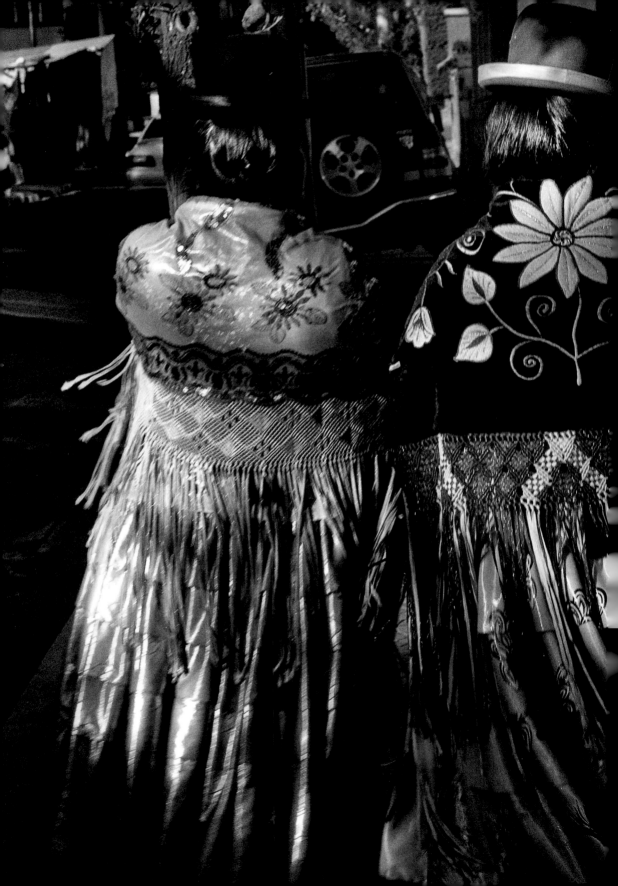

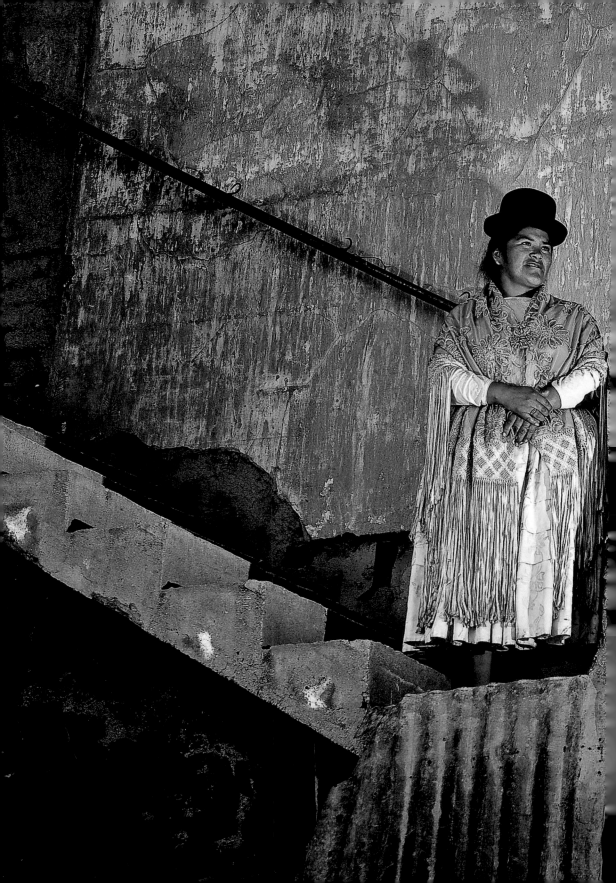

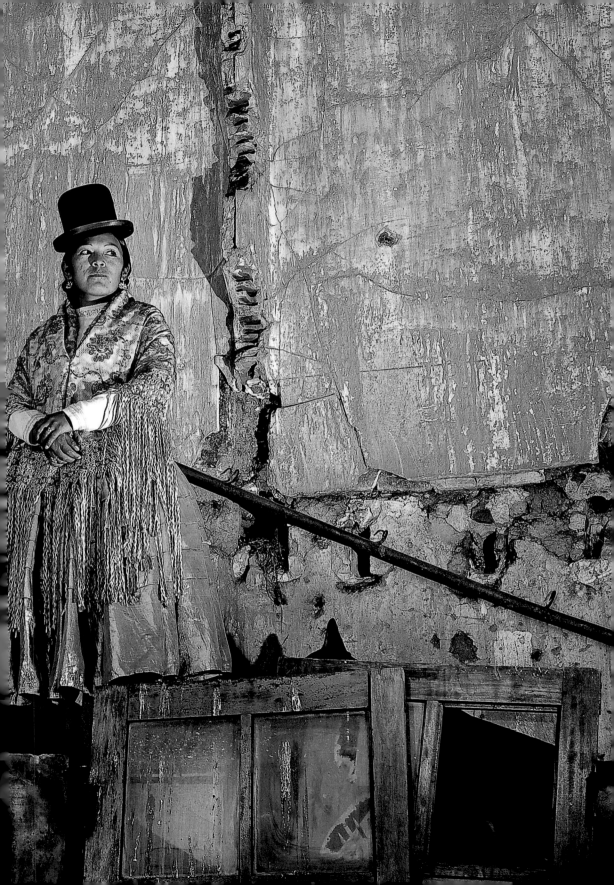

"Since the age of eleven, I have devoted myself to wrestling, although initially not professionally. I am one of the pioneers of female wrestling; I love it more than my family. I founded the group Las Diosas del Ring (Goddesses of the Ring). My motto is 'Combine strength and violence with grace and elegance.'"

Polonia Ana Choque Silvestre, aka Carmen Rosa la Campeona

Lidia Flores, aka **Dina la Reina del Ring (Dina the Queen of the Ring)**

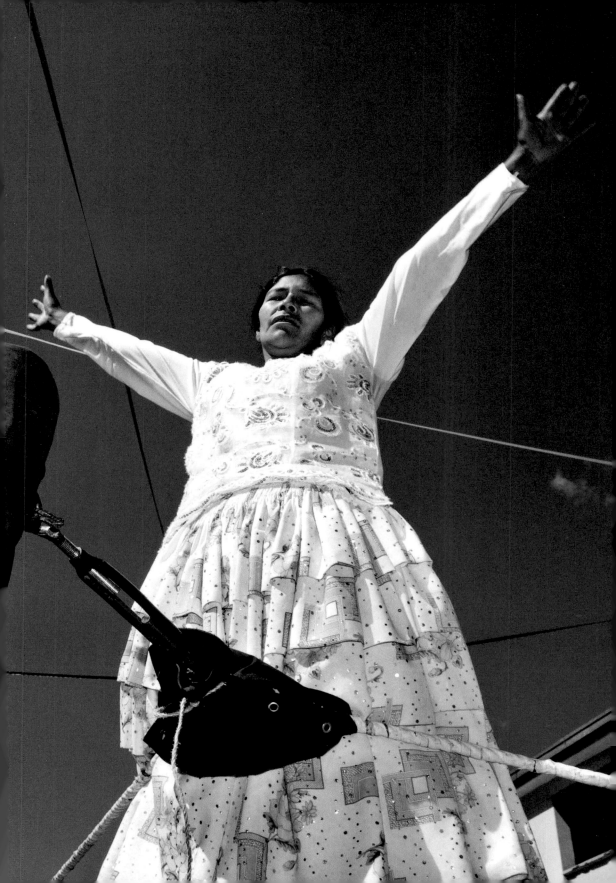

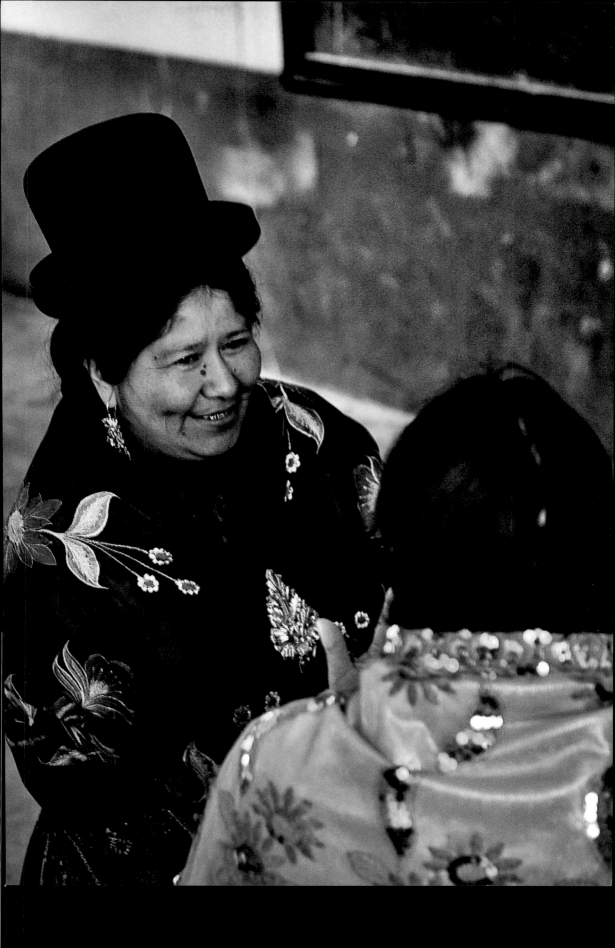

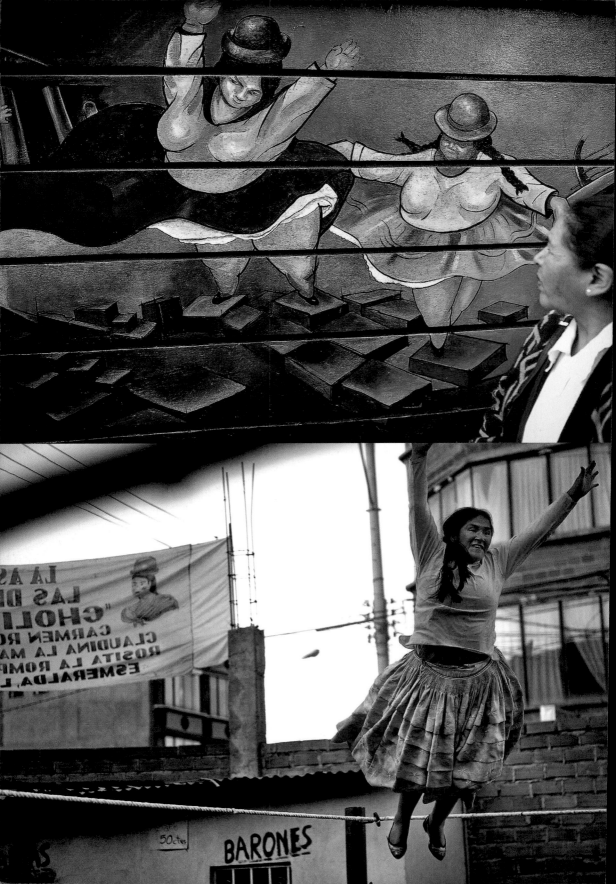

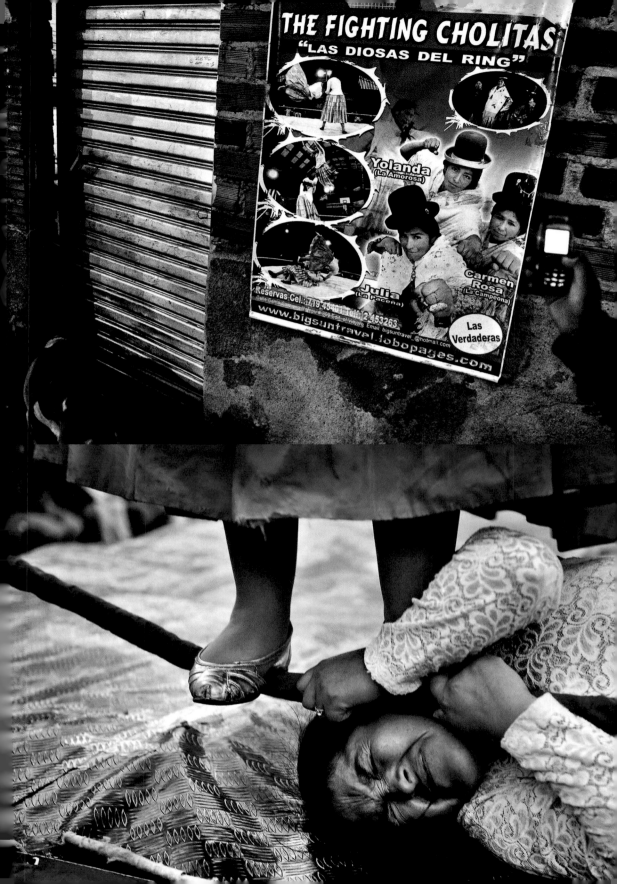

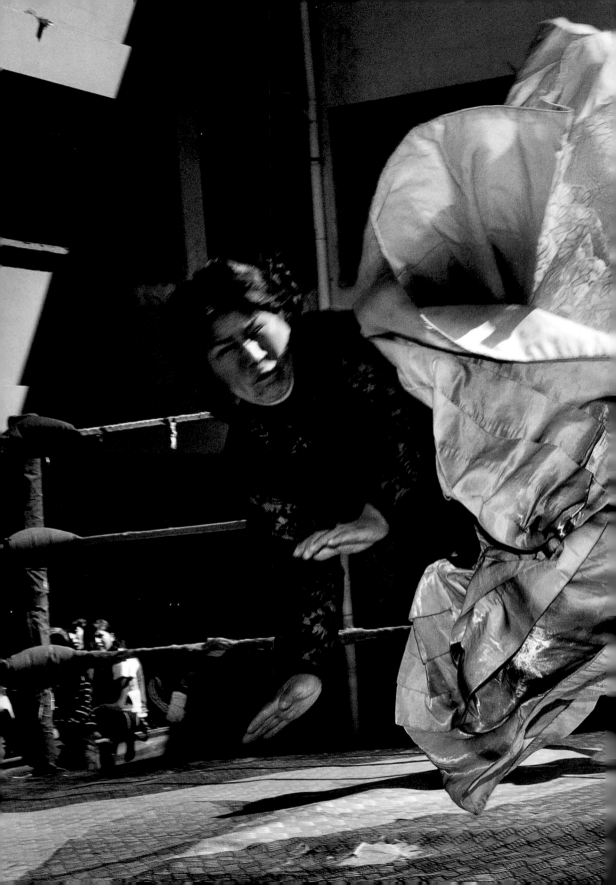

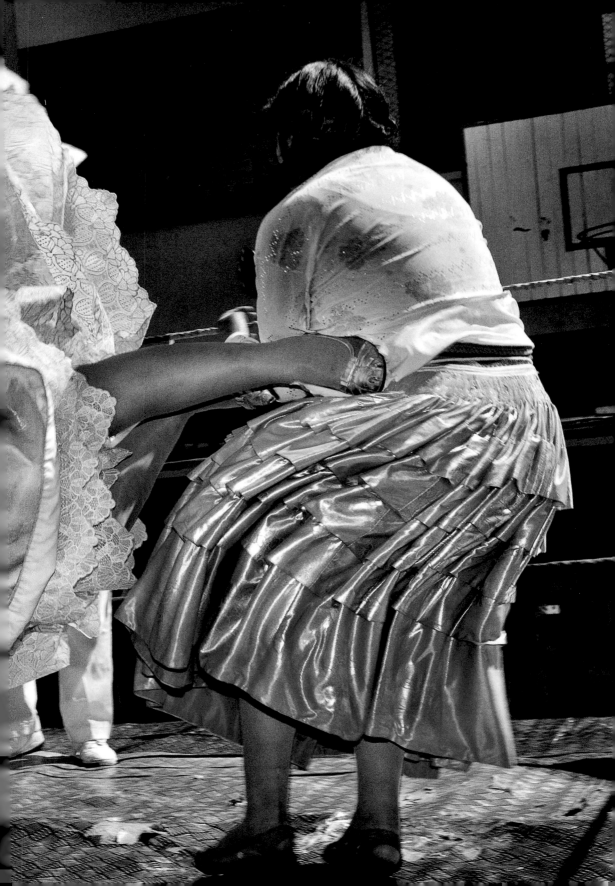

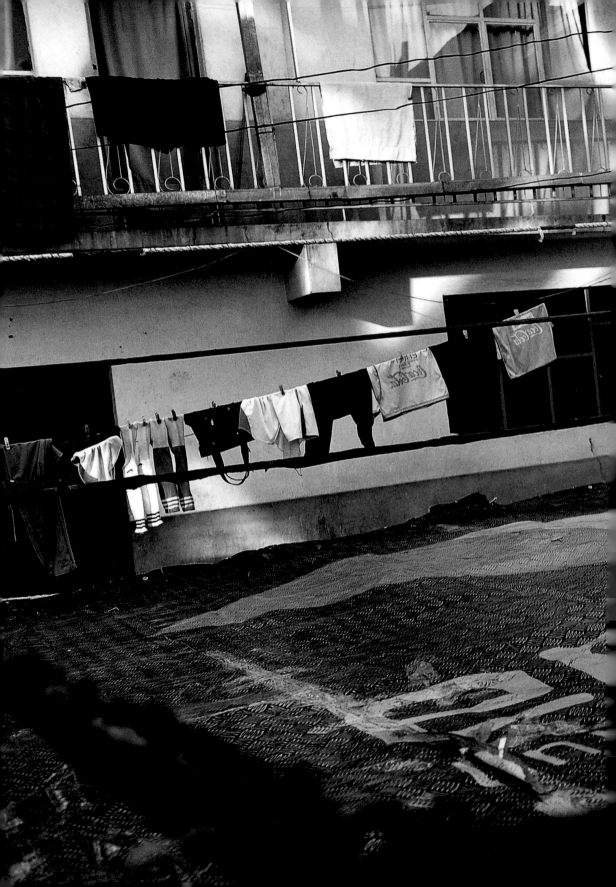

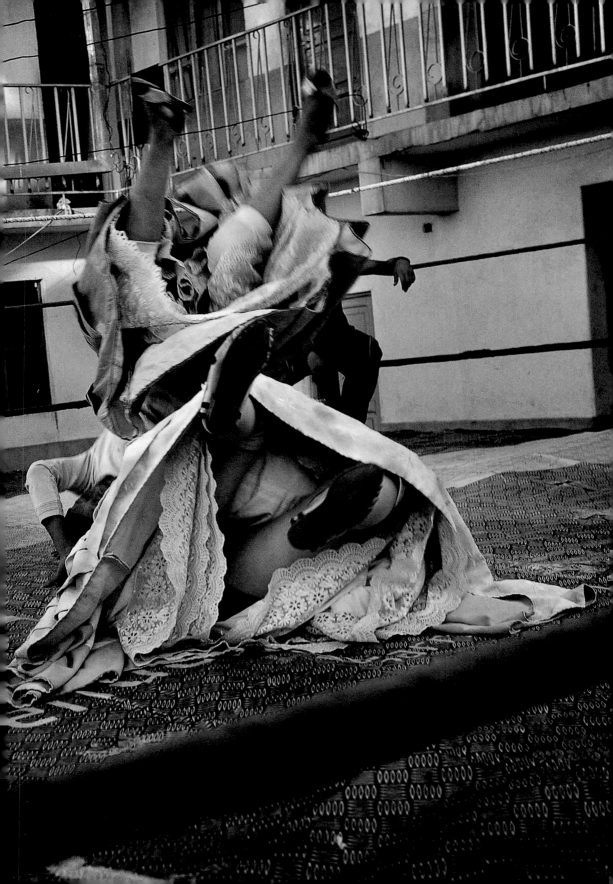

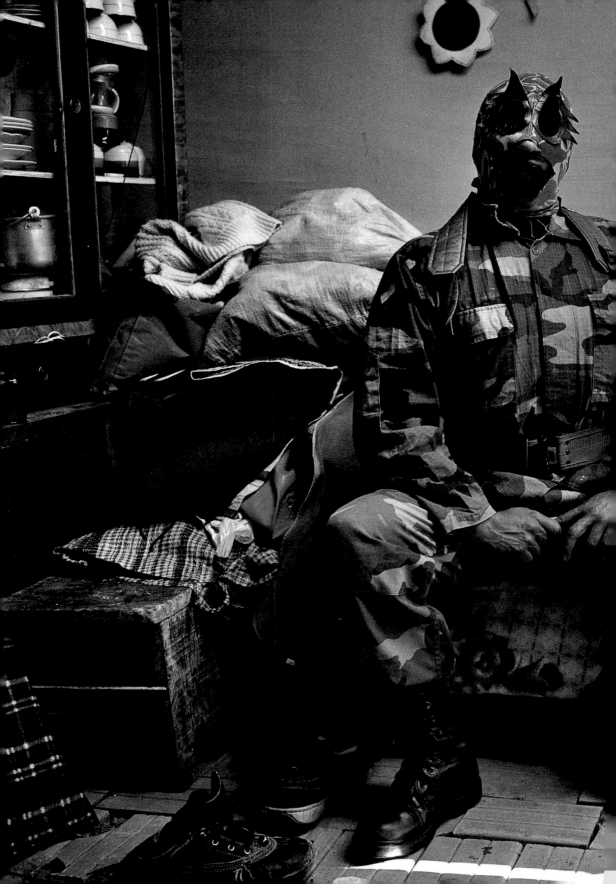

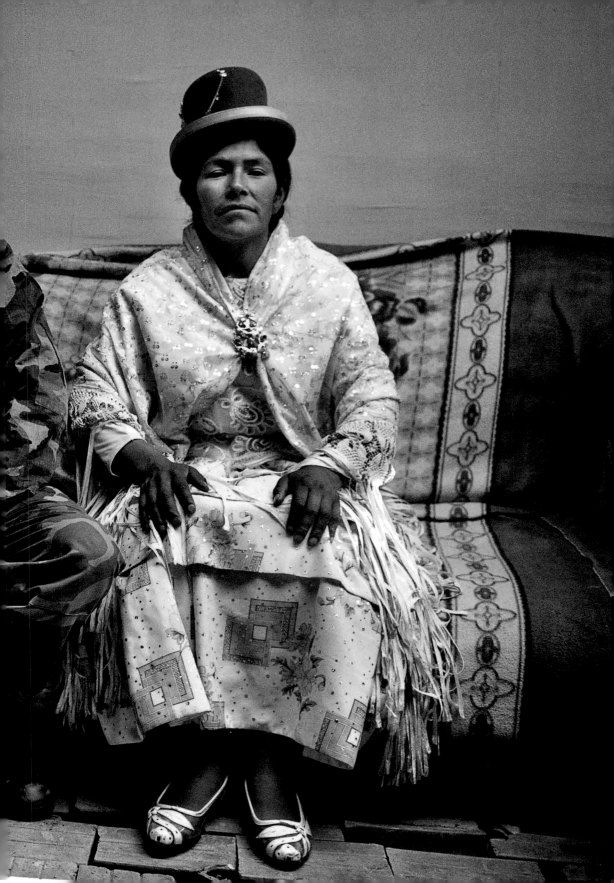

GENTLEMEN OF TRANSGRESSION

Brazzaville, Republic of the Congo

Gerardo Mosquera
*Critic and art historian, and former curator at the
New Museum of Contemporary Art in New York*

Gentlemen of Bacongo is a series of photographic portraits and scenes of *sapeurs*—the members of the SAPE (Societé des Ambianceurs et des Personnes Elégants [The Society of Ambiance-Makers and Elegant People])—taken in Bacongo, a poor district in Brazzaville, the Republic of the Congo's capital city. This society, which professes an almost religious devotion to fashion (and has its own rules of ethical behavior), has spread from there to the neighboring Democratic Republic of the Congo, and even on to the Congolese immigrant communities in Paris and Brussels. Originally founded as an all-male society, the SAPE has now expanded to include women as well.

The French idiom *sapeur* means "big spender," but its sense has evolved with the growing presence of the sapeurs and now refers to anyone who dresses with elegance—and it is used as a play on the acronym SAPE.

The sapeurs, dressed in clothes that confront accepted standards and that are sometimes tailored by leading international brands, rise in stark contrast to their social environment. The way they choose and combine their outfits looks picturesque, but it acts as a creative expression of local tastes, attitudes, and aesthetics that favors the use of bold colors cheerfully combined. Their style involves the theatrical posturing that befits the

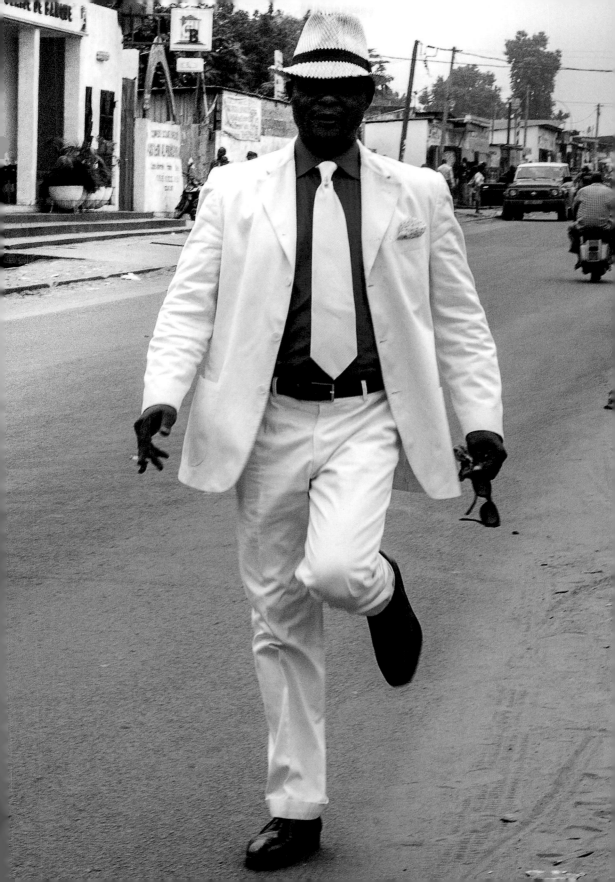

dandy and the studied poses of the fashion model. All this is beautifully conveyed by Tamagni, who was able to make the sapeurs feel comfortable enough to pose in spontaneous ways for his photographs. Tamagni's work also captures the contrast between the sapeurs' sartorial splendor and the setting in which they parade it, achieving a unique combination of heterogeneous fashion photography and social reportage. The images highlight the shifting, blending approach of contemporary photography, a blurring of the boundaries between genres. Tamagni shuns the superficial exotic appeal of the sapeurs—while not avoiding it—in order to focus on both the fascinating, vibrant cultural background in which these impoverished dandies flourish and their aesthetic expression.

The sapeurs' proclaimed elegance and their often expensive clothing do not strictly function as status symbols, however, because their fashion does not always correspond to their economic situation, despite the great efforts taken to spruce up in such a peculiar way. Elegant dress is more of a fictional status symbol, one that is represented and theatrically performed. The sapeurs' playful aesthetic does not relate, for example, to the kitschy, grandiose display of obscene wealth by drug traffickers in Latin America, Africa, and Eastern Europe, which also constitutes a menacing expression of power. It is more akin to the inclination toward luxury and conspicuous spending in disproportionately poor contexts in places such as Central and West Africa, where brand-new Mercedes cars are parked in the mud in front of shacks, in a sort of competition—"mine is larger than yours."

The cultural phenomenon of the sapeurs so neatly captured by Tamagni is clearly controversial. It may be dismissed as a feckless waste of money, as male exhibitionism, or as a surrendering to Western values and the dictates of the international luxury market. Such critical judgment is valid, but it is not expressed in Tamagni's approach to the sapeurs. However, Tamagni's view is neither superficial nor intended to caricature or parody. Rather it reflects a close relationship with the people that he photographs and their environment, and as a result his series conveys a complex understanding of their costumes and values. He is not a voyeur, but an artist who delves deep into the context in which he works.

Tamagni's art makes us see the sapeurs in a different, parallel light, in photographs that connote their "incorrect" appropriation and resignifying of Western fashion. Local subjects function here as agents of a creative response to international culture, arising from the values of their own context. The sapeurs consume fashion in an active way, performing an operation of "decoding and recoding," as sociologist Stuart Hall would say. At the same time, they champion individuality and subjectivity in the face of poverty: a symbolic way of proudly overcoming or escaping it. Cultural critic Néstor García Canclini has argued that consumption "may be a stage for the commercial shaping of habits and distinctions, but also a place that provokes thought." African dandyism reflects the importance of aesthetics as a basic human need, and of fashion as a space for transgression, in terms not only of its design but also of its varied and inventive uses. Tamagni's

Gentlemen of Bacongo series celebrates a free, jubilant experience of heterogeneity.

Western culture was imposed by colonialism in Africa and elsewhere as the operative global metaculture of the contemporary world. However, its objectives of conversion and domination also implied a more generalized access to international information. If Western culture's imposition sought to convert the Other, its availability facilitated the use of this very same metaculture for the Other's own, different ends, transforming the metaculture from within, as we can so eloquently appreciate throughout Tamagni's oeuvre. The sapeurs do not wear traditional costumes, as many other people in West Africa do; they dress in international fashion in a transgressive manner that constitutes a contemporary activation of subaltern "traditions" (mores, tastes, aesthetics, values) that de-Eurocentralizes Western canons.

This process of globalization-differentiation is a conflictive articulation of forces that implies intricacies, ambiguities, and contradictions on all sides. It cannot be taken passively as an inevitable inclination that occurs without pressure exercised by subaltern sectors, as sapeurs spontaneously do. The dynamics of culture are woven amidst shocks and dialogues resulting in phenomena of mixture, multiplicity, appropriation, and resemanticization. There is no viable return to precolonial traditions, since that would consist of going back to the myth of an uncontaminated past, with little margin of action in the postcolonial world. The goal would be to create contemporary culture from a plurality of experiences and agendas, as the sapeurs have done so flamboyantly. The current postcolonial structure makes this difficult, due to the distribution of power and to the limited possibilities of action possessed by vast sectors of the global population. However, cultural processes advance resolutely in that direction—perhaps in the form of wearing a provocative pink suit, as a gentleman of Bacongo does in one of Tamagni's powerful images.

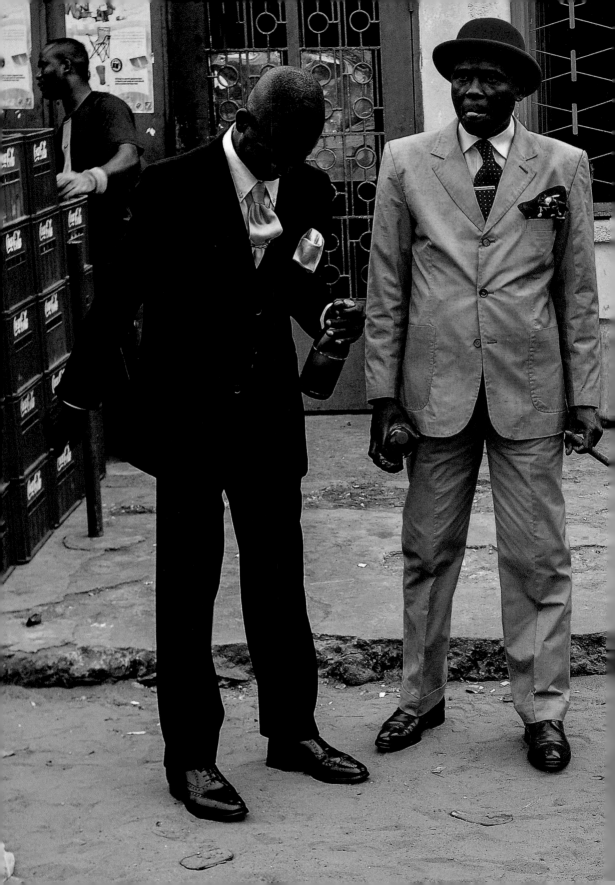

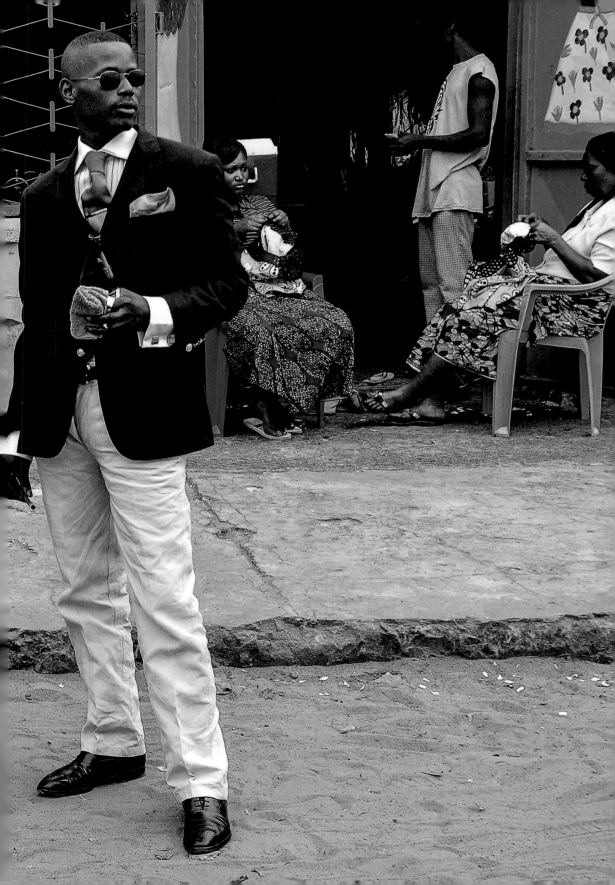

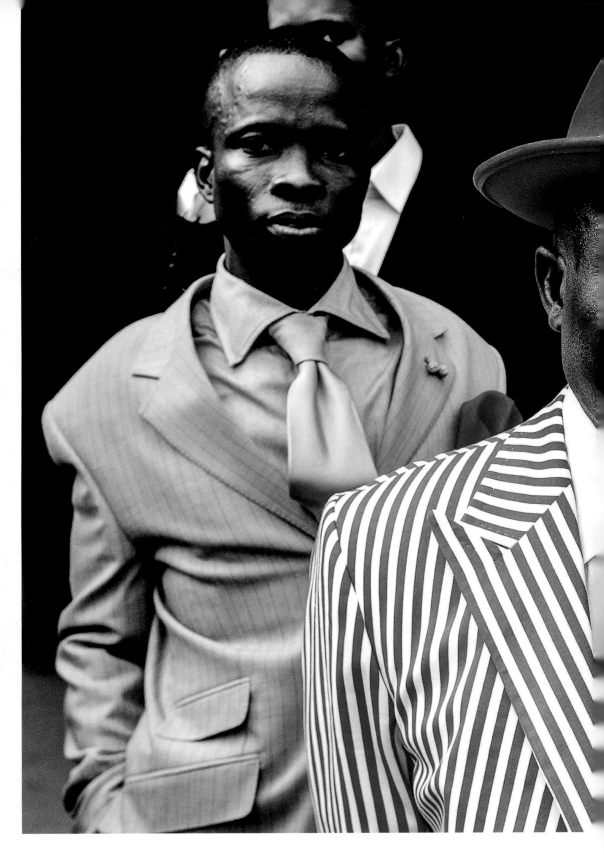

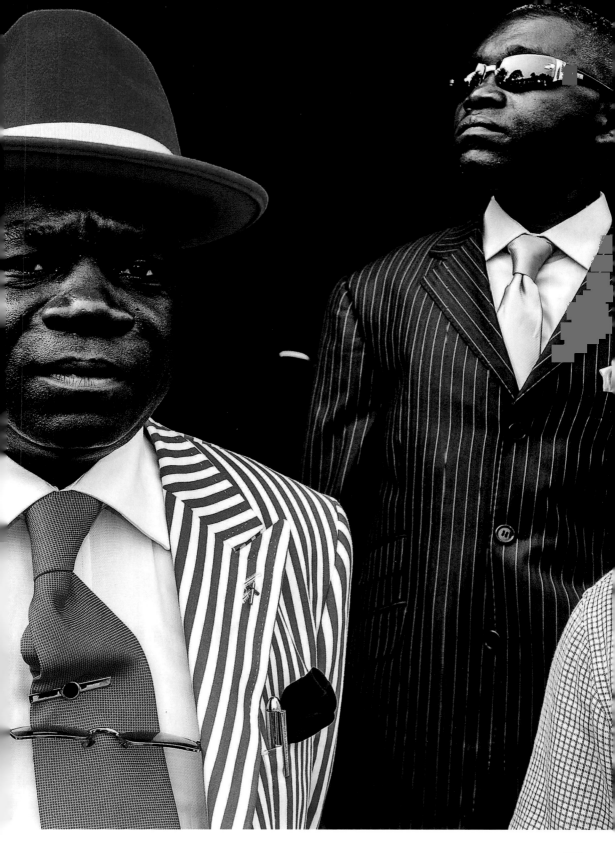

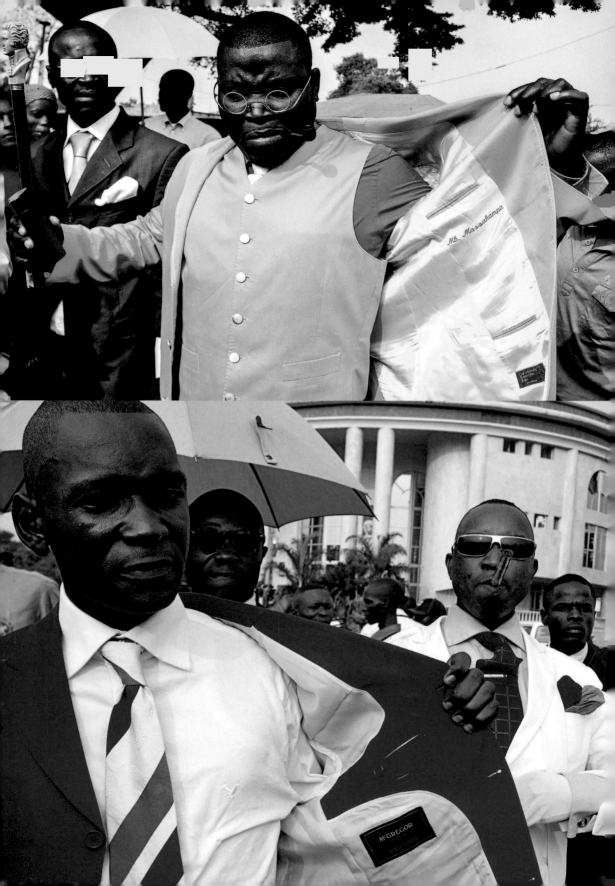

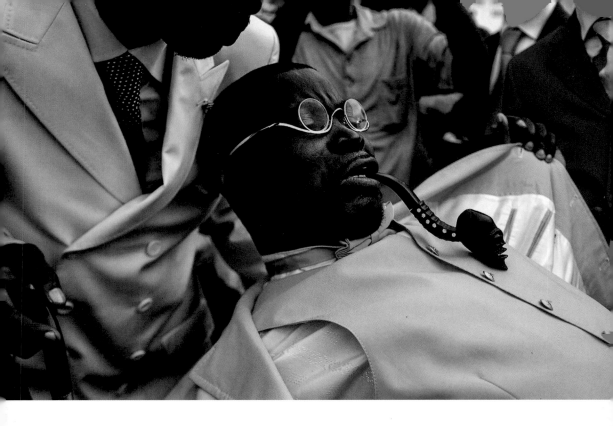

"La sape *is the art of making colors sing. But you also have to know how to marry them together, never more than three colors per suit.*"

L'Etoile de la Sape

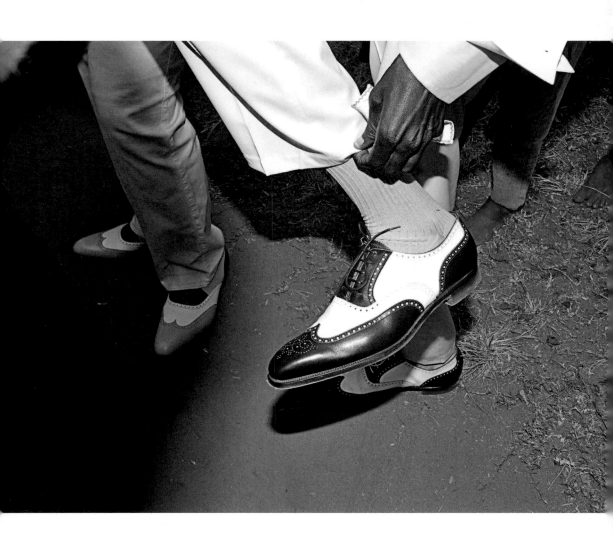

"Shoes are important and have to be real leather and always clean. J.M. Weston crocodiles are what I cherish most."

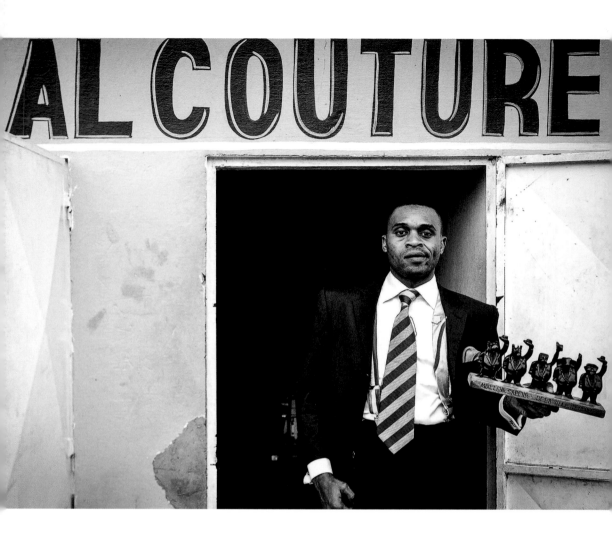

"*Every sapeur who attains the title has to have two basic things: a full suit and a unique repertoire of poses. Fashion is frenetic—it's always changing— but a real sapeur is immutable in his courtesy and refined mannerisms.*"

Hassan Salvador

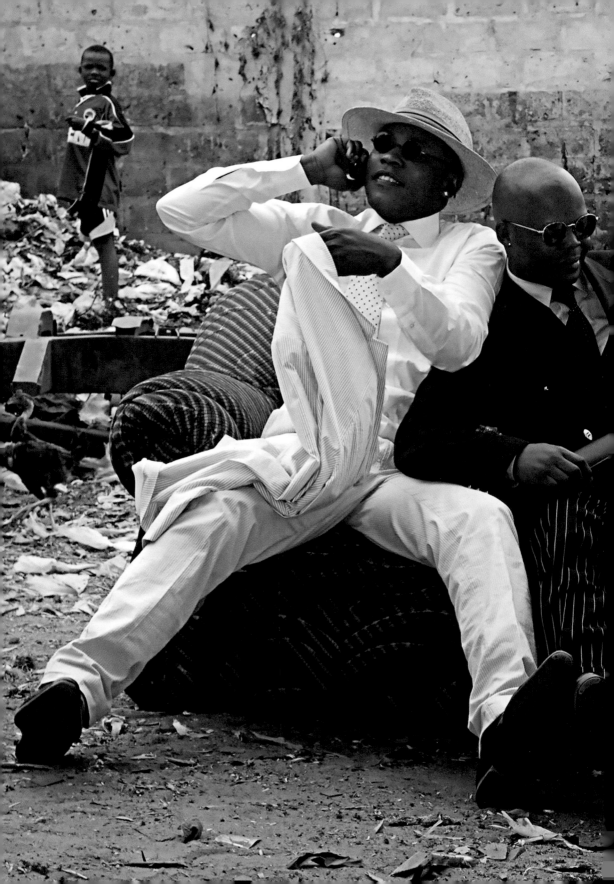

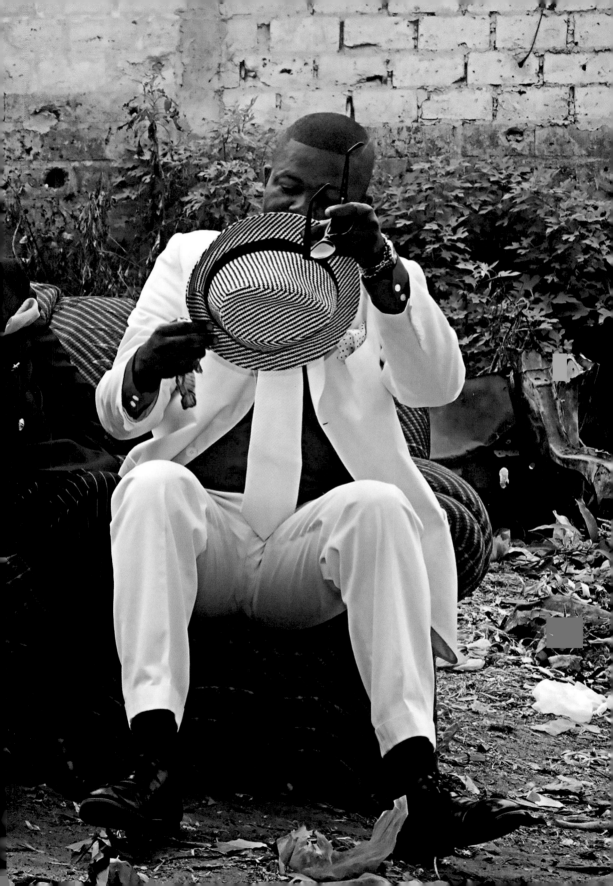

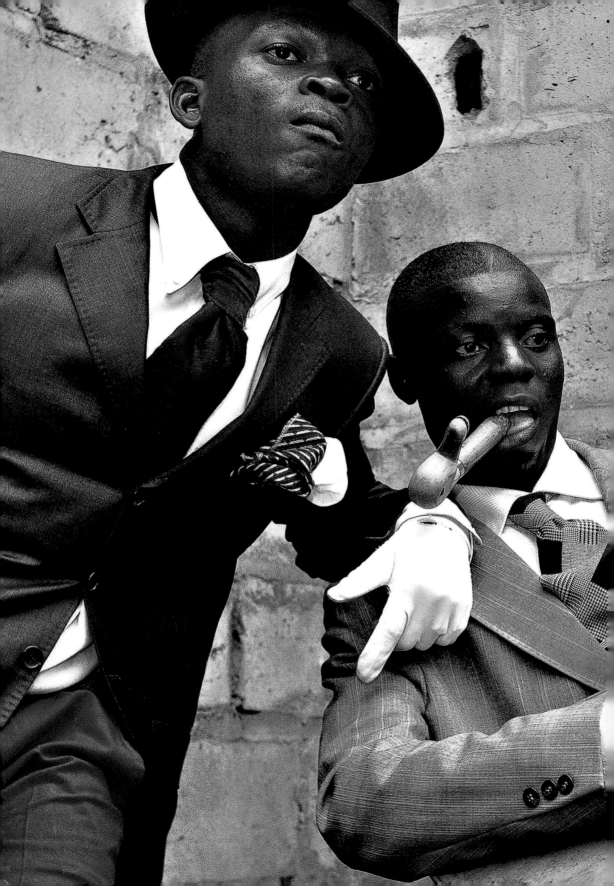

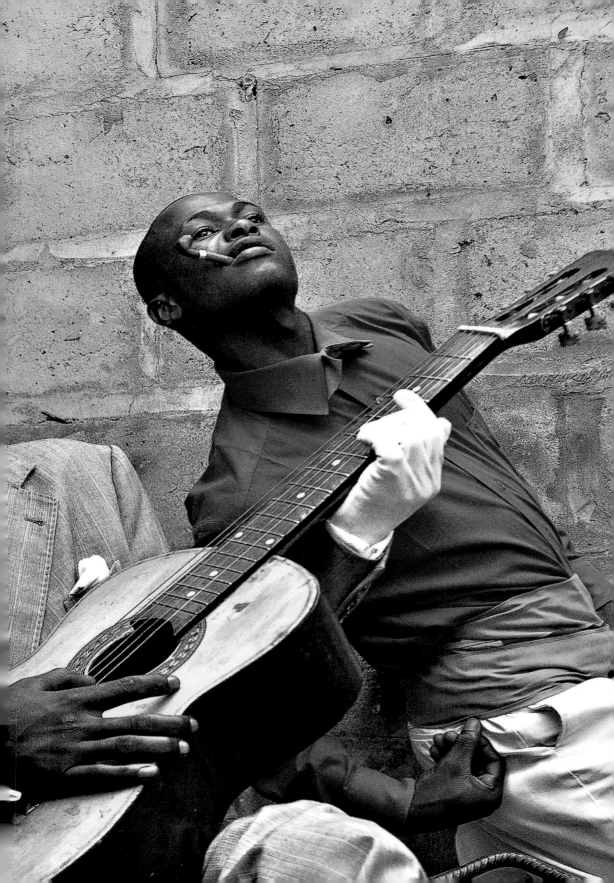

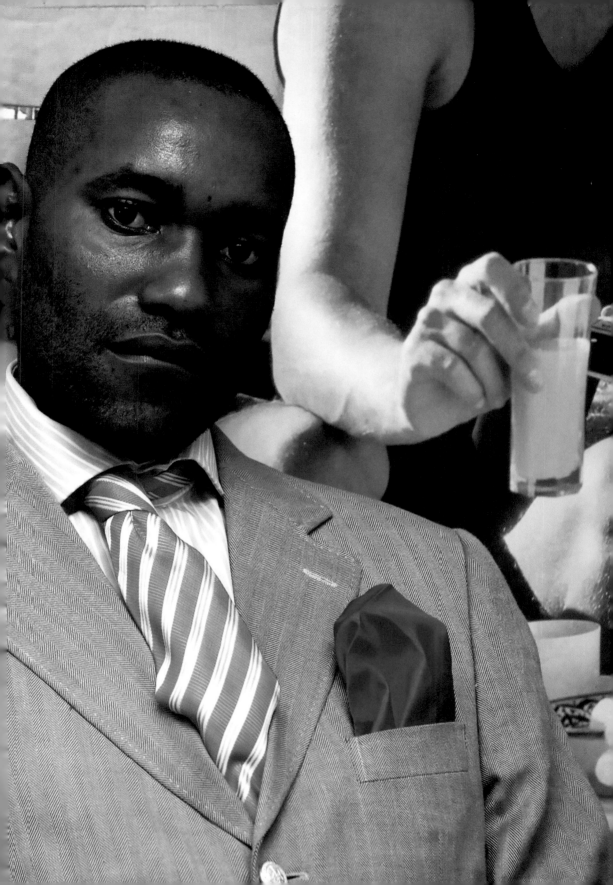

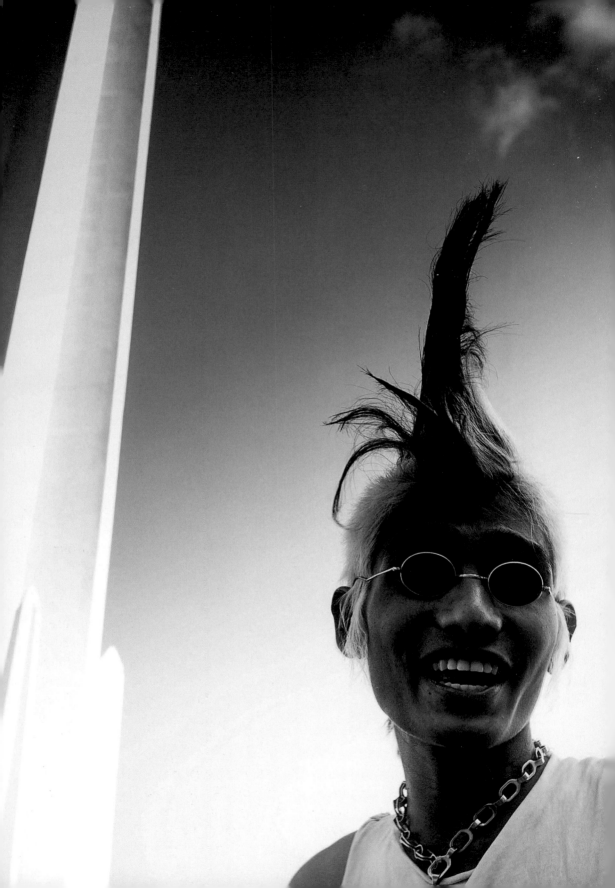

BURMA PUNKS

Rangoon, Myanmar

Peter Popham
Correspondent and feature writer with the Independent, *London*

For Daniele Tamagni, exploring and documenting the punk style of Burma constituted a new direction. In his pioneering work among the dandies and grandes dames of Cuba and Africa, he gave us the blindingly vivid local interpretations of high fashion and the look of the well-heeled man-about-town—the style of the white colonial ruling class, but exaggerated, stylized, and reinterpreted in the hallucinogenic colors and materials of the tropics.

In Burma the subject matter was completely different. Here were young, urban Burmese with no interest in aping or subverting the foreign dandy look, but inspired instead by the English punks of the mid-1970s—whose style was an antistyle, just as their music was antimusic. Deliberate ugliness, excess without elegance, slashed holes, rampant safety pins, clothes that were too big or too small, bought secondhand in rummage sales—everything about the original punks said, *Do your eyes a favor, look the other way*. The punk movement was a huge middle finger to the world.

This was the style the punks of Rangoon and other Burmese cities embraced. As in the UK, there was a political context: fifty years of repressive military rule, accompanied by economic austerity, per-

vasive surveillance, and official paranoia, all overlying a pious Buddhist culture bent out of shape by nearly a century of colonialism punctuated by war.

Punk began to emerge in Burma around the time of the Saffron Revolution of 2007, when huge processions of barefoot monks pounded city streets all over the country in defiance of military rule. It was a watershed moment for the democracy movement, and despite the vicious way it was brought to an end, it lent courage to dissenters of every sort, the punks among them. Nonetheless, they risked persecution until late 2011, when President Thein Sein began releasing political prisoners and retiring the machinery of surveillance and control that had sustained military rule for half a century.

This draft reform gained momentum after the release of Aung San Suu Kyi, the democracy leader, and the election of Sein, a former general but one with a relatively enlightened worldview. Slowly Burma began to rejoin the world. Censorship was relaxed. Hundreds of thousands of spies were laid off. Foreign companies and organizations were admitted. And amidst all this, the punks arose. But given the hugely different social and political contexts, it is no surprise that Burmese punk was radically different from the English original.

Take Satt Mhu Shein, Tamagni's favorite subject, who has adopted the name Einstein MC King Skunk. He boasts the typically punk mohawk haircut but has dyed it blond as it approaches his scalp. At the time of being photographed he also had blond, vaguely Hasidic ringlets hanging down in front of his ears. His lips and ears are studded with the usual punk stigmata, and his leather jacket bristles like a porcupine. But John Lennon—decades pre-punk—was the inspiration for his granny-like sunglasses, and he rides an old sit-up-and-beg bicycle painted in psychedelic tones. The clincher is the gorgeous pink flower that spills out of a brass vase fixed to the handlebars. In the West, punks and hippies were like cowboys and Indians. But in the person of Einstein, the punk and hippie styles have married and settled down.

As for me, my first glimpse of Burmese punks was in March 2013, in central Rangoon, when I saw four or five of them ambling down a main road. It was like a hallucination. I was accustomed to Burma's traditional human zoo, the monks in maroon robes and the nuns in pink, the women and the older men in *longyi* (sarongs), the younger ones in jeans. But as in most other Asian countries, one sees little in the way of visual eccentricity, and the default attitude of youth is respect and conformity. In that context, the impact of the punk look was explosive.

Today, Burma's punks no longer have to skulk. And they can let their originality rip, especially as the traditional Burmese life also has something bacchanalian that easily resonates with punk provocation and exhibitionism. During the annual Thingyan water festival, the whole country goes crazy for the best part of a week and everybody douses everybody else with water.

There is a covered market in downtown Rangoon known in colonial days as Scott Market and now as Bogyoke (pronounced "bo-joke" and meaning "general," after General Aung San) Market, which is unlike any other in the country,

a magnet for local artists and craftsmen as well as tourists and money changers. It is located just across the road from Rangoon's only ladyboy colony. Every year, one day before the general water-pelting of Thingyan gets under way, ladyboys, foreign punks, and other marginal types stage their own raucous, sopping-wet event in the market.

As Einstein explains to me, it was a water festival event that introduced him to the world of punk. I was warned that he would be a tough nut to crack for an interview, but this did not prove to be the case: He has gentle manners and a blinding smile and was delighted to talk. Near the end of 2014 I met him at a rooftop beer hall in Rangoon's Mingalar Market, where two of the bands he has appeared in, Chaos in Burma and Hooligan Army, were to play onstage along with a dozen others, including Rebel Rant, Unknown Criminals, and State of Ash. During a pause in the music we slipped away to a smelly but quiet corner of the roof, and in rough but fluent English he told me how he became what he is today.

"I was born in Rangoon in 1993. My father is an ex-seaman and my mother works in a supermarket. My brother is an engineer with a government job," he says. He did well in school: "I got high marks in math, chemistry, physics, and biology, and after that I attended the University of Medicine here in Rangoon."

At Bogyoke Market, the punks had fascinated him. "I wanted to know who they were, why they dressed and behaved like this, everything. I could speak English enough, and the foreigners there gave me books about punk, and I read all the books and I changed my life." And

after two years—outraged, he says, by the arrogant behavior of wealthy medical students—that's what he did. And Satt Mhu Shein mutated into Einstein MC King Skunk. "At middle school, all my friends called me Einstein, because I was smart. MC stands for 'Medical College,' 'King' because I was the king of medical school." Einstein has little of the angry nihilism of the stereotypical Western punk. He still lives with his parents, and survives by teaching schoolchildren at an informal crammer in his aunt's home.

The time of general persecution of Burmese punks has passed, but Burma remains a highly conservative society, and Einstein's look is guaranteed to have an effect. In one of Tamagni's photographs, his blond mohawk forms a visual counterpoint to the golden pagoda of Shwedagon, Burma's most famous and revered Buddhist monument. During the shoot, the police pounced. "They arrested me for having the picture taken there. But Buddha didn't say anything about hair, so why arrest me?"

Quite unlike the seedy, drink- and drug-addled punks of the West, Einstein is clean living. "I know the effects of drugs because I studied them at medical school," he says. "I don't take drugs, and I tell other punks not to take them. I drink a little beer at parties. In my songs I attack the rich people. I also sing spontaneous lyrics of my own. One of my songs is half in Burmese and half in English—it's called 'Fuck Off.'"

Yet Einstein, one feels, wouldn't say "fuck off" to a goose. Burma's gentle punk has reinvented the genre.

"I love my punk style. It defines my identity as an anarchist and as being against the rules that are imposed by society. No one should be judged for the jacket they're wearing. I might have problems if I enter a pagoda, but I don't think Buddha will be interested in my clothes. You should be judged for who you are, not for your appearance."

Satt Mhu Shein, aka **Sid** or **Einstein Mc King Skunk,**
lead singer of C.I.B. (Chaos in Burma)

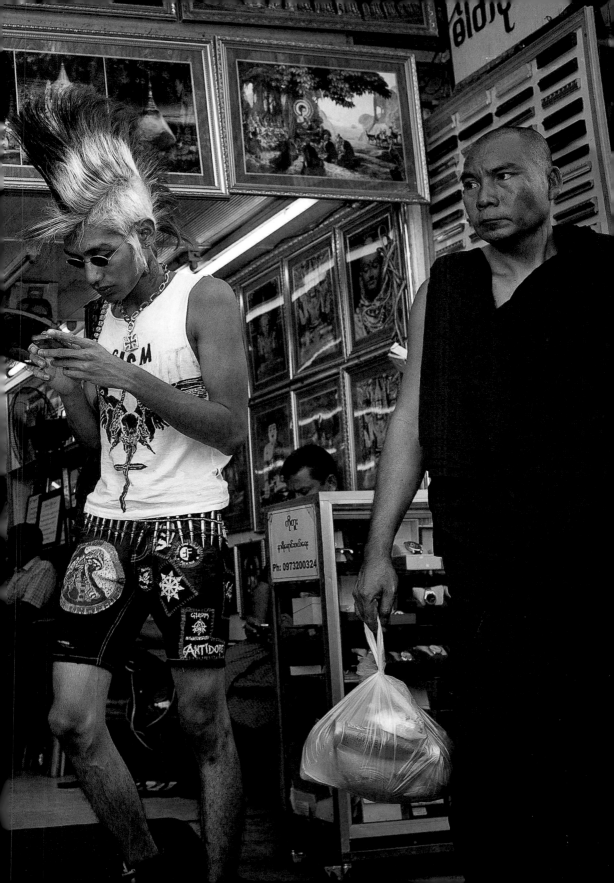

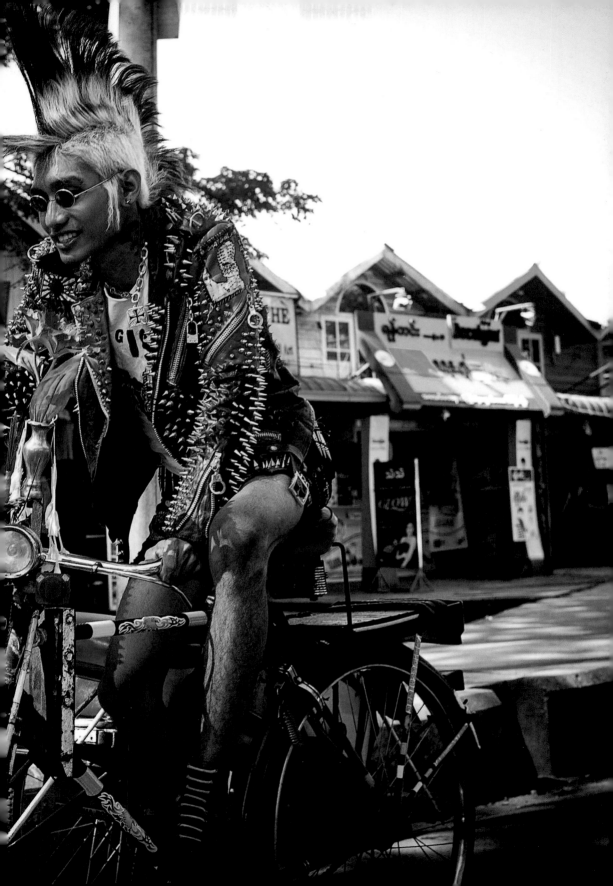

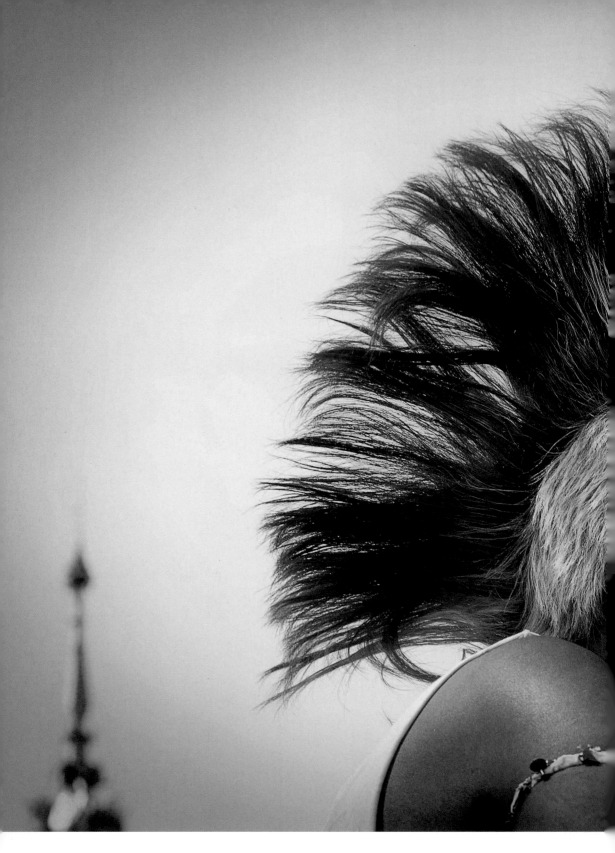

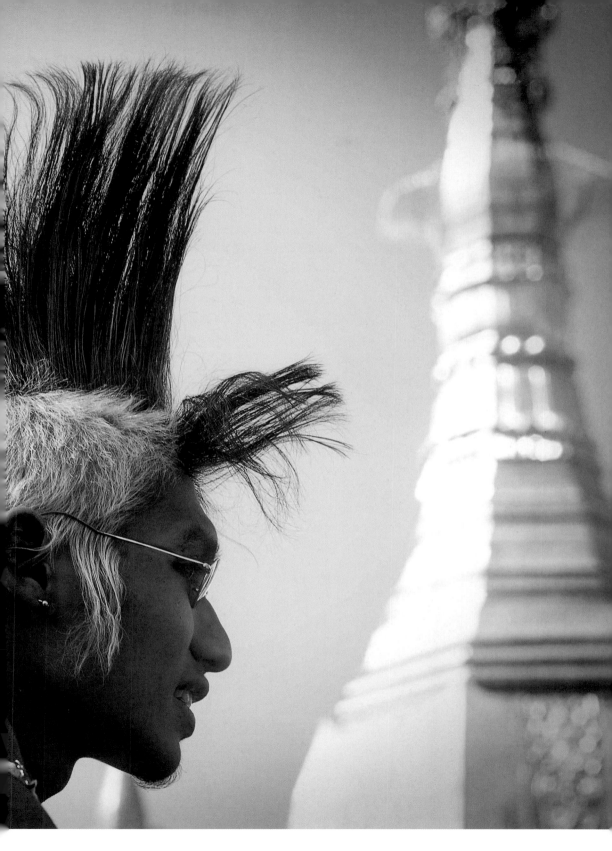

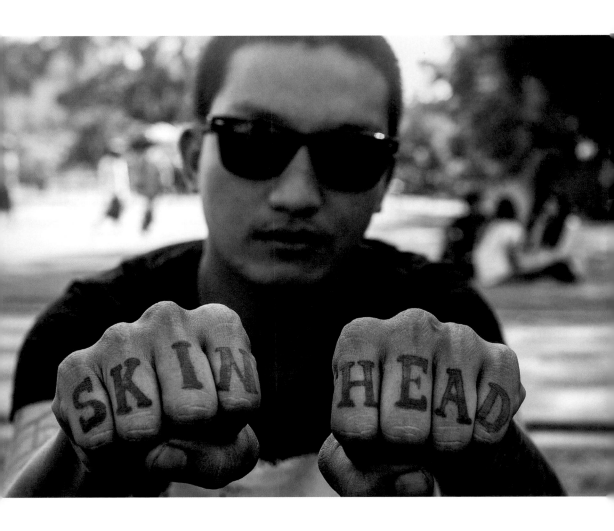

"My style is skin; I feel that I am a skinhead against fascism and racism. I call my style 'skin fashion.'"

Kawminhem Gugu,
leader of Hooligan Army, a group that produces hardcore street punk music

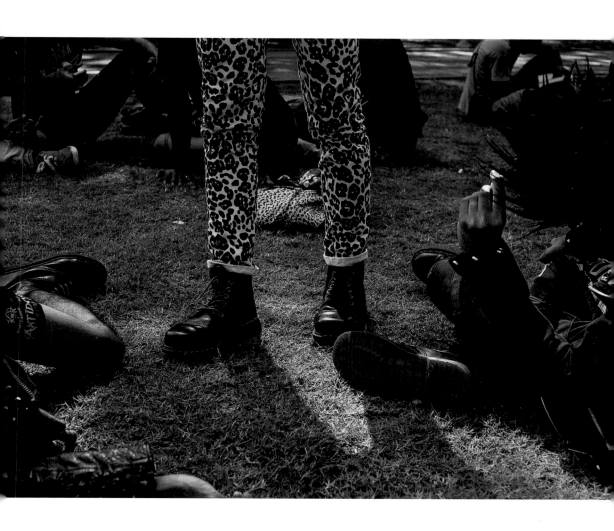

"*Our look? We draw inspiration from the big punk bands, like our pants imitating the Sex Pistols' style, for example. But we only do mohawks sometimes. The weather isn't ideal for the hairstyle's stability.*"

Kolyae

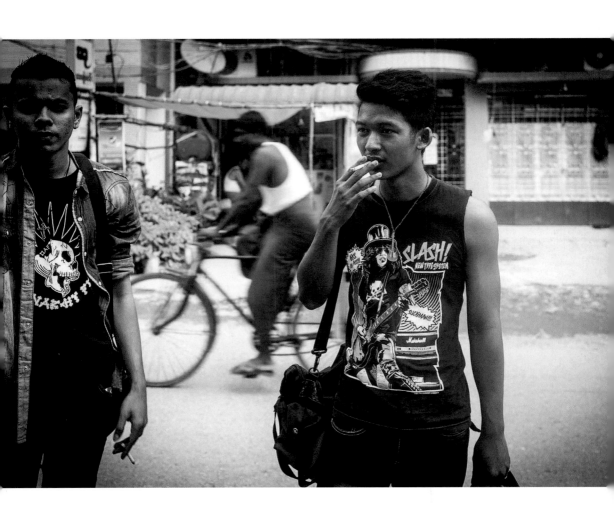

Members of the group Our Anarchy Focus

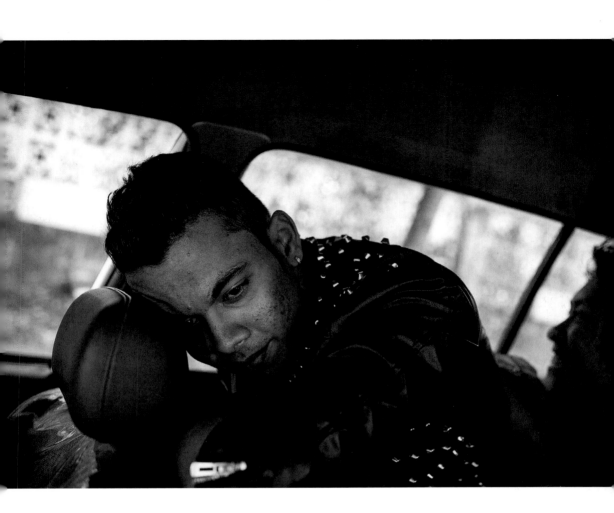

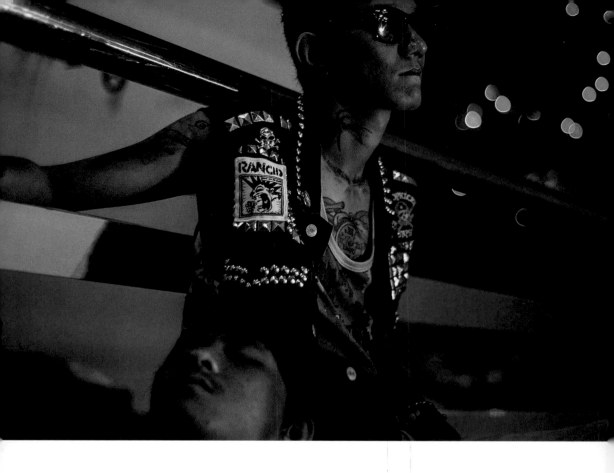

"My mother didn't used to like this style, this music, but now she shares my anti-establishment ideas. To win her over, I got a degree in technology, so she left me alone. I like to feel that I am rebelling against the system, and style, understood as a way of dressing, is also important for emphasizing our identity, which attempts to avoid rules or impositions."

Dennis

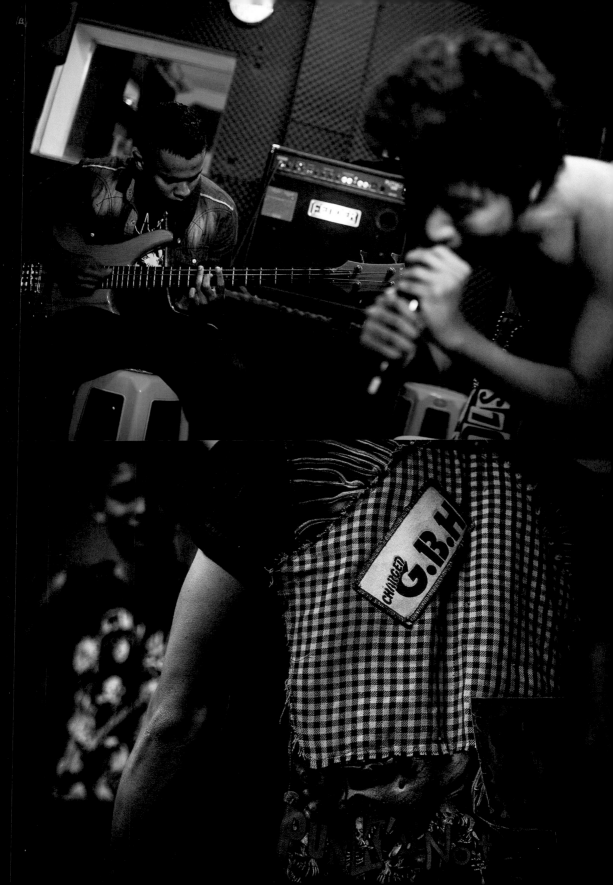

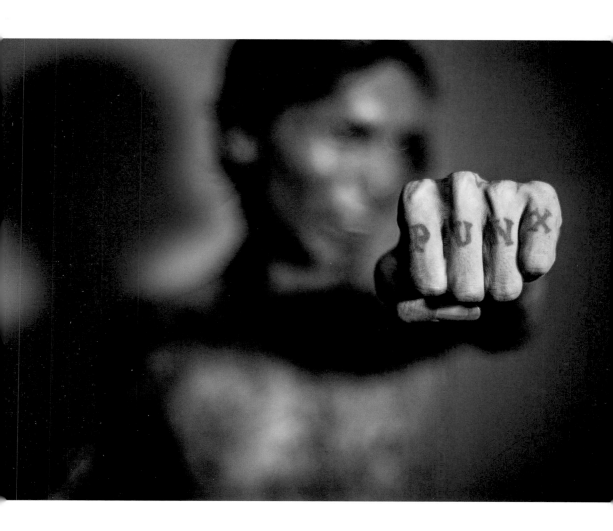

*"I'm punk in life and in music.
Punk is my life philosophy."*

Skum, leader of KulturSchock

"I was in the clutches of drugs until I was thirty years old. I felt rejected by society. But I'm free now. I think about the value of life. I don't want to waste my time anymore. I want to change as much as possible."

Skum, leader of KulturSchock

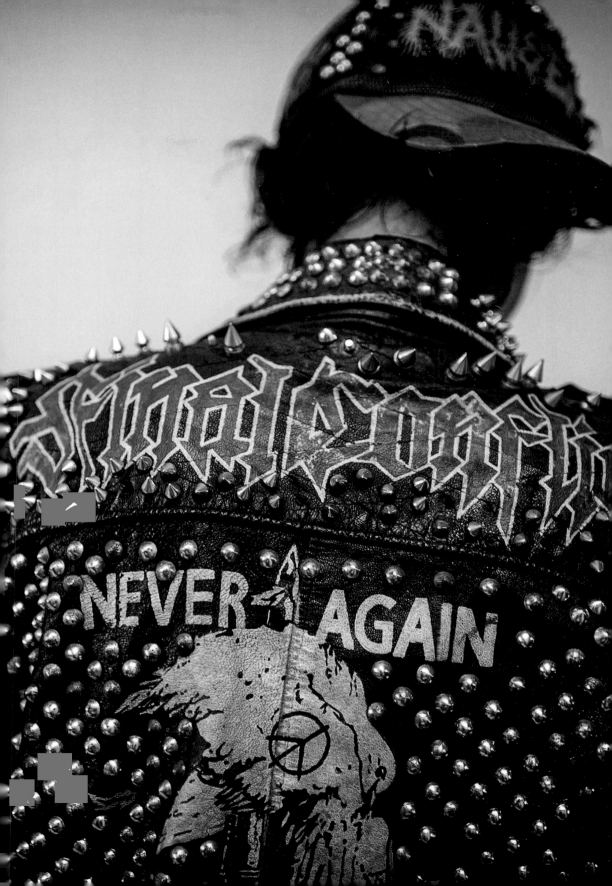

AFROMETALS

Gaborone, Botswana

Katie Breen
Independent journalist, editorial consultant

Rock on, Botswana! Not everyone on the planet knows about Botswana. Some know that it borders South Africa. Those over thirty might have read the adventures of Precious Ramotswe, owner of "The No. 1 Ladies' Detective Agency." Others might have seen *The Gods Must Be Crazy*, the story of a Bushman who gets hit by a Coca-Cola bottle in the middle of the Kalahari Desert. But few people will know about the growing fame of its heavy metal bands. Just two years ago, if you had searched "metal + Botswana" on Google, you wouldn't have read about music. You would have learned that there is a wealth of copper, zinc, and gold in this country, which also ranks third among the world's diamond producers. Botswana is a rich country, but things have changed: Its inhabitants, somewhat surprisingly, now get a kick out of the rebellious sounds of heavy metal.

The story of Botswana heavy metal goes back a long way. Once upon a time, an Italian psychiatrist named Giuseppe Sbrana decided to settle his family in Botswana, where he started what is now the largest psychiatric hospital in Africa. One generation later, in the savanna village where they lived, his two sons, Ivo and Renato, started their own project. It was the 1970s, and they formed a rock

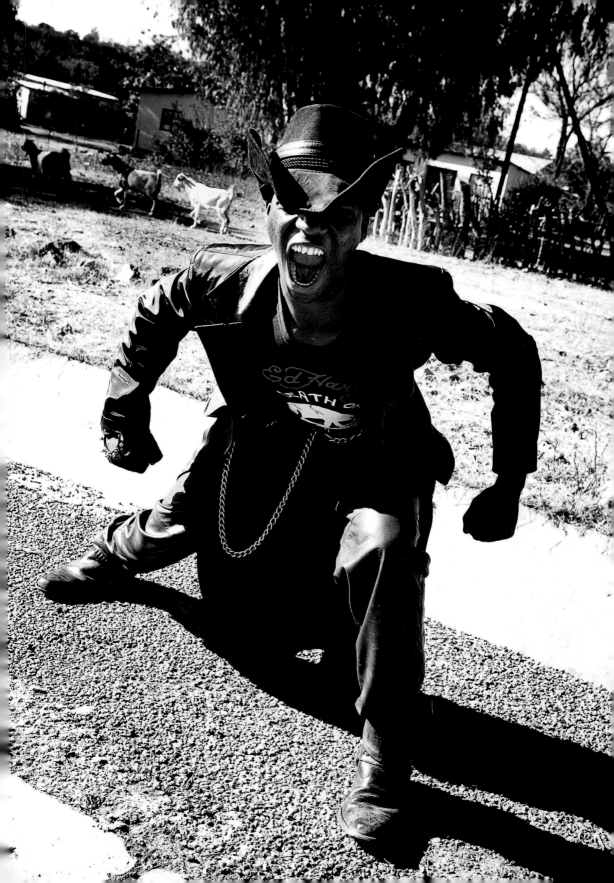

group called Nosey Road, the first—and most famous—rock band in Botswana. In 2006, third-generation Sbranas went from rock music to heavy metal, African style. They created Skinflint, which means "knacker" (a slang word for a slaughter-house employee). The name also includes the word *flint*, the stone that people used to light fires. Twenty-five-year-old Giuseppe, Ivo's son, is the lead guitarist and vocalist of the group, which is currently the most popular of the African metal bands. Twenty-two-year-old Sandra, who also goes by the name Hurricane Sandy, is Renato's daughter, Giuseppe's cousin, and Skinflint's drummer. Kebonye Nkoloso plays the bass.

When you think of heavy metal, Skinflint isn't the first group that would come to mind. Metallica, Black Sabbath, and Megadeth—these bands and their members are more familiar to Western metalheads. Plus, Skinflint, a diverse group that includes a white man, a mixed-race woman, and a black man, doesn't look like what you'd see on stage at a heavy metal concert. But as Giuseppe says, "The metal nation knows no racial boundaries. We're all one. We all speak one common language, and it's called heavy metal." For Giuseppe, knowing no boundaries also means mixing African traditions with Western-inspired metal. African mythology and folklore loom large in Skinflint lyrics. "We have always used African culture and environment to hone our style," says Giuseppe. "This, I believe, gives our music a unique tribal atmosphere, while still maintaining an old-school-metal sound. It sounds raw and feral, like a wild beast from the Kalahari Desert." Giuseppe adds that he was raised in a small Botswana village, where he could hear the howls of jackals and hyenas at night and "feel the ancestral spirits taking possession of the souls."

Skinflint is not an anomaly in Botswana. There are a number of other metal groups in the country: Remuda, Dust n Fire, Disciplinary, Simple Sex, Stane, Vitrified. What is interesting is the growing subculture of metal enthusiasts that these groups have created in this quiet and remote country. Metal fans here have managed to create a unique style with a strong African flair. One such metal fan is Morima Ludo, a young woman who studies business management and goes by the name Dignified Queen. "At first, it was all about music, but now music and style come together. Now we dress in a very intense way. We, the girls, have an African style, a grace in our attitude, we have pride and dignity. That's why my nickname is Dignified Queen," she says. "I love rock attire because it has a unique identity, which differentiates me from the rest." So when she walks in town with her boyfriend, Trooper, people take notice. On Saturday afternoons you can see them and other metalheads strolling the streets of Gaborone (Botswana's capital city), Maun, Francistown, Lobatse, or Kanye, a village in the countryside. With their incredible style, they look like stars, and they behave like stars. Some of them are very popular around town—the children follow them and try to imitate them.

How could one define their style? If you were a biologist, you might say that it is the result of the merging of two cells: the biker's cell and the cowboy's. "Here in Botswana," explains Sandra, "we have a very cowboy look, but we're dressed in

leather from head to toe. We never wear jean jackets or pants. Leather is very important." But isn't it way too hot to wear black leather in Botswana, where the temperature is higher than 100 degrees Fahrenheit for several months a year? "Yes, but they don't seem to mind," Sandra says. What about herself? Does she wear black leather during shows? "Never, it's too uncomfortable. I move a lot on stage." For some, leather is reserved for evenings, when the temperature goes down. But leather is also very versatile, and it's easy to personalize: You can nail studs or install some objects on it.

Among these metalheads' fashion accessories you will see belts, large black hats, bracelets, chains, and crosses. The men always include a symbol that represents Africa, such as horns or other animal relics, and hunting knives. Hell Rider, an electronic engineer from Gaborone, describes his style as "very showy." "I wear studded leather jackets," he says, "metal-studded bracelets reminiscent of medieval knights, and I can add some local flavor with the skull of a baboon." Botswana metalheads might also be caught drinking out of the hollowed-out horns of cows.

Like metalheads in other parts of the world, they wear T-shirts emblazoned with logos or images of their favorite bands. The most popular in Gaborone are T-shirts of Iron Maiden, the iconic British group from the seventies. Movies are a great source of style for them as well. Rockphex, a butcher who lives in Lobatse, is inspired by Sergio Leone's westerns. "Botswana," he says, "with its boundless landscapes, lends itself to ride with the herd, and this feels very much like being in an American western." Rockphex has a very country-like cowboy style, and he loves to show it off—he poses as a model and walks around with a cheeky attitude.

Dignified Queen's boyfriend, Trooper (Gaobothale Gabatwaelwe), is thirty. He is a physically imposing and statuesque guy who likes to display his amazing look. He draws inspiration from Michael Jackson and Iron Maiden, but also from action films such as *The Delta Force*, *Hard Ride to Hell*, and *Terminator* for his military style. He identifies with soldiers: "We walk in a particular way," he says, "and, between ourselves, we say good-bye in a very physical manner, as if we were a group of soldiers."

The aggressive music the Botswana metalheads cherish and their rather theatrical style tend to mold their personalities. The clothes they wear, the way they walk, and the way they shake hands are expressions of their strength and energy. When they attend local shows, they meet up in groups before the concert and make entrances that are quite spectacular, carrying sticks and chains, making a lot of noise.

Most of them adopt new names, such as Bone Machine, Demon, Deadmonsta, Morgue Boss, Coffinfeeder, Venerated Villain, Hell Rider. Given these names, it would be easy to dismiss these rockers as thugs. But they're not as transgressive as their names would suggest; they're not the Hell's Angels. Most of them work and have families. Among the musicians, Sandra is an architect and Kebonye teaches chemistry. And as for the fans, many are employed in government, and some are soldiers, engineers, technicians, butchers, and cowboys from villages.

It's obviously more difficult for women to fit in that world. "People in the streets are surprised to see women involved in heavy metal," says Dignified Queen, but most reactions turn out to be positive. "Men treat us differently than they would any ordinary woman. Some of them tell us they really like our style, while others are intimidated by our look. In any case, they take us seriously; we are never made to feel inferior."

The most difficult reactions to deal with are those of their families. Gee Rock, a twenty-nine-year-old hairdresser, had many problems at first. "I could understand the family. When they see people dress like we do, they wonder what we're up to, they ask questions about our strange rituals. . . . It's not easy for them to understand why we women in particular would like to be part of these very male, awe-inspiring groups. However, they have now started to accept my choices." One can understand that families might be worried when they see the name Cannibal Corpse on a T-shirt or when they listen to Skinflint's latest album, *Dipoko*, which explores "spiritual wickedness" and includes references to "juju occultism," such as some frightening practices of ritual killing.

When Kyle (Kellen Shirley M Gaoskelwe) joined groups of metal fans and started dressing in black leather, her parents were afraid. For them, black clothes meant mourning, and they believed that metalheads belonged to the "dark world." In fact, Kyle does not like death metal very much. "Death is too noisy," she says. "I'm a Christian, and I feel it's too antireligious." She also says there aren't that many female fans. They mostly get involved to support their men and to help their female friends form bands. According to Kyle, some of the guys teach them how to play guitar and drums.

Still, female musicians remain a rarity in African metal. Sandra, Skinflint's drummer, is quite unique in these groups. She is considered a great musician, but being part of the Sbrana family, she probably had a better chance of making it as a musician—she has been playing with her cousin Giuseppe since they were teenagers. "Rock metal, a male thing?" she asks. "This is a stereotype to be broken. If you're passionate about something, you have to follow your passion, girl or boy." In any case, when you ask around about female musicians in African metal, only one group is mentioned: Sasamaso, a female-fronted thrash metal band from Antananarivo, in Madagascar.

By all accounts, metal rockers are well thought of in Botswana, in spite of their unusual appearance. They have a reputation of being open and kind people. As a soldier named Ono Joe says, "I like the energy of metal, but I'm not aggressive. I'm a peaceful guy. My external appearance does not reflect it, but I like to challenge the stereotypes of appearance." Some of the metal fans are involved in charitable activities as well. Or as Kyle says, "People are beginning to appreciate us because we are strong, we are disciplined. We do charitable things, we also give advice and guidance to each other. As a result, our rock community is growing every day."

Like other groups, Skinflint has engaged in community activities, in particular by holding several concerts to help

fight the AIDS epidemic in Botswana. "Sadly," says lead singer Giuseppe, "AIDS still remains a major problem in Botswana, and its effects have been devastating to our society. We will continue to do whatever we can to address the issue at our shows, as we feel that heavy metal is a perfect medium to get the message across. This is true because metal music is a form of expression that is not afraid to look death in the eye, and this can help get across the sheer brutality of this disease."

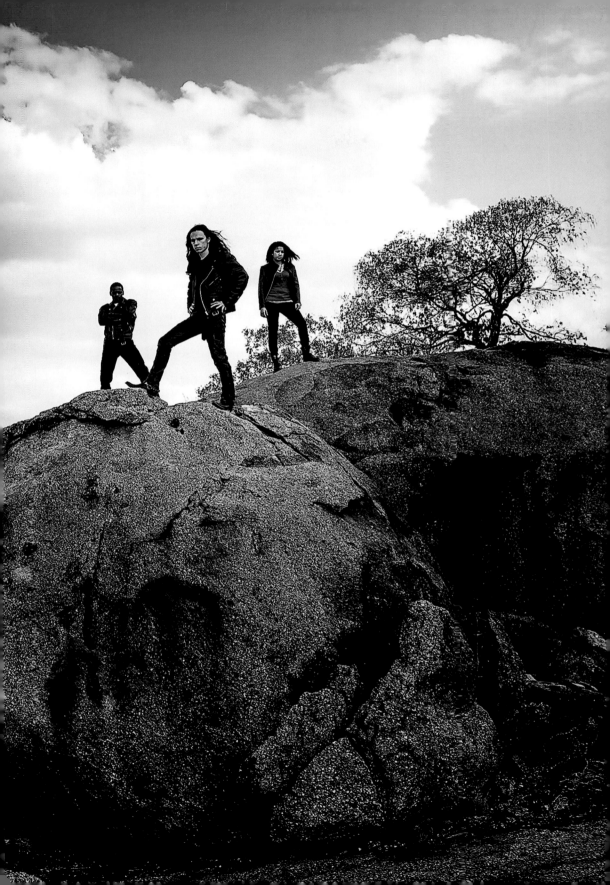

In Botswana, metal music landed in the nineties, but rock came in the seventies by way of two Italian brothers, Ivo and Renato Sbrana, born and raised in the heart of Africa. Their band, Nosey Road, introduced to Gaborone the breakneck speed and revolutionaries of a musical genre unknown at this latitude. Twenty years later, two descendants of the Sbrana family, twenty-five-year-old Giuseppe (vocals and guitar) and twenty-two-year-old Sandra (drummer), have created, along with bassist Kebonye Nkoloso, twenty-seven years old, the band Skinflint.

Giuseppe Sbrana, vocalist and guitarist of Skinflint

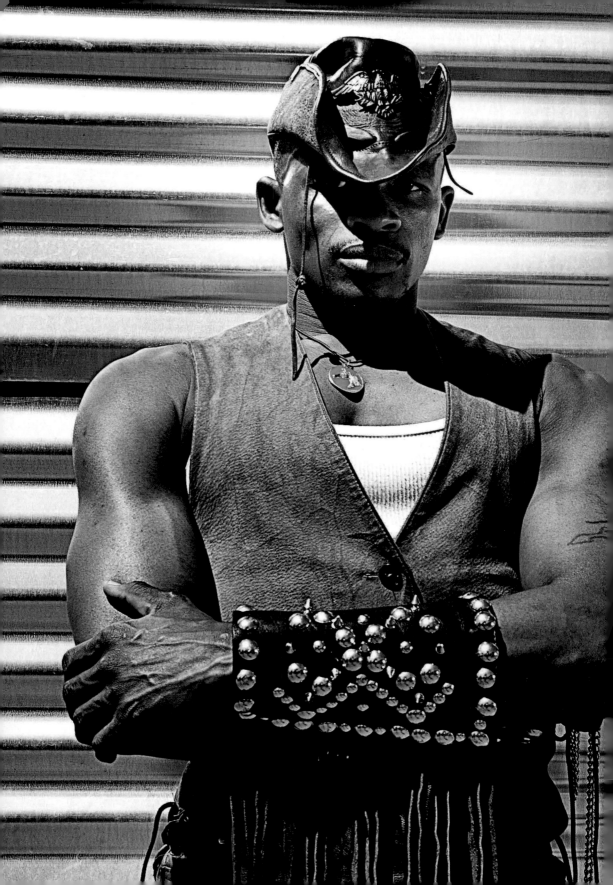

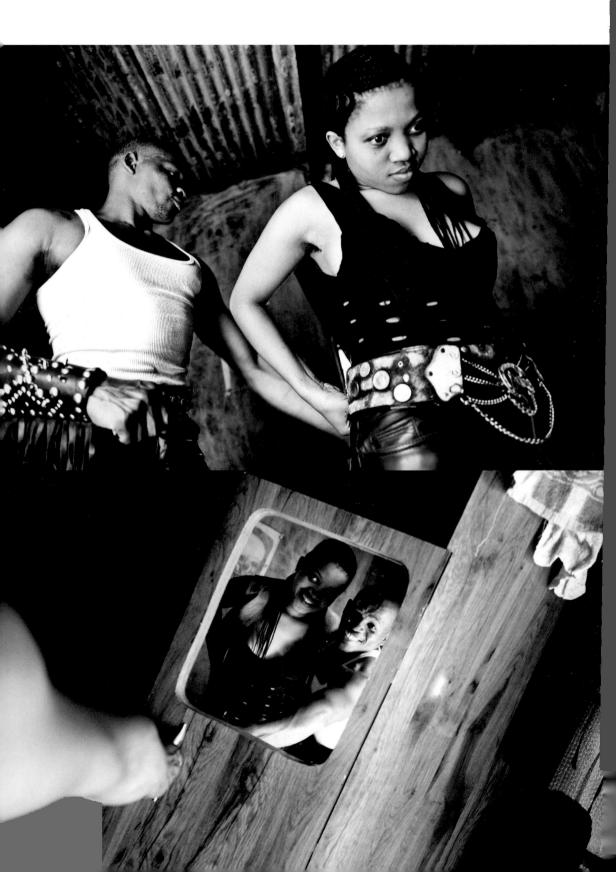

"*I have been inspired by Sergio Leone's spaghetti western films. Botswana's landscape is very wild; there are a lot of cattle. I used to ride horses dressed up in cowboy style, and now I mix it with heavy metal accessories because I like this music. It is a lifestyle.*"

Rockphex, a thirty-five-year-old butcher, lives in Lobatse

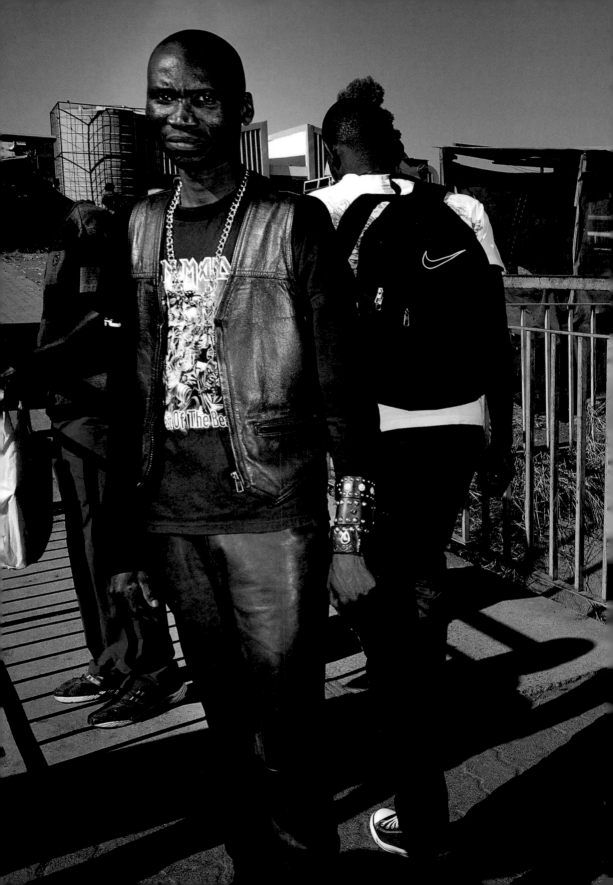

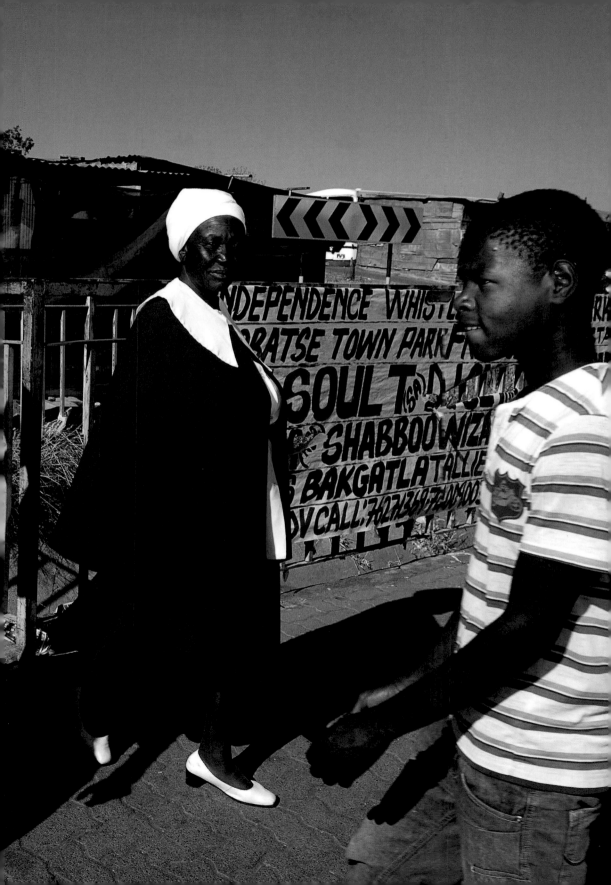

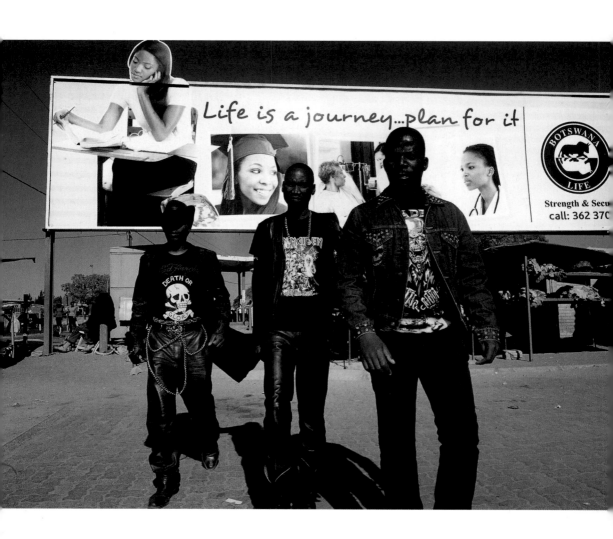

The billboard reads: "Life is a journey...plan for it" — BOTSWANA LIFE — Strength & Secu... call: 362 37C

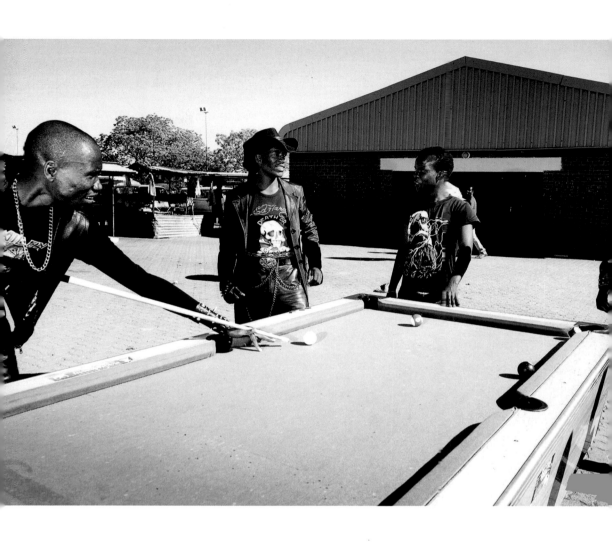

A contagious passion for rock music was imported from neighboring South Africa and soon swept the frequencies of local radio stations. The sound of the first electric guitars began to spread in the early nineties. Every Saturday evening, Radio Botswana aired a program devoted to the fast rhythms of heavy metal, and in 1993, the first local band, the Metal Orizon, appeared.

Katie;
Gunsmoke and **Trooper** (following spread)

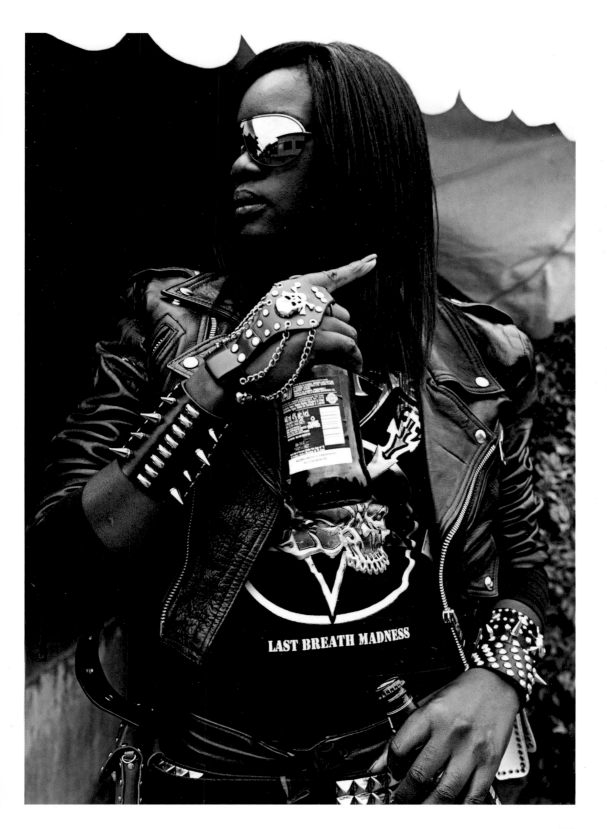

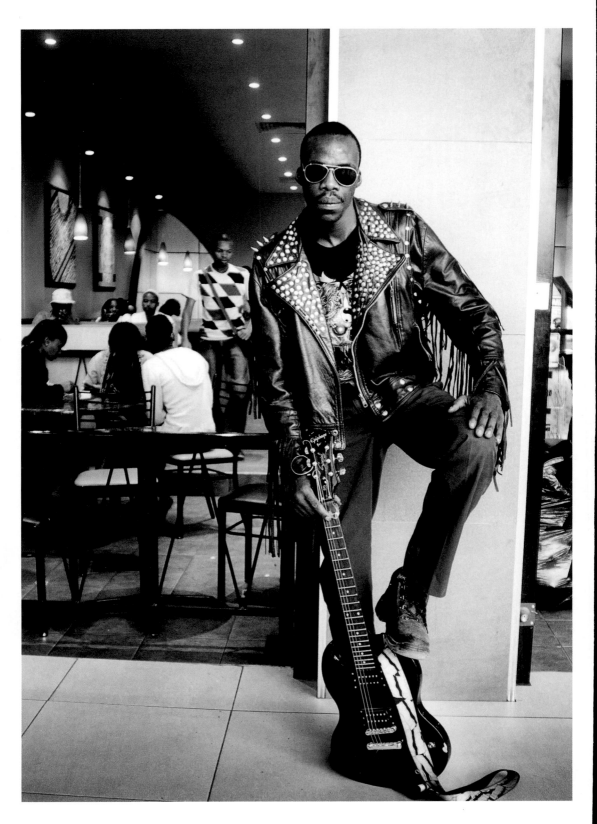

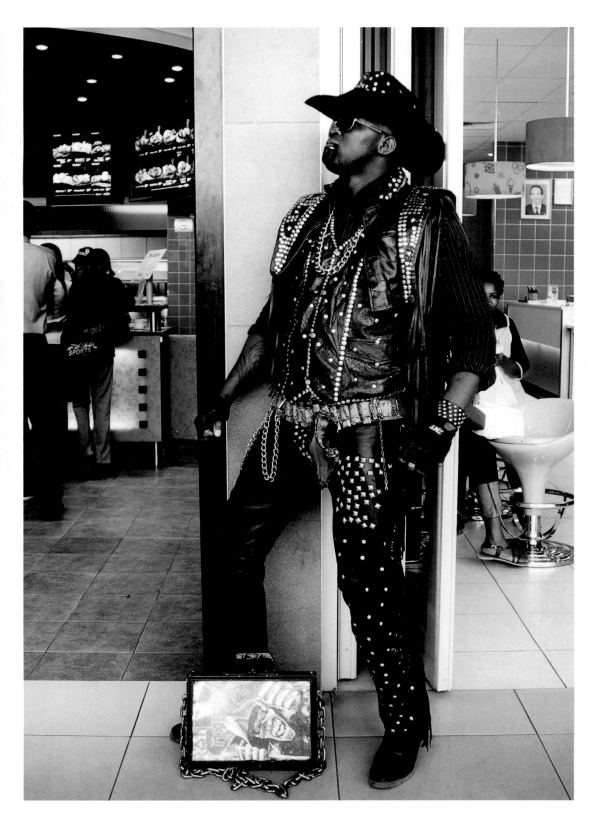

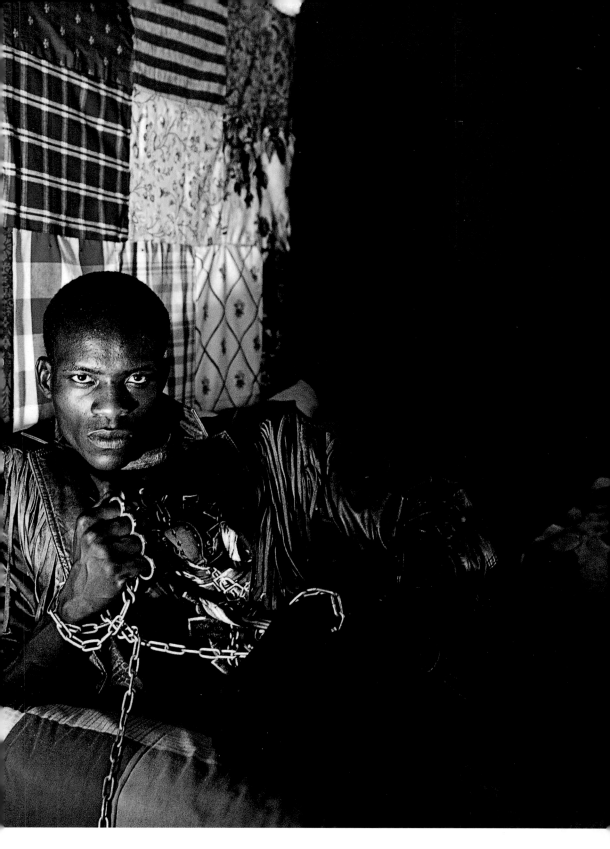

"People do not understand that, in being part of this movement, we are being true to ourselves. We live as we choose and it feels good, that's all. My passions are motorcycles and horses. Around the age of sixteen, I started watching spaghetti westerns and listening to rock music and this led to attending events and adopting the distinctive 'lifestyle.'"

Kellen Shirley M Gaoskelwe, aka **Kyle**

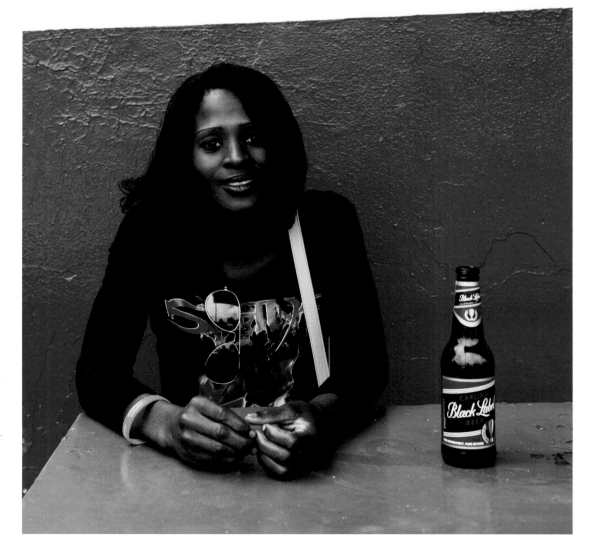

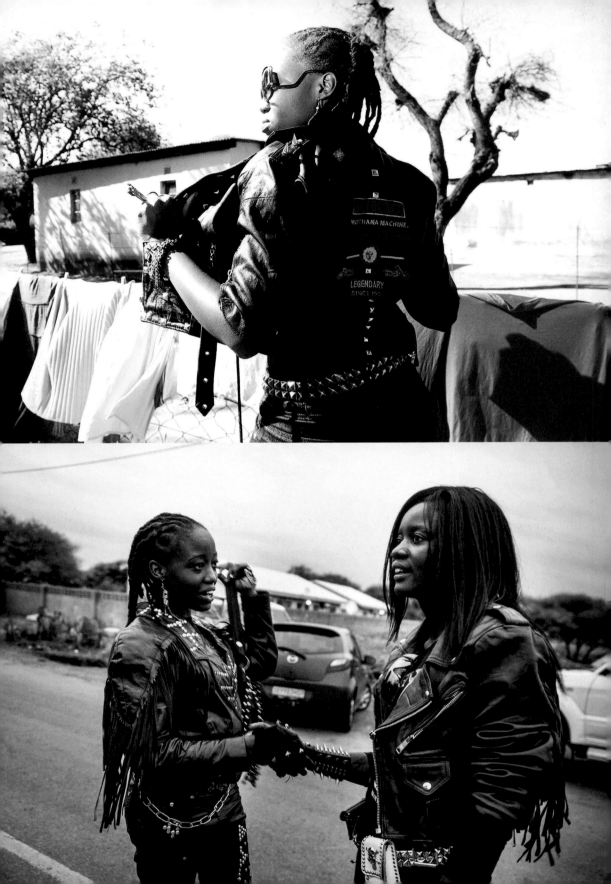

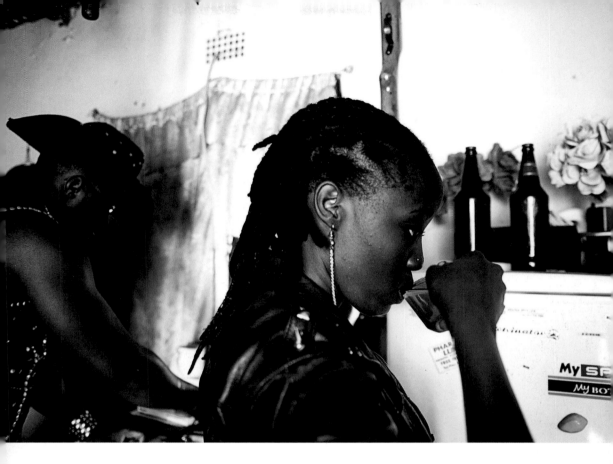

"*I am a very private person, rather shy and not at all aggressive. There are no rivalries among women. We are all united,*" *says Dignified Queen, a name reflecting her dignity and pride. She claims that the "girls" personalize their clothing with a touch of Africa.*

Morima Ludo, aka **"Dignified Queen,"**
a twenty-five-year-old student in business management

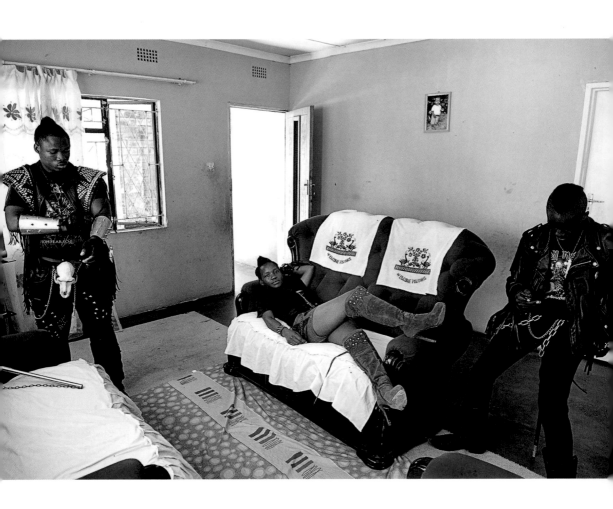

"I am a hairdresser, but in the past I worked as a croupier in a casino, and also at a discotheque, where there was house music. But I have always had a passion for rock. My cousin, his friends, and I feel like a 'family' when we go to concerts. Kyle, another girl, always updates us on Facebook. At first it was difficult for our family to understand us; when people see us dressed like this, they wonder what we are doing, and question our strange rituals. Also, because we are women, it isn't easy to be understood, respected, but I don't care about the judgment of others. In any case, now my family also accepts me."

Edith, aka **Gee Rock**

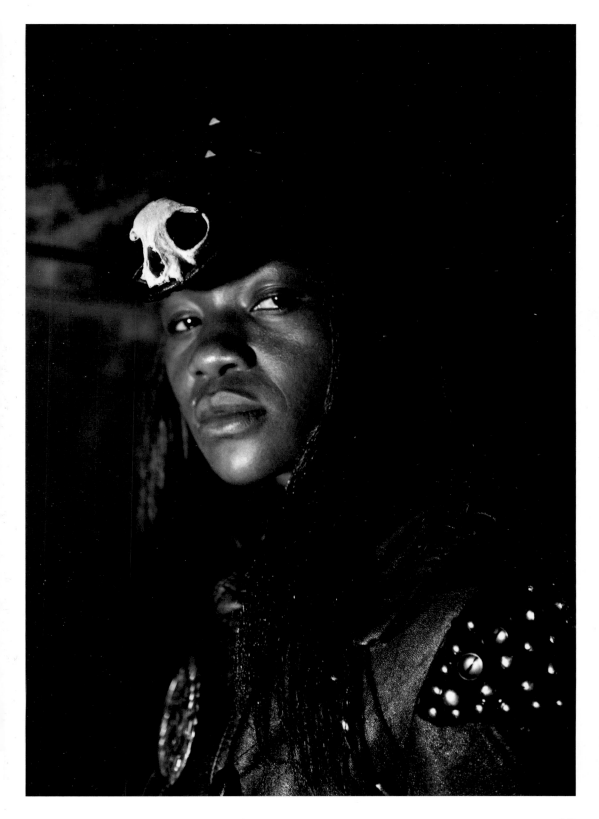

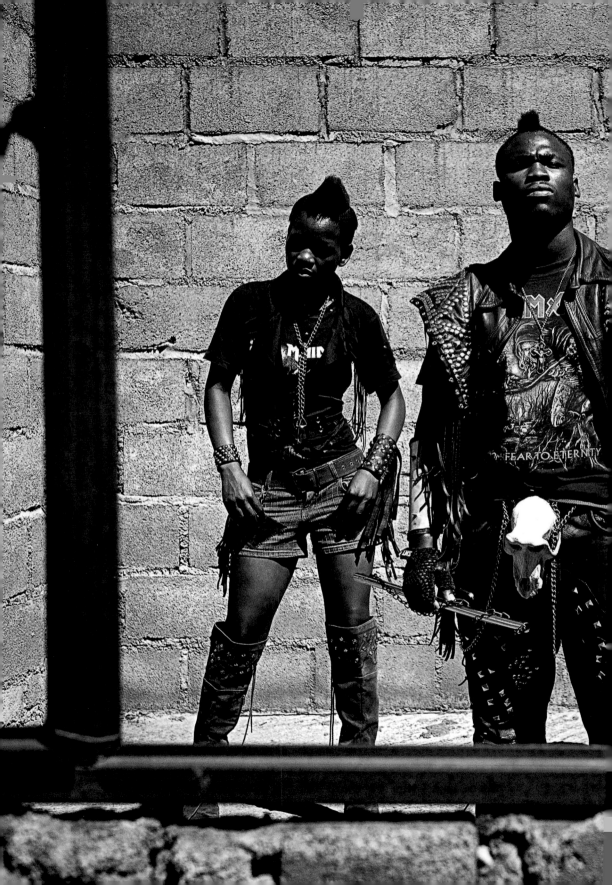

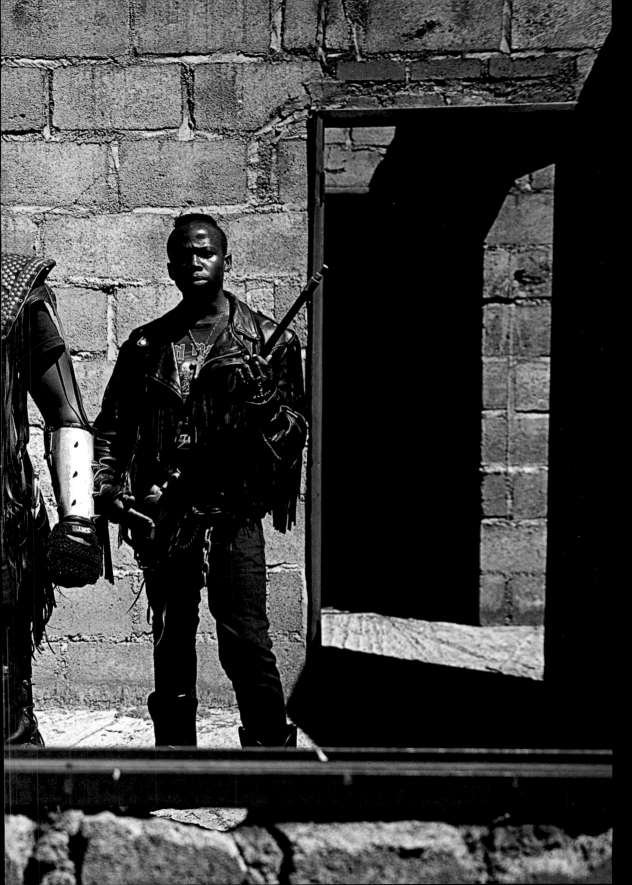

"I love my style, it means a lot; I feel an inner power. When I die I will go in the coffin dressed like this, because it explains who I am."

Afro metal fan

Where do they go to find their distinctive metalhead clothes? The most popular stores are Mr. Rock Moshopa, Cut Price, Options, and Top Line. They cannot, however, find everything they want locally and often have to search abroad. This means the clothes can be expensive. A pair of shoes might cost 1,000 pula (102 US dollars), a jacket likewise, while pants can go for up to 1,200 (123 US dollars).

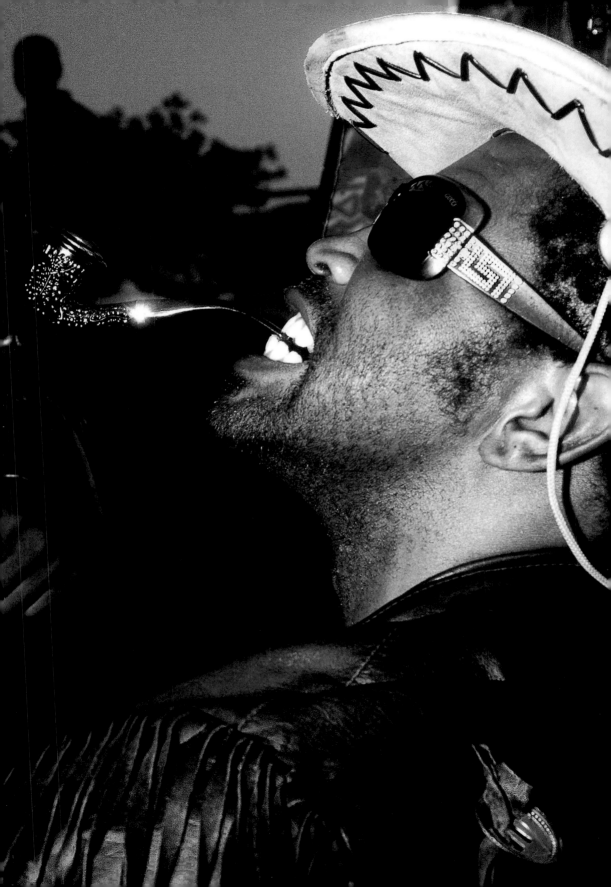

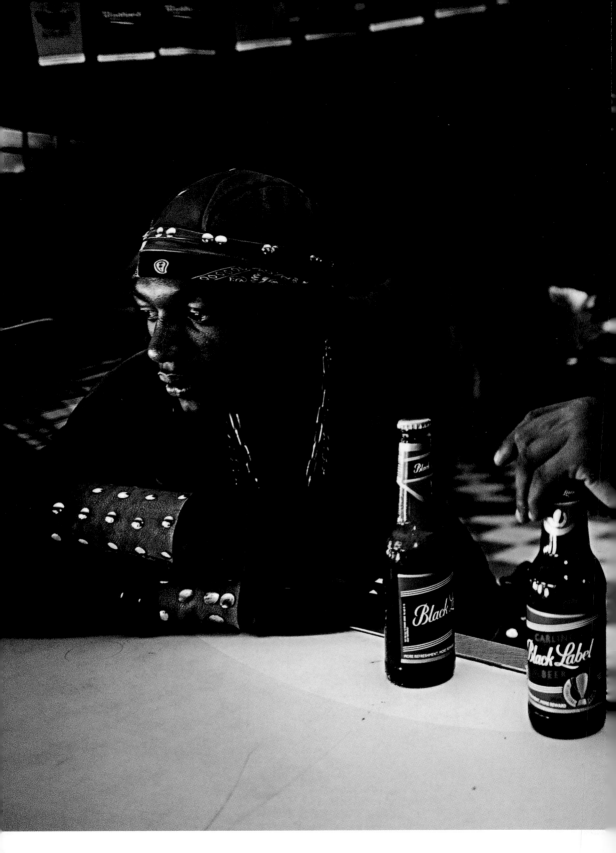

Hell Rider

DadMonstaKingofdarkness

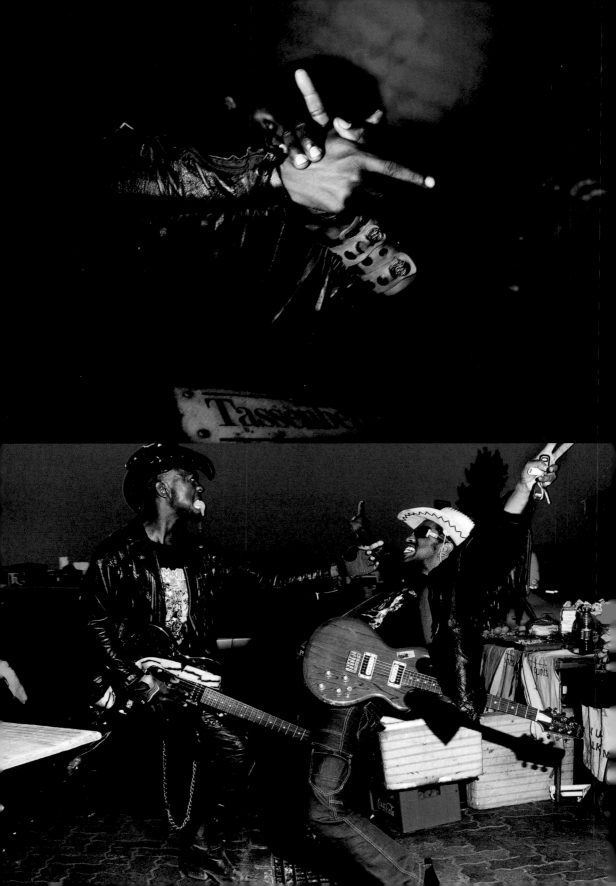

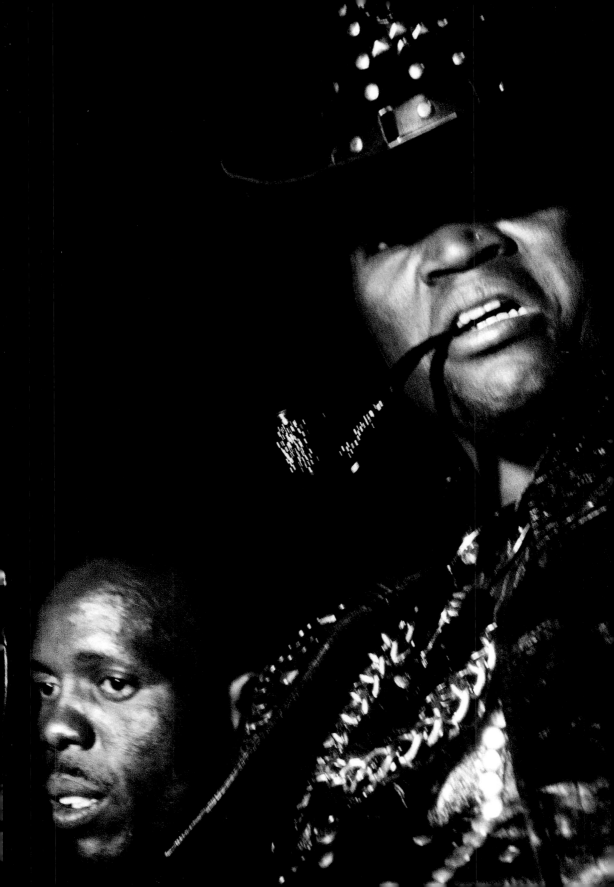

ACKNOWLEDGMENTS

I want to thank:

Els van der Plas. We talked about this project at great length and she always gave me the confidence to realize this book.

Rosario Dawson and Abrima Erwiah for their participation.

My publisher Dominique Carré for his support.

Stefano Bianchi for his graphic design.

All the international contributors, journalists, sociologists, artists, and curators who accepted my invitation to participate in the project: Katie Breen, Emmanuelle Courrèges, Véronique Marchand, Gerardo Mosquera, Peter Popham, Asanda Sizani, and Tonel. Their specific knowledge of each situation helped me to understand the contexts, which is so essential when introducing the images.

Thank you, everyone.

Finally, thanks go to my father, to Luca Rocco, and to Philip Stroomberg.

BIOGRAPHIES

Daniele Tamagni

Daniele Tamagni, born in Italy, began his career as an art historian before he became a freelance photographer. He came into the spotlight when he won the 2007 Canon Young Photographer Award for his reportage on Congolese dandies. In 2009, he published *Gentlemen of Bacongo*, with a preface by Paul Smith, who drew inspiration from his photographs for his 2010 spring-summer collection. In 2010, he won the International Center of Photography Infinity award for fashion. He then traveled to Bolivia and in 2011 won the World Press Photo Contest in Arts and Entertainment for his reportage on female wrestlers in La Paz. Since 2011, Tamagni has focused on the aesthetic of different street fashions. His photographs have been exhibited in the most important museums and private galleries worldwide.

Els van der Plas

Els van der Plas served as director of the Prince Claus Fund for Culture and Development (1997–2011), and then as director of Premsela, the Netherlands Institute for Design and Fashion, until August 2012, before taking on the role of general director of the Dutch National Opera and Ballet in Amsterdam. She also edited *The Art of African Fashion*, published by Africa World Press in 1998. Additionally, van der Plas curated several shows for the Prince Claus Fund Gallery, and she was the main advisor for Africa Remix, Contemporary Art of a Continent, a show that was put up from 2005 to 2007 at the Centre Pompidou, the Museum Kunstpalast in Düsseldorf, and the Hayward Gallery in London. She was a producer of the Sahel Opera from 2005 to 2009, bringing sold-out shows to Paris, Amsterdam, and Bamako. She is coeditor and coauthor with Georg Freeks and Berma Klein Goldewijk of *Cultural Emergency in Conflict and Disaster*, which was published by NAi Publishers/Prince Claus Fund in 2011, and coeditor with Malu Halasa and Marlous Willemsen of *Creating Spaces of Freedom*, published in 2001 by Saqi Books.

Asanda Sizani

Asanda Sizani is a fashion editor, creative consultant, and columnist from South Africa. River Island calls her "a style-tribe influencer" and *Style Italia* named her "an IT fashion editor." Her experience in the fashion industry includes roles as fashion editor at *ELLE South Africa*, columnist at *Grazia South Africa*, and stylist and content producer for retail giant Woolworths. Asanda has been profiled by the UK's *Never Underdressed*, *Arise* magazine, the German magazine *Brigitte*, as well as various television programs and radio stations. She is a stylist and creative

consultant for Consol Glass and collaborates with various brands, such as Levi Strauss & Co. and KISUA. She makes an appearance in Solange Knowles's music video for "Losing You," at the singer's personal request. In 2014, Sizani served as a judge for the prestigious Marie Claire Prix d'Excellence Awards. Sizani uses her profile to promote African designers farther afield. She is a member of the Berlin UP Fashion Committee, which creates trade and networking opportunities for African designers in Germany. In 2014, she was appointed curator for the renowned Design Indaba Expo 2015.

Emmanuelle Courrèges

Emmanuelle Courrèges is a French independent journalist. Born in Africa, she spent almost twenty years in Cameroon, Senegal, and the Ivory Coast. She began her career as a reporter at *Afrique* magazine. Five years later, she turned her attention toward women's magazines. Alternating between literary columnist, reporter, and beauty editor, she has worked with many prestigious publications. Her articles have been published in *ELLE*, *Marie Claire*, *Vogue Paris*, *Numéro*, *L'Express Styles*, and *Paris Match*. Specializing in social issues, she is particularly interested in women, identity, and diversity. She has written on numerous subjects regarding African fashion and African talent for *ELLE*.

Antonio Eligio (Tonel)

Antonio Eligio (Tonel) graduated with a degree in art history from the University of Havana in 1982. He is an artist, critic, and curator who divides his time between Canada and Cuba. His work has been exhibited extensively, including in group shows at the Havana, São Paulo, Berlin, and Venice biennials. His texts on Cuban and Latin American contemporary art have been published regularly in Cuba and elsewhere. He is the author of *Loss and Recovery of the City (in the Cinema)*, published by White Wine Press and Pisueña Press in 2010. His artwork is included in several collections in Cuba, Europe, and the Americas.

Véronique Marchand

Véronique Marchand is a doctor of sociology from the Lille University of Science and Technology. She is a researcher at the French National Center for Scientific Research (CNRS-CLERSÉ), and she currently works at the European Social Sciences and Humanities Research Institute (MESHS) in Lille, France. She spent nineteen months in La Paz, Bolivia, studying the fights of the cholitas as part of her thesis, which ultimately led to the book *Organisations et protestations des commerçantes en Bolivie*, published by L'Harmattan, Paris, in 2006. Her research examines interethnic and gender relationships, with particular attention paid to look and clothing—in this case, *la pollera*—as analytical representations of the complexity of social relationships in Bolivia.

Gerardo Mosquera

Gerardo Mosquera is an independent art critic, curator, historian, and writer based in Havana and Madrid. Chief curator of the fourth San Juan Poly/Graphic Triennial in 2015, he is advisor to several international art centers and journals. He was a cofounder of the Havana Biennial, and he served as the artistic director for Photo

Spain in Madrid from 2011 to 2013. He recently curated the exhibitions Lost in Landscape for the Museum of Modern and Contemporary Art of Trento and Rovereto and Artificial Amsterdam for the de Appel. Author of numerous texts and volumes on contemporary art and art theory, the book to which he most recently contributed, *The Global Contemporary and the Rise of New Art Worlds*, was recently translated into Chinese. He has lectured extensively around the world, and he received the Guggenheim Fellowship in 1990.

Peter Popham

Peter Popham is an author and foreign correspondent. He started his career as a journalist in Japan in the 1980s, and in 1985 he wrote an acclaimed book, *Tokyo: The City at the End of the World*, on the Japanese capital and its futuristic modern culture. He lived in India for five years, covering India, Pakistan, Burma, and Afghanistan for the *Independent*, then moved to Italy, where he first met Daniele Tamagni. After nearly a decade in Rome and Milan he returned to London, his hometown, where he writes a weekly column for the *Independent*. His bestselling 2011 book *The Lady and the Peacock*, a biography of Aung San Suu Kyi, Burma's democracy champion, has been translated into several languages, including Mongolian.

Katie Breen

Katie Breen is an independent French journalist and editorial consultant, and former editorial director of the international editions of *Marie Claire*. Her writing has recently appeared in the international editions of *Marie Claire*, France's *Géo*, Italy's *Io Donna*, and Germany's *Viva*. Trained in economics and political science, she holds a PhD in political science from the Graduate Institute of International Studies in Geneva. After some time spent teaching, she worked as a features editor and writer for the French edition of *Marie Claire* before traveling the world to help set up and monitor new editions of the magazine in various countries. She created Coverlines, her own company, in 2005. For more information, please visit www.coverlines.net.

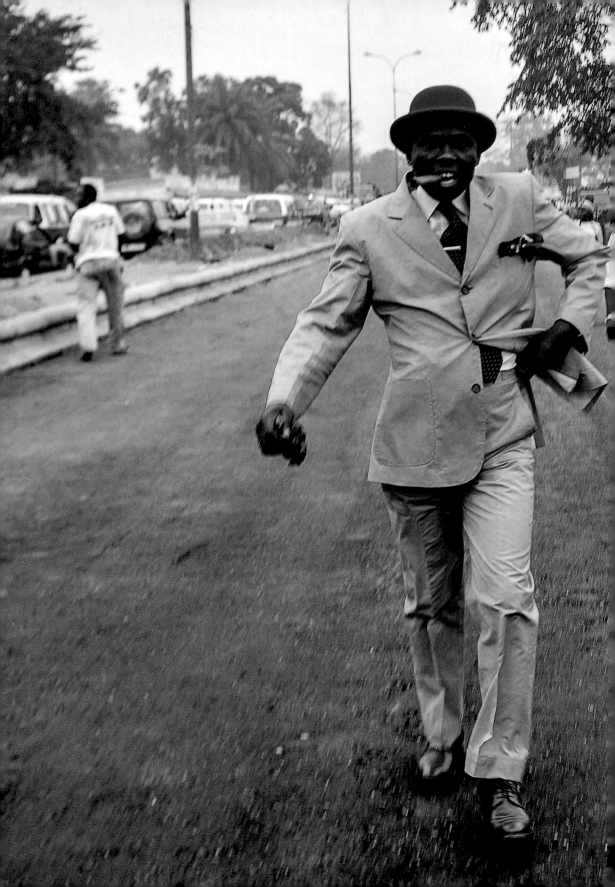

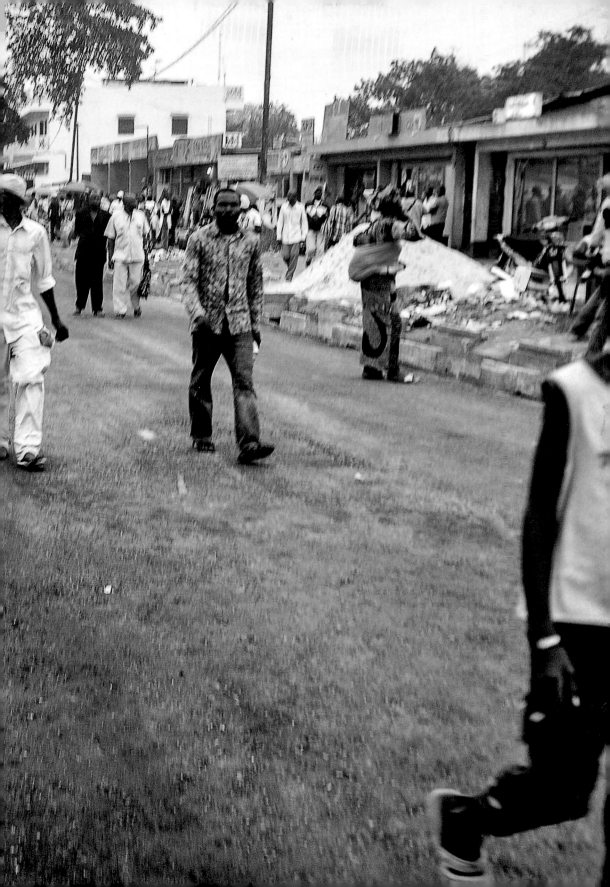